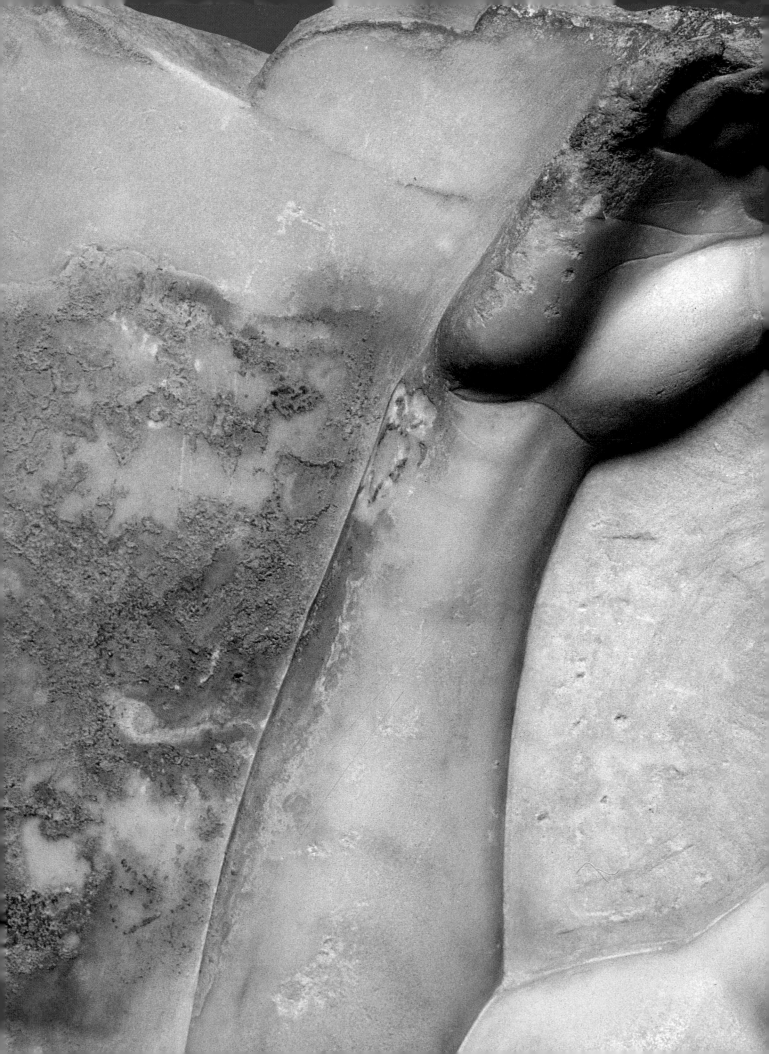

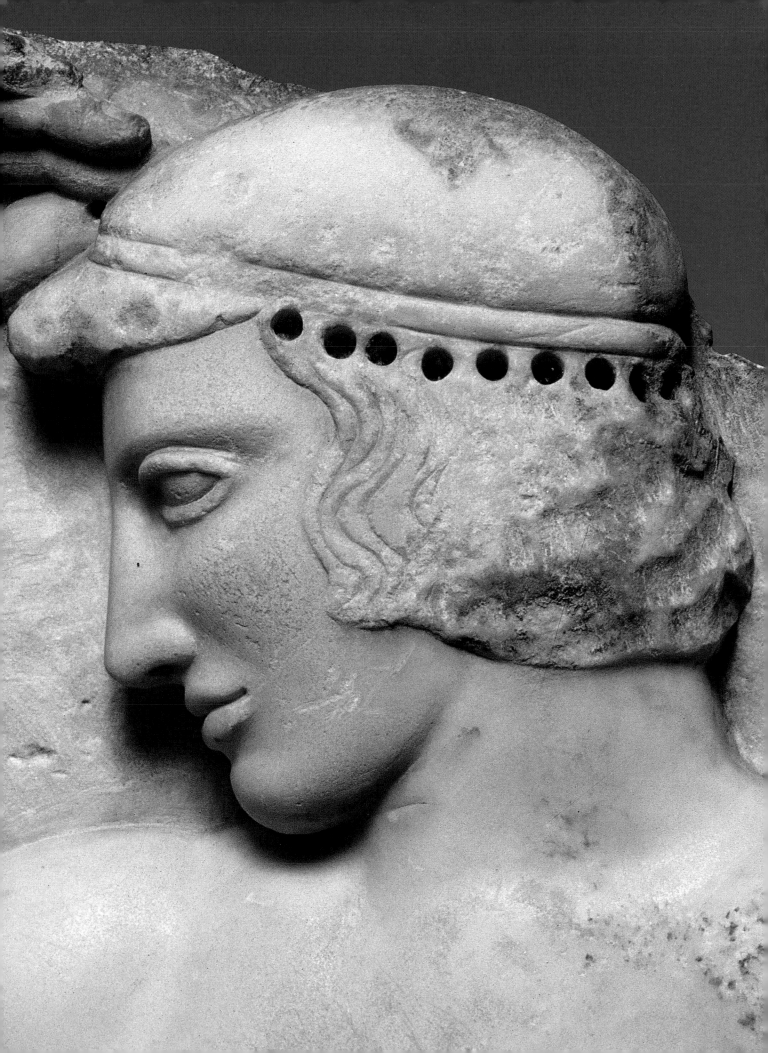

The Human Figure in Early Greek Art

The Human Figure in Early Greek Art

GREEK MINISTRY OF CULTURE, ATHENS/NATIONAL GALLERY OF ART, WASHINGTON

Editors of the catalogue
JANE SWEENEY, TAM CURRY, YANNIS TZEDAKIS

Design and production of the catalogue
RACHEL MISDRACHI-CAPON

English translations
NANCY WINTER, EVELYN HARRISON, MYRIAM CASKEY, DAVID HARDY

Photographs
GEORGE FAFALIS, MAKIS SKIADARESSIS (38, 55, FRONT VIEW)

Artistic Advisor
MOSES CAPON

Maps
ANTONIA KOTSONI

Typesetting
VIP SYSTEMS, INC., ALEXANDRIA, VIRGINIA

Color separations
SELECTOR L.T.D.

Stripping
G. PAPAPANAGOPOULOS

Printing
S. KARYDAKIS

Binding
EFTAXIADES-IOSSIPHIDES

Paper
ZANDERS 135 gr. illustration

Cover illustration: cat. 66

Printed and bound in Greece, 1987

Exhibition dates:
National Gallery of Art, Washington 31 January–12 June 1988
The Nelson-Atkins Museum of Art, Kansas City, Missouri 16 July–2 October 1988
Los Angeles County Museum of Art 13 November 1988–15 January 1989
The Art Institute of Chicago 18 February–7 May 1989
Museum of Fine Arts, Boston 7 June–3 September 1989

We wish to acknowledge the Greek section of the International Council of Museums for their help in completing this catalogue and Ekdotiki Athinon for using its maps as reference.

Library of Congress Cataloging-in-Publication Data
The Human figure in early Greek art.
 Bibliography: p.
 1. Art, Greek—Exhibitions. 2. Human figure
in art—Exhibitions. I. National Gallery of Art
(U.S.) N5635.W37H86 1988 730'.0938 87-28234
ISBN 0-89468-107-9

CONTENTS

MINISTER'S PREFACE

Now, as then.

Then, at the beginning of the first millennium before Christ.

Greek youths have set forth on the road of exploration, some named, others nameless, and have traveled further than ever before, youths in full blossom, to new, fresh worlds, the Archaic smile on their immortal lips, their marble lips, taking captive the gaze of beauty in their flashing eyes.

Holding in their hands the art of wisdom and the golden mean.

And the pain of freedom.

Ageless youths, the eternity of the Odyssey in their breasts, the lyrics of Sappho on their breath, the humanity of Hesiod in their thoughts. Their bodies swaying to the rhythm of the iambus, of the dochmius, of the anapest. From the past to the present they have come, conferring new dimensions. Naked, clothed only in their own self.

Then, as now.

Today, at the end of the second millennium after Christ.

Our memories, our eternal doubts have set forth on the road of "recognition" and, some named, others nameless, have traveled beyond dream to this New World, History alive in their Minds, to illuminate the darkest levels of our consciousness.

The *kouroi* and the *korai*.

In an age of impasse, in a world held captive in the net of its own loneliness; *kouroi* of inner self-sufficiency, *korai* of human grandeur.

In the century of space wandering, the torchbearers of earthly exploration.

To enlighten our perfection and self-knowledge.

Let us bid them welcome with the eyes of our soul wide open.

Melina Mercouri
Greek Minister of Culture

DIRECTORS' FOREWORD

During a critical evolutionary period that spanned some four to five hundred years, from the late tenth to the early fifth centuries B.C., there occurred in Greece a discovery that charted the course for the subsequent development of Western art. Greek artists learned to represent the human figure in a naturalistic way. While we tend to take this accomplishment for granted, it is the bedrock on which European representational art was based for two thousand years. *The Human Figure in Early Greek Art* refocuses our attention on these formative centuries, revealing to us in objects of all sizes and many different media the series of changes that led ultimately to the unsurpassed ability of artists to show man as if he were alive. Here, with the linear economies of vase painting as well as the volumetric fullness of sculpture, we see the body both in motion and at rest.

Artists defined the human form visually; at the same time poets, statesmen, and philosophers struggled to describe this strange creature, "wonderful but terrible" in the words of Sophocles, capable of great good and great evil. The era covered in this exhibition, the Geometric, Orientalizing, and Archaic periods, illustrates how it was possible for the great Classical style of the fifth century to emerge, giving us the opportunity, in spite of historical distance, to assist at the birth of humanism. Moreover, the exhibition bears witness with *kouroi* and *korai* to the articulation of one of Western culture's most forceful standards of beauty: the perfection of youth.

This exhibition came into being following conversations with Spyros Mercouris, special advisor to the minister of culture, and Yannis Tzedakis, director of antiquities of the Greek Ministry of Culture. Some of the objects were displayed in Florence during the fall of 1986 in an exhibition entitled *From Myth to Logos,* part of the Greek contribution to that year's Cultural Capital of Europe celebration. The selection of objects shown in the United States results from collaboration between Dr. Tzedakis and his colleagues and staff members of the National Gallery of Art, Washington.

We are most grateful to the government of Greece; vital support has come from His Excellency the President of the Greek Democracy Christos Sartzetakis, Prime Minister Andreas Papandreou, and, in particular, the Minister of Culture Melina Mercouri, whose vision of the importance of cultural exchange has driven the project from its inception. Our warm thanks go to the directors and staffs of the participating museums in Greece and to the members of the Central Archaeological Council for allowing these precious objects to travel to the United States, most of them for the first time.

We also thank His Excellency George Papoulias, Greek ambassador to the United States, the Honorable Robert V. Keeley, United States ambassador to Greece, and their staffs; and the staff of the United States Information Agency for their participation in promoting this cultural exchange.

In addition, we are grateful to His Eminence Archbishop Iakovos and the Honorable John Brademas for their special efforts for the exhibition. We are also appreciative of the contribution made by Joannou and Paraskevaides (Overseas) Ltd. toward this exhibition. Atlantic Bank of New York has also supplied welcome assistance. Essential support has been provided by the government of the United States, which provided an indemnity through the Federal Council on the Arts and the Humanities.

In addition to all those in Greece, many individuals in Kansas City, Los Angeles, Chicago, Boston, and Washington deserve thanks for their work on the exhibition. Our final thanks go to those who have contributed to this catalogue and especially to Diana Buitron-Oliver, who has served as the National Gallery's guest curator for this project. Without her considerable talents, her valuable scholarship, and her commendable devotion, this undertaking would not have reached such a happy and satisfying conclusion.

J. Carter Brown
National Gallery of Art, Washington

Marc F. Wilson
The Nelson-Atkins Museum of Art, Kansas City, Missouri

Earl A. Powell III
Los Angeles County Museum of Art

James N. Wood
The Art Institute of Chicago

Alan Shestack
Museum of Fine Arts, Boston

11

COMMITTEE OF HONOR

His Eminence Archbishop Iakovos
*Primate of the Greek Orthodox Church
of North and South America*

His Excellency George D. Papoulias
Ambassador of Greece

The Honorable Robert V. Keeley
American Ambassador to Greece

Paul Mellon
*Honorary Trustee,
National Gallery of Art*

The Honorable John Brademas
President, New York University

Dr. Homer Thompson
*Professor Emeritus, Institute for
Advanced Study, Princeton University*

The Honorable Paul S. Sarbanes
U.S. Senator (D-Md.)

The Honorable Gus Yatron
U.S. Representative (D-Pa.)

The Honorable Nicholas Mavroules
U.S. Representative (D-Mass.)

The Honorable Olympia J. Snowe
U.S. Representative (R-Me.)

The Honorable Michael Bilirakis
U.S. Representative (R-Fla.)

The Honorable George W. Gekas
U.S. Representative (R-Pa.)

ORGANIZING COMMITTEE

Spyros Mercouris
General Coordinator of Exhibitions in Greece and Abroad,
Greek Ministry of Culture

Stathis Lozos
First Secretary, Embassy of Greece, Washington

Dr. Yannis Tzedakis
Director of Antiquities, Greek Ministry of Culture

Dr. Olga Tzachou-Alexandri
Director of the National Archaeological Museum, Athens

Dr. Evi Touloupa
Director of the Acropolis Museum, Athens

Dr. Nikolaos Kaltsas
Archaeologist, Greek Ministry of Culture

Mary Pandou
Archaeologist, Greek Ministry of Culture

Roza Proskynitopoulou
Archaeologist, National Archaeological Museum, Athens

Stalo Stylianou
Archaeologist, Greek Ministry of Culture

Dr. Ioannis Touratsoglou
Archaeologist, Numismatic Museum, Athens

Despina Picopoulou-Tsolaki
Archaeologist, Greek Ministry of Culture

LIST OF LENDERS

Aegina, Archaeological Museum
Argos, Archaeological Museum
Athens, Acropolis Museum
Athens, Agora Museum
Athens, Kerameikos Museum
Athens, National Archaeological Museum
Chalcis, Archaeological Museum
Delphi, Archaeological Museum
Eleusis, Archaeological Museum
Eretria, Archaeological Museum
Herakleion, Archaeological Museum
Olympia, Archaeological Museum
Samos (Vathy), Archaeological Museum
Sparta, Archaeological Museum
Tenos, Archaeological Museum
Thasos, Archaeological Museum
Thera, Archaeological Museum
Thessaloniki, Archaeological Museum

ACKNOWLEDGMENTS

The classic image of the human figure we know from Athens in the fifth century B.C. represents the culmination of centuries of effort and experiment by Greek artists. Tracing the process of the development of the human figure by presenting actual works of art has never before been attempted in an exhibition in the United States. The opportunity to draw on the riches of the Greek museums—stone sculptures, bronzes, terracottas, vases, many of them textbook examples in the history of Greek art—has been encouraged by the minister of culture of Greece, Melina Mercouri, and by the director of antiquities, Yannis Tzedakis. We are greatly indebted to Dr. Tzedakis in his role as co-organizer of the exhibition and for the assistance of his team at the ministry: Mary Pandou, Despina Picopoulou-Tsolaki, Stalo Stylianou, and other members of the Greek organizing committee.

Spyros Mercouris, who first proposed the exhibition, has smoothed the course of events with great skill, facilitating travel to examine the works of art and on many other occasions. Choosing objects was a cooperative venture from first to last. The ministry was sympathetic to our desire for objects of top quality, and aided us in every way possible.

The Ministry of Culture and the National Gallery of Art shared commissioning the scholars who wrote the entries and essays in the catalogue: Alan Boegehold, Ioannis Touratsoglou, Despina Picopoulou-Tsolaki, Mary Pandou, Martin Robertson, R. V. Nicholls, Theodora Karaghiorga, Evelyn Harrison, Roza Proskynitopoulou, and Nikos Kaltsas. We are grateful to all the catalogue authors for their patience and willingness to write under tight deadlines.

Rachel Capon worked tirelessly to produce the design of the book, in cooperation with the various editors and authors, and with George Fafalis, who made most of the photographs. Frances P. Smyth, editor-in-chief at the National Gallery, negotiated the production of the catalogue with the Ministry of Culture; Jane Sweeney and Tam Curry edited the texts. Nancy Winter, director of the library of the American School of Classical Studies in Athens, translated the entries and essays that were written in Greek. She was assisted by Evelyn Harrison, the Edith Kitzmiller Professor at the Institute of Fine Arts, New York University. We are also greatly indebted to Evelyn Harrison for help and advice throughout the planning of the exhibition. We are grateful to Stephen G. Miller, former director of the American School of Classical Studies, and the staff of the school; and to others who have helped and advised at various stages: Louise Berge, Ariel Herrmann, Caroline Houser, Richard M. Keresey, William L. MacDonald, Richard Mason, Carol Mattusch, Margaret E. Mayo, James R. McCredie, Alan Shapiro, and especially my husband, Andrew Oliver.

We would also like to acknowledge the interest and assistance of Harriet Elam, who was the United States cultural affairs officer at the American Embassy in Athens, and Pat Kushlis, the desk officer for Greece at the United States Information Agency, and also the staff of the Embassy of Greece in Washington.

We thank the directors and ephors of the museums in Athens and in Greece who have generously lent objects, especially those who allowed us to examine them: the director of the National Archaeological Museum, Olga Tzachou-Alexandri, the ephor of the department of sculpture of the National Archaeological Museum, Katerina Romiopoulou, the ephor of the department of bronzes of the National Archaeological Museum, Petros Kalligas, and the ephor of the department of vases and terracottas of the National Archaeological Museum, Ios Zervoudaki.

We thank the director of the Acropolis Museum, Evi Touloupa, the director of the Kerameikos Museum, Theodora Karaghiorga, and Maro Kyrkou, archaeologist at the Agora Museum.

At Delphi we thank Evangelos Pentazos, director of the Delphi Archaeological Museum, and Lela Bakolouka of the administrative staff; at Chalcis, Evi Sakellaraki, director of the Chalcis and Eretria Archaeological Museums, and Amalia Karapaschalidou, archaeologist at the Chalcis Museum; at Olympia, Angelos Liangouras, director of the Olympia Archaeological Museum; and in Tenos, Photeini Zaphyropoulou, director of the Samos, Tenos, and Thera Archaeological Museums, and Nikos Krondiras, museum custodian, Tenos.

In addition we thank the directors of all the other museums that have lent objects: Vassilis Petrakos of the Aegina Archaeological Museum, Photeini Pachyghianni of the Argos Archaeological Museum, Theodora Karaghiorga of the Eleusis Archaeological Museum, Ioannis Sakellarakis of the Herakleion Archaeological Museum, Theodoros Spyropoulos of the Sparta Archaeological Museum, and Julia Vokotopoulou of the Thessaloniki Archaeological Museum.

Throughout this endeavor I have been deeply grateful for the cheerful and efficient organization of the National Gallery of Art. At all times we have had the generous and attentive support of J. Carter Brown. It has been a pleasure to work with D. Dodge Thompson, Cameran G. Castiel, and Deborah Shepherd in the department of exhibitions; and with Gaillard Ravenel and Mark Leithauser in the department of installation and design. The colleagues and friends involved with this exhibition have made my tenure as guest curator interesting, rewarding, and memorable.

Diana Buitron-Oliver
Guest curator
National Gallery of Art

INTRODUCTION

The basic approach today in the policy of the Direction of Antiquities of the Ministry of Culture for the organization of archaeological exhibitions is that the objects be "set" in the display area according to the criteria of a specific theme, and with a well-considered educational purpose. The idea is to avoid the traditional museum model in which the objects to be displayed are of necessity confronted as masterpieces placed "on parade."

This philosophy imbued both the exhibition in Athens in 1985, *Democracy and Classical Education*, and the Greek exhibition in Florence in 1986, *From Myth to Logos*. Both were organized with particular success within the framework of the celebration of The Cultural Capitals of Europe. The present exhibition, *The Human Figure in Early Greek Art*, is, in fact, an extension of the exhibition in Florence. Thus it adheres to the same philosophical outlook and it has the same goals. The objects to be exhibited (marbles, terracottas, bronzes) cover a chronological span of some five centuries. They reflect the entire struggle of the Greek people for political, economic, and cultural development in a region familiar to them for centuries, but nonetheless fraught with difficulties and problems. In time, this struggle is transformed into an extensive and lasting Greek presence in the region stretching from Italy to the Black Sea, with monuments unique in art, literature, and philosophy, decisive for the evolution of international culture.

It would be difficult indeed, if not impossible, for this exhibition to be successful were it not for the full support of the minister of culture, Mrs. Mercouri, and continuous and exhaustive work on the part of the Greek organizing committee, which has devoted itself to the editing of essays and entries, and to matters of organization and procedure.

To a great degree success is due also to collaboration with the director of the National Gallery of Art, J. Carter Brown, and his colleagues there. During the course of this collaborative effort, many difficulties quite understandably arose. They were resolved in a friendly atmosphere, and the result, I believe, shows that those responsible were right minded in proceeding with collaboration in the organizing of the exhibit and in the co-editing of the catalogue.

I should like, once again, to thank warmly all who labored for the success of this project, and especially the directors of the Greek archaeological museums who have lent the objects for the exhibition, Mr. Panagiotis Bitsaxis, president of the Archaeological Receipts Fund (TAP), Mr. Nicos Belloyannis, chemist, Mrs. Christina Tritou, sculptor, Mrs. Yanna Dogani, conservator, Mr. Stelios Bergeles and his staff, who were responsible for the packing and transportation of the items in Greece, Mrs. M. Caskey and Mr. David Hardy for translating some of the texts, Mrs. Rachel Capon for the design and production of this catalogue, and all the Greek archaeologists and technicians who worked for the preparation of this exhibition in Greece and in the United States as well as their American colleagues.

I would like to thank for their kind assistance and cooperation the directors, the head and the staff of the departments of all museums involved in the exhibition, and particularly of the following offices and departments of the National Gallery of Art: the offices of the deputy director, the administrator, the secretary-general counsel, the registrar, and the departments of exhibition programs, conservation, education, publications, installation and design, public information, and security.

Yannis Tzedakis
Director of Antiquities
Greek Ministry of Culture

ABBREVIATIONS

AJA	*American Journal of Archaeology*
AM	*Mitteilungen des Deutschen Archäologischen Instituts, Athenische Abteilung*
ArchEph	*Archaiologike Ephemeris*
Beazley, *ARV²*	J. R. Beazley, *Attic Red-figure Vase Painters*, 2nd ed. (Oxford, 1963)
BCH	*Bulletin de correspondence hellénique*
Boardman, *Greek Sculpture*	J. Boardman, *Greek Sculpture, The Archaic Period* (London, 1978)
Brouskari, *The Acropolis Museum*	M. Brouskari, *The Acropolis Museum* (Athens, 1974)
BSA	*Annual of the British School of Athens*
Coldstream, *Geometric Greece*	J. N. Coldstream, *Geometric Greece* (London, 1979)
Coldstream, *Geometric Pottery*	J. N. Coldstream, *Greek Geometric Pottery* (London, 1968)
CVA Athens	*Corpus Vasorum Antiquorum*
Deltion	*Archaiologikon Deltion*
Greek Art of the Aegean Islands	*Greek Art of the Aegean Islands* [exh. cat., The Metropolitan Museum of Art] (New York, 1979)
Higgins, *Greek Terracottas*	R. A. Higgins, *Greek Terracottas* (London, 1967)
Jdl	*Jahrbuch des Deutschen Archäologischen Instituts*
JHS	*Journal of Hellenic Studies*
LIMC	*Lexicon Iconographicum Mythologiae Classicae* (Zurich, 1981–)
RM	*Mitteilungen des Deutschen Archäologischen Instituts, Römische Abteilung*
Richter, *Korai*	G. M. A. Richter, *Korai, Archaic Greek Maidens* (London, 1968)
Richter, *Kouroi*	G. M. A. Richter, *Kouroi, Archaic Greek Youths*, 3rd edition (London, 1970)
Rolley, *Greek Bronzes*	C. Rolley, *Greek Bronzes* (London, 1986)
Schweitzer, *Geometric Art*	B. Schweitzer, *Greek Geometric Art* (London, 1971)

CONTRIBUTORS

N. K.	Nikos Kaltsas
R. P.	Roza Proskynitopoulou
D. T.	Despina Picopoulou-Tsolaki
I. T.	Ioannis Touratsoglou
M. P.	Mary Pandou

NOTE TO THE READER

Dimensions are in centimeters, followed by inches in parentheses.

PART I
EARLY GREEK LIFE AND THOUGHT

LIFE IN EARLY GREECE

Alan L. Boegehold

Sometime around 1100 B.C., a potent Greek civilization, now generally called Mycenaean after one of its centers, came to an end. That civilization flourished for hundreds of years in the Peloponnesus and on the mainland, and for shorter times on Crete, on the coast of Asia Minor, on the Dodecanese, and on Cyprus. Traces of this civilization have also been found as far west as Italy. Rulers of the time, rich in productive land and expansive on the sea, built networks of roads. They also acquired gold and silver and ivory, enough for the employments of many generations of artisans. They in turn had patrons and consequently time to imagine and execute a varied profusion of paintings, sculpture, jewelry, weapons—all sorts of things for use and adornment. The nobles hunted and made war, and their ladies attended extravagant entertainments, safe within their well-built halls. In the last stages of this world, scribes kept detailed accounts of palace utensils and provisions. They shaped clay tablets in the form of palm leaves and scratched into them signs that stood for objects, for numbers, and for sounds of the Greek language. Fires consumed the palaces and baked and so preserved the tablets.

After the palaces burned, what survivors there might have been did not rebuild. Whether this was because of a catastrophic change of climate, or an invasion, or a generally ruinous family struggle, we do not know.

During the three hundred years that followed, Greeks left little in the way of material remains—not much more than graves with pots and armor and personal effects (which, however, show skillful work in bronze, faience, and gold, as well as iron, a metal not in use in earlier times). There is no sign of towns, almost none of houses. There is no writing. At Athens, which was not one of the great centers of the earlier Mycenaean civilization, archaeologists can show in the pottery of the time an unbroken sequence of changing shapes and decoration, but nowhere else do the physical remains allow even so sketchy a survey to be attempted. In graves at Lefkandi, the site of a ninth-century settlement in Euboea, imported Attic pottery shows that the people had commerce with their neighbors to the west. They also traded with Phoenicians from the East and had gold to use for grave offerings.

During this so-called Dark Age, people made a living from the land. Their dwellings, so far as any impulse toward social organization can be divined, were in scattered hamlets, each with its own burial plot. Each can also be imagined to have had a leader, styled *basileus* (king). They tended to stay at home. The sea was always near, but its possibilities seemed more threatening than not. They spoke Greek, although not everyone spoke exactly the same Greek. One might on occasion find another's dialect funny or even verging on barbarous, but Greeks understood one another. Some burned their dead and committed the ashes to urns; at Athens some burned and others buried their dead in cists cut into the soft green stone that underlies much of Attica's thin soil. Their gods were the Olympian pantheon known from later years: Zeus, Hera, Poseidon, Apollo, Artemis, Athena, Aphrodite, Hephaestus, Ares, and Hermes, along with Demeter, Dionysus, and Hades of the lower realms.

By the middle of the eighth century the Greeks are again highly visible, as though they had stepped from deep shade into bright sunlight. They use the sea to find new territories and riches. Hesiod, a Boeotian poet, who composed a *Theogony* and a *Works and Days,* gives advice on when to sail (but elsewhere in the same poem, he lists good things that come to a just man, and among them is a dispensation from having to go to sea). Commerce with the East and colonization in Sicily and Italy to the West stimulate new aspirations. New metalworking techniques are imported from the East.

A radically different way to organize neighboring hamlets evolves. The rulers and councillors of many small agglomerations of people found it possible in various parts of Greece to form single central administrations. The political conformation that results is called *polis* (city-state). It is essentially an area of land, usually defined by natural features such as mountains or water, whose administration is lodged in one or more towns or cities within the area. Along with political innovations, there appear new aims for craftsmen: artists essay grander projects such as temples and life-size and monumental sculpture. Pan-Hellenic athletic games are founded at the great sanctuaries of Zeus at Olympia and Nemea, of Apollo at Delphi, and of Poseidon at Isthmia. The Greeks have discovered an identity. No matter which of the dialects they speak, the certainty that they are Greek is reaffirmed at the sanctuaries, where they assemble for games and festivals, and in the epic poems, which many of them know by heart.

Homer, a blind singer whom many cities claim as their own, appears as archetypal bard. He and others compose long, complex, and yet shapely songs set in dactylic hexameters, telling the adventures of warrior-heroes who ruled the great houses of the now legendary, earlier Greek civilization. Two of the best of these epics survive complete, namely the *Iliad,* which concerns episodes during a famous Greek siege of Troy, and the *Odyssey,* which tells how Odysseus, one of the chief heroes, returned home to Ithaca from Troy.

Hesiod in the same heroic measures transmits practical wisdom of his day, some of it from the East. In succeeding generations, new songs composed in new metrical schemes come into the world. Stesichorus composes variations on the old sagas. Archilochus devises animal fables, and in another strain, intensely personal revelations: how he threw away his shield to save his life, how he intends to make love. Tyrtaeus celebrates battle. Sappho wryly observes herself falling in love again.

The Greeks rediscover writing. A northwest Semitic alphabet is adapted sometime before 750 to represent single sounds of the Greek language. The resulting capital letters show by a few local variations in shape and sound three slightly different Greek alphabets, which remain distinct until well after the Persian Wars (490–479). Eventually these signs make an important change in Greeks' whole response to the needs of communal life, but in the years under consideration, speaking and listening was a sufficient—and on occasion sublime—level of intercourse. There was no need to fix all the details of life in writing.

Hesiod lived on the east slope of Mount Helicon in Ascra, which he calls "a dreary hamlet, bad in winter, hurtful in summer, never any good at all." His

landscape is that of Boeotia in the eighth century. It is a rural world with scattered centers of habitation and "kings," among whose powers apparently was that of summary adjudication. They sit in judgment in the marketplace, and it is worth something to get their attention. They eat up bribes.

But a man could move. The Dark Ages may have flattened out some class distinctions. It was not just that you could go off to a new colony. You could work hard and get ahead at your own trade, be it farming, pottery making, or metalworking. Get yourself a house, a woman, and an ox. Marry when you are about thirty years old. Choose a virgin, preferably from the neighborhood. She can be sixteen or seventeen. You could hope to get rich if you worked hard. Life offered more choices than a struggle for food. Your place in the world was not fixed by the limits of your parents' land. It was different, however, for a woman; her part was to stay indoors and keep herself soft and undefiled until marriage.

One characteristically human question makes itself apparent: why is it that some get life's rewards and others do not? The remote and beautiful Olympian gods seemed not to be directly operative. If answers to such questions were revealed at Eleusis during celebrations of the mysteries, they were for the initiated. Obviously, you could bring troubles down on your own head by folly, and a man's crime could hurt his whole family including descendants—his whole city in fact. Tradition and speculation, moreover, had room for predestined happenings. But what to do about the random, malevolent powers that can wreck a man's whole life, the ones that aim a lightning bolt, a crippling or fatal accident, a drought, a flood, an enemy's weapon? Hesiod offers rules whose original aim, we can surmise, was to ward off such visitations. Do not enter a river without washing your hands. Do not urinate while walking forward. Do not attempt to conceive a child just after having been to a burial with its ill-omened sounds of grief. Do so, however, after a feast, where proper offerings have been made to the gods.

That is life in the country, not much different from life in one of the hamlets or larger settlements that made up a polis. In the town that Homer's Hephaestus devises on Achilles' new shield, young people are dancing, and dancing is a ubiquitous expression of the Greek spirit. One of our earliest examples of written alphabetic Greek is a single dactylic hexameter (with part of another) scratched into the shoulder of a wine pitcher. The inscription makes a prize of the pitcher, to be awarded to the dancer who sports most featly.

That the dancing was a contest is characteristic. Homer describes Achilles' funeral games for his friend, Patroclus. Friends and allies compete passionately for prizes in chariot races, boxing, wrestling, throwing a weight, archery, and spear casting. One young man, Antilochus, in his eagerness tries to force his chariot past Menelaus' in a narrow place. In doing so he puts Menelaus in danger. He is rebuked in an informal tribunal, admits he was at fault, and is forgiven with heroic generosity. This same willingness to submit to regulations can be seen in the later pan-Hellenic games.

Another scene on Achilles' shield shows a different side of life. One man has killed another. He has paid a sum of money to the dead man's father or brother or cousin, hoping to stop a vendetta. The sum—or his claim that he gave it—is in dispute. The dead man's relations want to kill him. He seeks the protection of a trial. Senior compatriots who know something about the circumstances deliver opinions in a formal conclave. People of the town listen and respond. The best opinion will determine the outcome, and the best judge will get a rich fee for his opinion. It is a beginning of communal participation in judicial procedures.

A quarrel, if serious, could harm the life of a community. An impulse to settle quarrels, once writing was known, produced written law. Whole codes of law were formulated, written down, and published, sometimes cut into stone walls, sometimes incised on bronze plaques that were hung or nailed up in public places. The act of publication was important, for when the laws were there for

anyone to see, all the people of a community used them, and not just the law-makers. Those who could not read could have the law read to them. At Athens, Draco gave his people laws that later tradition exemplifies as severe. His laws on homicide, however, still preserved in part, are rationally founded and were still in use—recovered and republished in fact—more than two hundred years after his time.

It may be that some of Draco's other laws were unworkable, for landowners continued to absorb the properties—and finally the personal freedom—of their less-fortunate neighbors. Even so, however, by the beginning of the sixth century, they relinquished certain advantages in the interest of communal harmony.

Around 590 an Athenian named Solon gave Athens laws that both democrats and oligarchs consecrated many years later as the foundation of democracy. Solon declares in a poem that he could have become tyrant but he chose not to. Instead he freed land for the disadvantaged, without, however, resorting to an overall redistribution of land, which some wanted and others feared. He left to the fortunate a degree of power they could accept. No contemporary tells exactly why the rich were willing to give up as much as they did, and there is no tradition of a popular leader. Armed force may have been a factor. In later tradition, Solon canceled debts, revised the Athenian monetary system (Greeks elsewhere had adapted coinage long before), and established a tribunal consisting of hundreds of citizens as judges. He also encouraged community industry. Attic black-figure pottery, for one thing, began to be circulated throughout the Greek world.

In the years that extend down to the end of the Persian Wars, the radiant beginnings of Greek civilization continued to illuminate the world. Greeks rationalize cosmological speculation. As states were formed, the troubles that afflict such bodies grew and had to be confronted. The civilized life and leisure of whole cities became dependent on the unpaid labor of slaves. Epidemic diseases and crop shortages threatened whole populations. Tyrants emerged as popular and then as oppressive rulers.

The mountains, valleys, and water that physically separated Greeks kept them independent in spirit as well. And their forms of government reflected their diversity. Sparta maintained a polity at whose head two kings ruled. Athens after tyrants founded a democracy, Corinth, an oligarchy. Boeotia had another form of oligarchy, and the Locrians yet another. States were pertinaciously at war with one another, both before and after a decade within which mighty Persian armies arrived twice in Greece. At the time, imperfect alliances of Greek states saved what may with all due qualifications be termed the integrity of Greece, and the start of another productive and problematic era. But that is an era beyond the range of the present exhibition.

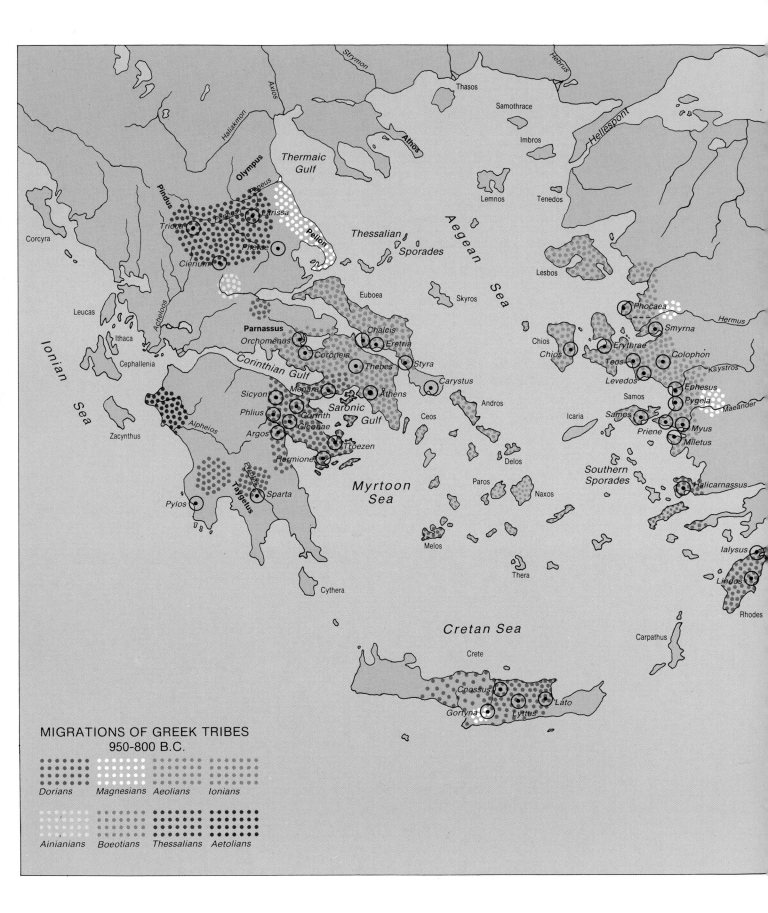

MIGRATIONS OF GREEK TRIBES
950-800 B.C.

Dorians	Magnesians	Aeolians	Ionians
Ainianians	Boeotians	Thessalians	Aetolians

The spelling of the Greek toponymes is based on B. Head, *Historia Numorum* (Oxford, 1911).

THE ALPHABET OF HISTORY
THE FIRST AND SECOND
GREEK COLONIZATIONS

Ioannis Touratsoglou

By the end of the twelfth century B.C., the seafaring expeditions of the Mycenaeans "rich in gold" are a thing of the past. This ancient Achaean culture, grown complacent from resting on its laurels, vainly seeks security inside the walls of its citadels. Yet the unsettling news of invaders from the north is only the messenger of the downfall, for the decline had been visible for some time.

The Dorian newcomers, a Greek tribe from the periphery of the Hellenic world, by introducing the use of iron set their seal upon an age that will later be revived in the memories of eighth-century Greeks in the form of epic narration. The immediate result of the Dorian migration was the redistribution of the tribes that inhabited mainland Greece. The newcomers are now the prevailing element in the eastern and southern parts of the Peloponnesus.

By contrast, Attica was never to be invaded. In Boeotia, it would seem that a peaceful equilibrium was established between the population already settled in the East and the new northwestern one. During the later phase of the invasion, the Dorians reach Crete, settle in the Sporades and southern Cycladic Islands, and travel as far as Caria and Pamphylia. Like the Achaeans before them, however, they will never succeed in establishing an empire.

Exhausted and impoverished by the great upheavals caused throughout the Aegean by world events in that century, the Greek civilization lost its drive and unifying power. The breakup of the so-called Mycenaean koine in art is succeeded by a number of divergent local styles. Nevertheless, the transition from the sub-Mycenaean phase to the Protogeometric and after that— beginning around the middle of the ninth century—to the Geometric style is not to be defined solely as an artistic change of direction. It marks a profound alteration in the attitude of the Greeks to the world around them. We see the signs of this change in the invention of the Greek alphabet, in the formation of the first city-states as symbols of civic life, and in the creation of an ethnic awareness of a common descent and a common destiny.

The colonization of the western coast of Asia Minor by the Greeks of old Greece was due in part to the conditions that brought about the movements of peoples in the Aegean area. But it was also due to the increase of population on the mainland, which began to suffer from overcrowding in the narrow expanse of land that had been subjected to uninterrupted agricultural exploitation. By repercussion, even regions such as Arcadia and Attica, which had not been touched by the great migrations, were affected by the impulse for flight and themselves joined the enterprise. The wave of refugees spilled over onto the coast of Asia Minor without any set program, passing first by way of the islands of the Aegean. The Ionians spread into Euboea, the Cyclades, Chios, Samos, and the coast of Asia Minor from Phocaea to Miletus, which seems to be the oldest Ionian settlement. Achaeans from the west Peloponnesus reach Lesbos, where they are assimilated linguistically to the Aeolic-speaking inhabitants of the area. They also get as far as Ionia, Crete, and Cyprus, following in the footsteps of their fellow countrymen who had migrated there in earlier times.

The Dorians who had possession of the Argive plain emigrate in their turn to Crete and go on to Rhodes, Cōs, and the shores of Caria. Included in the first Dorian settlements are Thera, Melos, and Cnidos. Magnesians from the Thessalian Ossa and Pelion end up on the banks of the Maeander and at the foot of Mount Sipylus.

The majority of the migrations and the most important ones took place in two phases, around 1130–1120 and 1050–975 B.C. Dorians and Aetolians, Thessalians, Boeotians, and Magnesians, Achaeans, and Ionians make up the first waves of refugees. In the beginning the migratory movements are infrequent. They become intensified between 1120 and 1050, only to diminish again until around 800 B.C., though now they are distinguished by the faraway destinations for which the colonists set out.

A new world is born, or rather, an old world on new soil, differentiated in dialects and in manners and customs, with different tribal characteristics, but united in the face of common dangers and under common gods. United, too, in its expectations and hopes for a better future. The colonists make the strange new world familiar by means of myths; by planting memories on the shores of Asia; and by raising temples of wisdom. Now for the first time the measure of man is imposed on the infinite universe.

The Greeks did not mimic the Phoenicians—those well-traveled merchants who traversed the Mediterranean and the Aegean as early as the outset of the ninth century, enduring loneliness for the sake of profit, selling to their many customers exotic perfumes, oriental trinkets, embroidered fabrics, finely carved ivories, and storied metal bowls. These Greeks are not overwhelmed by the technical achievements of eastern metalworkers, or daunted by the wealth of inspiration, the skill, and the long artistic tradition of the old civilizations of the East. With eyes and ears eager for knowledge, they soon surpass the stage of apprenticeship and with bold assurance take the reins of progress into their own hands, to become torchbearers of knowledge, acolytes of self-awareness, and worshipers of beauty within measure.

And since once again the land proved too small for the greatness of the human spirit and the mountains and rivers clumsy barriers to the flights of imagination, since the attraction of the easy life of cities was no match for the urge to explore, as early as the beginning of the eighth century Ionians, Dorians, Aeolians (named and unnamed) began streaming out to the ends of the earth, separately or together, in search of the Great Discovery.

It took daring and stoutness of heart to carry on that ardent quest, to tame the unknown in order to attain the impossible. It was a reasoned unreason, a boundless confidence in man that brought the first Hellenic sails to the boundless watery expanses of the hostile Tyrrhenian, of the frightful Libyan seas. Amid the thunderstorms and tempests, the man-eating Laestrygones and bloodthirsty Cyclopes, the Scyllas and fatal Sirens of Homeric verse, it took much pain and effort to forget the old homelands on the Ionian coasts and the Greek shores

of the Aegean. It required courage to overcome myriad difficulties and frustrations, such as we see depicted in glossy black on the surfaces of Middle and Late Geometric vases, in order that the Eretrians might get rich by the gold from the bowels of the volcanic earth of Pithecusae, modern-day Ischia (founded 770–760 B.C.); that the Tanagreans and the Euboeans might enjoy the fruits of fertile fields in Cumae (founded mid-eighth century B.C.); that Sicilian Naxos (734 B.C.), Leontini, and Catanae (728 B.C.) might live to come of age.

The Corinthians who disembark on Ortygia in 733 B.C. displace a settlement of Sikels there. But soon they leap across to the opposite shore and found Syracuse, together with the Eleans. Immigrants from Chalcis build Rhegium and welcome as cosettlers refugees from Messene (715 B.C.). The possibilities of finding safe harbor, as well as the rich soil, bring inhabitants from Helice, Bura, and Aegae in Achaea to found Sybaris, a city that became renowned for its production of grain, oil, wine, and timber and for its silver mines. Still other colonists from Sparta, with Phalanthus as their leader, build Taras on the Straits of Messene, a well-fortified place, provided with abundant and savory fish. At the end of the search are harbors, transit centers, and cultural settlements. This is the world of the West, the Great Greek world of the West. It is the world of Ionians and Dorians, laden with memories and with dreams, uprooted, interpreter of new visions, colonizer and founder of Magna Graecia, nurse and teacher of a nascent Europe, trader in eternal questions. In the East, on the other hand, Milesians, Samians, Phocaeans, and Tenedians—sunburned *kouroi*, youths from the shores of the Aegean—explore the dark waters of the north and found cities and trading stations fronting on inhospitable seas. They brighten the dim horizons of the skies beyond the north wind with famous names: Cyzicus (before 700 B.C.); Artace, Proconnesus, and Abydus (between 700 and 675 B.C.); Perinthus, Bisanthe (c. 600 B.C.); Sinope, Amisus, Trapezus; Istria (mid-seventh century B.C.); Apollonia, Odessus, Tomis, Panticapaeum, Theodosia. At the ends of the earth they light up the darkness with letters and alphabets, finding philosophical truths and bestowing on the barbarians the gift of history: history which now for the first time knows how to spell its own name.

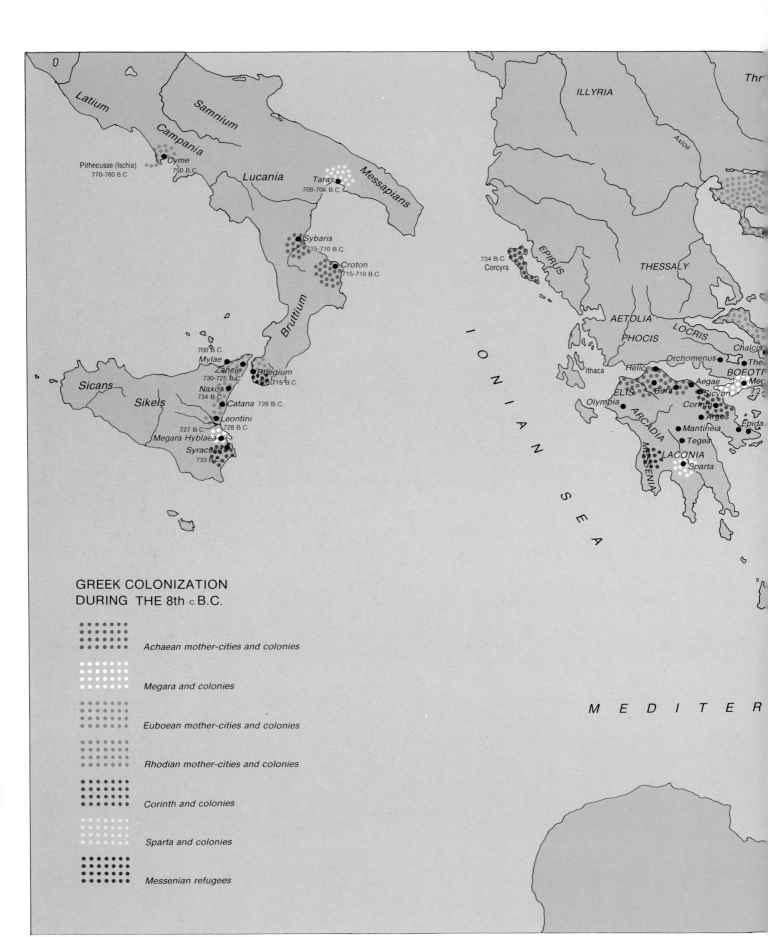

Latium

Samnium

Campania

Pithecusae (Ischia)
770-760 B.C.
Cyme
750 B.C.

Lucania

Messapians

Taras
708-706 B.C.

Sybaris
715-710 B.C.

Croton
715-710 B.C.

Bruttium

700 B.C.
Mylae
Zancle
730-725 B.C.
Naxos
734 B.C.
Catana 728 B.C.
Leontini
727 B.C. 728 B.C.
Megara Hyblaea
Syracuse
733 B.C.

Rhegium
720-715 B.C.

Sicans

Sikels

ILLYRIA

Thr

Axios

EPIRUS

THESSALY

734 B.C.
Corcyra

AETOLIA

LOCRIS

PHOCIS

Chalcis

Ithaca
Helice
Orchomenus
The

Aegae
BOEOTI

ELIS
Bura
Sicyon
Meg
72

Olympia
Corinth

ARCADIA
Argos

Mantineia
Epida

MESSENIA
Tegea

LACONIA
Sparta

I
O
N
I
A
N

S
E
A

M E D I T E R

GREEK COLONIZATION
DURING THE 8th c. B.C.

Achaean mother-cities and colonies

Megara and colonies

Euboean mother-cities and colonies

Rhodian mother-cities and colonies

Corinth and colonies

Sparta and colonies

Messenian refugees

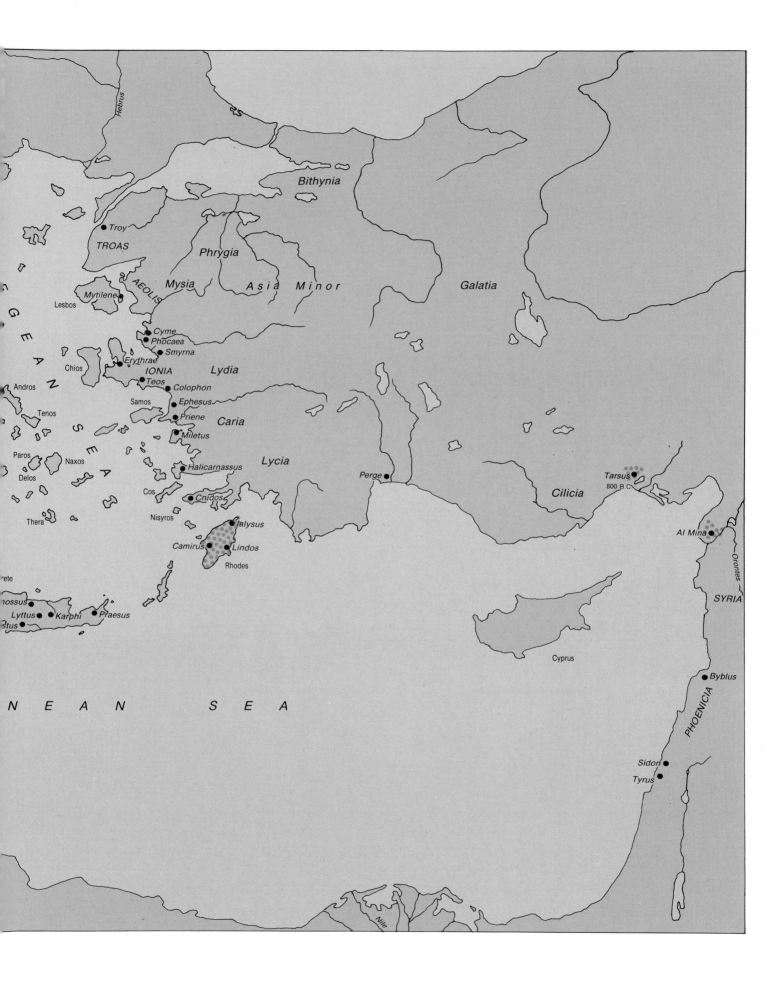

Bithynia

Troy

TROAS

Phrygia

AEOLIS

Mysia Asia Minor Galatia

Mytilene

Lesbos Cyme
 Phocaea
Chios Smyrna
 Erythrae
 IONIA Lydia
 Teos
Andros Colophon
 Samos Ephesus
Tenos Priene Caria
 Miletus

Paros Lycia
 Naxos Halicarnassus
Delos Perge Cilicia Tarsus
 Cos 800 B.C.
Thera Cnidos
 Nisyros
 Ialysus Al Mina
Crete Camirus Lindos Orontes
nossus Rhodes
Lyttus Karphi Praesus SYRIA
stus

 Cyprus

E G E A N S E A

 Byblus

N E A N S E A PHOENICIA

 Sidon
 Tyrus

 Nile

PART II
ASPECTS OF EARLY GREEK ART

CHART OF VASE SHAPES

Kantharos

Kylix

Alabastron

Aryballos

Pyxis

Skyphos

Oinochoe

Amphora

Loutrophoros

Pithos

Hydria

VASE PAINTING

Martin Robertson

Drawing and painting were as important in Greek art as sculpture, not least in the treatment of the human figure. Unhappily, except in certain periods which lie outside the range of this exhibition, painting on wall and panel has virtually perished, and we can trace its development only through its influence on pottery decoration. Usually this humble craft has little to do with fine art, but ceramic craftsmen in archaic and classical Greece did, exceptionally, emulate the fine drawing of contemporary painters. Given the subject of this exhibition, the human figure, this is something we shall need to keep in mind, but we must not lose sight of another fact: that pottery decoration is an ancient and independent craft with its own tradition. What pot decorators take from another craft, metalworking or painting, they take selectively, choosing what suits their own ends; and the degree of such borrowing varies greatly in different times and regions and in different classes of pottery. In the earliest phases covered by this exhibition, the end of the Bronze Age and beginning of the Iron Age, such borrowings seem nonexistent, and there may not have been much for potters to borrow from. This was a Dark Age in a double sense: dark to us, since the historical circumstances remain obscure; and dark in itself, the one evident fact being that it was a time of impoverishment and retrenchment. Minoan and Mycenaean pottery in earlier centuries had rarely made use of the human figure, but show a wide range of natural motifs, floral and marine, decoratively used but with a vivid sense of natural form. In the Submycenaean phase such old motifs continue in use in a style so totally formalized that their natural origins seem forgotten; and this development is accompanied by a decline in technical quality. Then, perhaps around the middle of the eleventh century, a change takes place. Improvement in quality is accompanied by the introduction of new shapes, more sharply articulated than the old, and a new range of abstract ornaments: concentric circles and semicircles, hatched triangles. The earliest vase in this exhibition, the Attic skyphos (cat. 2), well illustrates the character of the new style in ornament and shape. This style is known as Protogeometric because in the succeeding centuries it leads on to an elaborate and sophisticated style of pottery decoration based on purely geometric designs and so known as Geometric. Greek legend has tales of invasion during what must be the Dark

Age, but what took place is obscure and we cannot correlate the Protogeometric revival with "Dorian invasions." The first and the finest manifestations of Protogeometric are found in Athens, a city which tradition tells us escaped conquest by the invaders; and it is in Athens that the development to full Geometric can be most clearly traced and that the Geometric style reached its apogee.

In Attic Protogeometric an occasional horse or bird is introduced in a casual-seeming way; and in a phase of Cretan pottery in the second half of the ninth century (not illustrated here) a few quite elaborate scenes appear; but it is only in the Late Geometric stage, probably in the mid-eighth century, that a tradition of figure drawing begins on Attic vases from which the arts of archaic and classical Greece can be traced. On an early example shown here, a cup from a grave at Eleusis (cat. 3), the geometric ornament is omitted, replaced by two pictures of men in battle by land and sea. The figures are thin silhouettes drawn without detail but with life. More often, after this tentative start, figure scenes appear on larger vases and are combined with the geometrical pattern work and assimilated to it, particularly in the triangular silhouette of the torso and the formal disposition of the sticklike arms. Favorite subjects are connected with death: battle, mourning round a corpse (cat. 11), funeral procession. Such vases must have been made for funeral use. Among them are very large (man-size) vessels, in the same shapes as ordinary pots but designed to stand as markers on graves. These are among the first pieces of *monumental* art to appear in Greece after the Dark Age, and it is possible that this early prestigious use of painted pottery was among the things which allowed the craft to develop a "fine-art" side later in the Archaic period. Geometric pottery flourished in most Greek cities, and some developed figure styles: Argos, Boeotia, Laconia (cat. 14); but Athens is the unquestioned queen.

As the eighth century goes on there is a change in emphasis in Attic vase painting. The elaboration of geometric motifs is reduced, execution becomes freer, and where figure work is used it tends to take over more of the vase and to dominate the decorative effect (cats. 12, 13). This late phase of Geometric merges gradually in a new style, known as Orientalizing since it is characterized by clear borrowings from the arts of the Near East. This reflects a reopening of the Mediterranean through trade and colonization, in which Phoenicians and Greeks played a major part. The most evident borrowings are floral ornaments, animals and monsters, drawn in flowing curves foreign to Geometric tradition; and the same freedom creeps into the drawing of the human figure, filling out the silhouette and modifying it into outline with inner detail, a tendency cautiously anticipated in late Geometric. Attic examples of this early phase of Orientalizing are shown here (cats. 15, 18), and some from the next stage (cats. 19, 22), when figures become fuller and some color is added, especially big areas of white. In some areas (Crete, Laconia, Boeotia, the Cycladic Islands) large pithoi (storage jars) were made at this period with patterned or figured decoration in relief instead of painted (the fragment cat. 26 is a Cycladic example). It is in this time that the illustration of legend becomes common in vase painting (there seem to be a few in Late Geometric, cat. 12). Examples are the Attic jug with Odysseus and his companions escaping from Polyphemus' cave under the sheep (cat. 22), after the blinding of the giant shown on the Argive krater fragment (cat. 21). The man and woman on the neck of a Cretan jug (cat. 20) are very likely heroic too, but they have no specific attributes to make one certain, nor names written beside them. One of the things the Greeks learned from the Phoenicians was the use of letters, and figures are sometimes named or vases signed by painter or potter.

The Argive piece (cat. 21), on a smaller scale than most comparable Attic vases, has also richer and more naturalistic polychromy. Both these tendencies were developed in contemporary Corinth, though that Protocorinthian style is not represented in this exhibition. On tiny scent bottles, in an exquisite miniature style, Corinthian vase painters exploited a technique of fine detail in incision, lines drawn in the silhouette with a sharp implement: the "black-figure" tech-

nique. This was adapted in the later seventh century by Attic vase painters to their larger style; and black-figure became the principal method of Greek vase painting throughout the sixth century. Toward the end of the seventh huge grave vases go out of fashion (carved stone monuments begin about this time). Attic pottery tends now to be on a smaller scale, though not miniaturist, and much of it is rather hasty. Much Attic pottery is found now for the first time in Etruria, where Corinthian had long been popular, and it is possible that something of a trade war was fought between the two cities' potteries, mainly at the level of mass production rather than fine work; but other interpretations of the phenomenon are at least as likely.

Corinthian of this period is represented by the aryballos (scent bottle, cat. 31); the contemporary Attic style by the loutrophoros (cat. 33), a shape evolved for ritual use at weddings and funerals and not exported, and by the skyphos (cat. 34). This shape derives from that of the Protogeometric cup on a high foot, but was greatly modified over the centuries and in different centers. The form used here by the Attic potter is directly borrowed from one developed at Corinth. The cup with horsemen (cat. 36) and the little stand (cat. 37) show the same rather humdrum style carried on in the second quarter of the sixth century. By this time, however, a new style of wonderful refinement was being developed in Attic black-figure by craftsmen, some of whom have left us their names: Kleitias and Ergotimos, painter and potter of the famous François vase, Nearchos who signs as both potter and painter; and their successors in the next generation, the painter Lydos, the potter Amasis and the anonymous artist with whom he worked, the "Amasis painter," and another who combined both crafts, Exekias. Many more have left no name; and we must always bear in mind that the great majority of pots at all times have no pretension to fine art but are slightly, carelessly, often downright badly daubed. The most immediate impression of this Attic black-figure, good or bad, is its character as effective pot-decoration: orange clay surface, shiny black figures with sharply cut detail, white for women's skin and other elements, and details in cherry red. This style cannot have much relation to drawing on wall or panel; its connections seem rather with metalwork. What sixth-century painters were doing can be glimpsed in the outline drawing some craftsmen (especially the Amasis painter) like to intersperse among the silhouettes, and which is found more freely in contemporary and earlier Corinthian. The best black-figure drawing, however, has a great power of its own and can convey charm and fun (the Amasis painter) or strong feeling (Nearchos, Exekias).

Later in the century the elaboration of some fine black-figure seems overblown, while other painters go for a hastier, livelier style of drawing which does not seem altogether suited to the technique; and it is gradually displaced by a new technique, "red-figure," in which the shiny black is used for the background and the figures are left in the color of the clay surface. Since detail is then put in with a penlike instrument which gives a wiry black line, and a brush which gives various dilutions of the black to a golden brown, the drawing is at once subtler than is possible in black-figure and brings one close to normal traditions of draftsmanship, even though once again the direct influence on the potters' technique may be from metalwork rather than painting. A fine early example is the alabastron (scent bottle, cat. 60), attributed to a painter Paseas who left his signature on a black-figure plaque. It is lucky for our understanding of the evolution of Greek painting that this invention came when it did, in the middle of the second half of the sixth century, since toward the end of the century a revolutionary change began to come over Greek art, the process we call the change from Archaic to Classical. This involves a new interest in the rendering of the human frame as it appears in action and repose, and red-figure is able to record Greek painters' exploration of this new world in a way black-figure hardly could.

The pioneer draftsmen in this new style in red-figure (Euphronios, Euthymides, Phintias, and their companions) are not represented here, but the beautiful

little cups, one signed by the potter Phintias (cat. 50), the other by the potter Gorgos (cat. 51), follow on from their work. These give us a better idea of the superlative quality of the best figure work on Attic vases than anything shown here in black-figure does. The other red-figure cup (cat. 49) is a little earlier, and though of decent quality, is less outstanding. It bears the name of a potter Pamphaios, a name which appears on many vases in both black-figure and red-figure. He seems to have taken over the workshop of a potter Nikosthenes whose name is likewise found on many pieces in both techniques. The workshop seems to have been geared mainly to trade with Etruria, where the great majority of pieces with these names have been found, some of them on shapes borrowed from Etruscan ceramics. The two techniques ran side by side through the last quarter of the sixth century, but after that black-figure is more and more confined to mass-produced small vases or certain shapes dedicated to special uses.

The little cup with the name of the potter Gorgos gives a nice compendium of subjects popular on vases: heroic legend (the fight of Achilles and Memnon watched by their mothers); Dionysos with his following of satyrs and maenads; and a scene from daily life (a boy with a hare, a favorite love gift). Heroic legend had been popular on vases from the early seventh century. Dionysos and his revelers appear early in the sixth. Daily life, apart from the special case of vases made for use at funerals or weddings, was slower to find acceptance; but love scenes, especially between men and boys, become common from the mid-sixth century, and athletics from about the same time, first on the inscribed vases in which the prize oil at the Panathenaic games was given, and which continued to be decorated in black-figure through the fifth and fourth centuries and beyond. In red-figure everyday scenes become more popular and more varied.

TERRACOTTAS

R. V. Nicholls

C lay was one of the materials most readily available to the early Greeks for modeling three-dimensional likenesses of the human figure. When fired in the kiln as terracottas, they have proved remarkably durable.

Statuettes, Reliefs, and Vases in the Form of Statuettes

Produced in large numbers at most of the main centers and showing distinctive local styles, Greek terracotta statuettes offer something of the image of a wide-spread popular art when set beside the larger-scale sculptures in other materials whose evolution they tend to mirror and for which at some stages they offer the only surviving evidence. In the Archaic period, however, they also underwent major technical changes of their own, with the result that their appearance is often as much due to the way in which they were made as to their sculptural development. The biggest concentrations of them have been found in temple precincts, where they seem mainly to have represented the humbler dedications of ordinary folk, but they are also abundantly attested from the tombs and homes of the populace and from the remains of the factories where they were made. At their best they can achieve a wonderful freshness and immediacy sometimes lacking in more formal art.

Although seemingly a little austere on first acquaintance, the terracotta centaur from Lefkandi in Euboea (cat. 1) is by far the finest sculpture in any material yet discovered from the height of that Dark Age that followed the collapse of Mycenaean civilization in Greece. Clearly treasured even after it was broken, the head and body were found in two separate adjacent graves of the early ninth century B.C. To judge from the vase-type painted decoration, however, it may have been made rather earlier, still in the Late Protogeometric period of the tenth century. It has been claimed that the deep gash on his left foreleg may represent the unhealable wound of Heracles' poisoned arrow and identify the centaur as the wise Chiron, tutor to numerous heroes, because it was to end his suffering from this wound that he gave away his immortality. If that be so, the full richness of Greek mythology is suddenly upon us. His ears have holes pierced in the middle, as if to improve their hearing, still following a curious convention of the end of the Bronze Age. His missing eyes were apparently inlaid, normally a wood-sculpture rather than a terracotta practice. His animal body is a hollow cylinder formed on the potter's wheel, whereas his legs and human parts are fashioned by hand. These two techniques were normal in the Late Bronze Age and appear to have gone on being used for terracottas at some centers during the Dark Age.

The small, wholly handmade statuettes are often the most primitive of all and, when they were produced in large numbers, they tended to become highly stylized, both in Mycenaean times and again in the seventh and sixth centuries. Here it may be useful to deal with the horseman from Tanagra (cat. 32) out of sequence. His mount is an early example of the ordinary Boeotian stylized horses of the sixth century, although greater care has been taken with the rider and the animal's head. It is not known whether such figures represent contemporary cavalrymen or heroes, the great half-deified dead of long ago, often also depicted as riders.

To avoid cracking, larger statuettes tended to be fashioned either partly or completely hollow on the potter's wheel. The two closely related heads (cats. 16, 17) from the sanctuary of Apollo and Hyacinthus at Amyclae to the south of Sparta are almost certainly from such hollow figures, although what still survives is largely solid. The goddess' head has a hole pierced in the top of her low divine headdress (*polos*), recalling a venting arrangement met with at the end of the Bronze Age; indeed, this head was formerly mistaken for Mycenaean. To judge from their painted decoration, both heads in fact date from the Laconian Late Geometric period, c. 700 or not much later. The warrior's head is especially close to that of the contemporary bronze warrior from the Athenian Acropolis (cat. 6), but the crisp and angular planes of his face quite surpass the bronze, imparting a new tenseness and alertness. This angularity was probably achieved by retrimming the surface after the clay had hardened in the air and before it was fired. Other hollow wheel-made figures are the mourning women from Thera (cat. 23) and Boeotia (cat. 24), the latter more readily betraying this circumstance in her shape. The first of these tears her cheek, the other beats her head in her grief (see also the upper parts of mourners attached to the rim of the Attic funerary loutrophoros, cat. 33). The figure found in a cremation place in the cemeteries of the ancient city of Thera (cat. 23) has a molded head probably of the middle of the seventh century in the style known as Daedalic (see also the Delphi bronze, cat. 28, and the Mycenae relief, cat. 29). The head of cat. 24 has been finished by hand and is difficult to date, but another rather similar Boeotian mourner has a molded head of the early sixth century.

In the course of the first half of the seventh century, most major Greek centers seem to have learned how to make simple frontal terracotta molds for heads or for whole figures or reliefs, possibly acquiring the technique from the Levant or Mesopotamia. The head in relief on the painted plaque from the Athenian Agora (cat. 27) is Attic molded Daedalic work of the mid-seventh century. The raised-arm gesture is a very ancient one going back to the Bronze Age, and possibly signifies the epiphany of a deity. The identity of the goddess is not, however, known, although the snakes flanking her suggest that she is a chthonic deity, connected with the fertility of the earth or the cult of the dead. The other terracottas in the votive deposit with her were mostly horses, riders, chariot groups, and shields, possibly offerings to a hero. The plaque shows rich polychrome painting in fugitive tempera colors over a white slip. Early terracottas seem to have been made in potters' workshops with the wheel readily at hand and using vase-type fired painting, but, with the emergence of molds and polychrome decoration, specialized terracotta workshops began to develop.

The greatest technical innovation of all in this field in the Archaic period consisted of the hollow molding of statuettes and statuette-vases by using pairs of front and back molds, thereby achieving figures with fine sculptural detail executed completely in the round. This seems to have evolved in East Greece in the course of the second half of the seventh century and to have taken its inspiration from the similar technique used for the Greco-Egyptian faience vases in statuette form which began to appear there as local products in the mid-seventh century. The statuette-vase of the Aphrodite Group (cat. 43) may show Aphrodite holding her dove or a smart young woman bringing her a dove as an equally appropriate offering, and it reveals the truly sculptural quality being achieved by such small items in southern East Greece by about the mid-sixth century or very soon after. Closely similar in spirit is the slightly earlier bronze lady from Samos (cat. 42).

For a long time this invention from East Greece had little impact on the terracottas made in Greece proper. Some of the rare notable exceptions are to be found in a statuette-vase and the somewhat later head-vases of Athens. The earliest of these, dating from c. 540 and by far the finest terracotta in this exhibition, is the oil flask in the shape of a kneeling boy from the Athenian Agora (cat. 48), which is hollow molded apart from the arms and lower legs. Although the fabric seems Attic, the kneeling pose, the unemphatic musculature,

and the style of the head all carry echoes from East Greece, the face being especially close to molded heads attached to Clazomenian vases of just after the middle of the sixth century. A possible scenario is that a North Ionian may have fled his homeland to escape the invading Persians and brought the new technique to Athens, producing this figure there, along, incidentally, with some related molds for the heads of ordinary Attic statuettes (the Kneeling Boy Group). The boy's fists form slots as if to hold a headband, possibly itself forming part of the looped ribbon by which the vessel was carried, unless the gesture be that of a dancer. Between the time of the kneeling boy and the Early Classical period only meager fragments survive from other Attic statuette-vases, but the hollow molded Attic head-vases are well attested from Late Archaic times. These are in the form of truncated busts showing head and neck only and were often exported. The present exhibition includes a remarkable rarity from Tanagra (cat. 62), a local Boeotian version of such an Attic head-aryballos of the early fifth century B.C. Crudely hand finished, it nevertheless displays vigor and charm and has a local character markedly different from that of its Athenian models.

Apart from figure vases, ordinary Attic molded statuettes did not normally embrace the new technique until c. 480, and then at first somewhat clumsily. Until then they continued to be regularly fashioned in simple frontal molds, plain-backed and almost solid apart from a vertical hole pierced from below. The shattered fragments of large numbers of them were found on the Athenian Acropolis in the debris from the Persian destruction, including numerous brightly painted little *korai* such as cat. 59, the humbler counterparts of the Acropolis marble *korai* (see cats. 55–58). Cat. 59 belongs to the Ear-Muffs Group, produced at the end of the sixth and beginning of the fifth century and comprising a wide range of types whose original models and molds were apparently the work of a single craftsman. The Acropolis has also yielded the fragments of numerous fine terracotta reliefs of the early fifth century, many of them of the Agora Heracles Group. Cat. 61 shows a young woman seated on a couch with her legs swinging. A second more fragmentary example from the same mold confirms that she spins thread. The other Attic reliefs of this class usually show deities or, occasionally, heroes. Is the present young spinner one of the Moirai (Fates)?

Architectural Decoration

It seems to have been the Peloponnesians, especially the Corinthians and Spartans, who raised the making of tiled roofs to a fine art, devoting special attention to the decoration of their eaves and gables. The two examples exhibited here are, however, from Thasos in the northern Aegean, where such work appears instead to have drawn much of its inspiration from East Greece. The eastern Greeks themselves seem at first to have preferred flat roofs for their major buildings and only to have begun installing tiled roofs of this kind in the sixth century, although when they did they brought to them a great wealth of molded relief decoration with fired vase-type painting to resist the weather. The antefix (cat. 44) restricts its shape to that of the eaves cover-tile to which it is attached, apart from the small palmette projecting at the top, and its relief decoration shows Bellerophon mounted on Pegasus. Their quarry, the Chimaera, appeared on other closely similar antefixes possibly alternating with the present type. These antefixes appear to be from a reroofing of the early polygonal building in the sanctuary of Heracles in Thasos, perhaps of c. 530. The relief of fleshy, somewhat silen-like centaurs (cat. 30) is probably from a raking *sima* (edging of the roof) that formed a frieze along the top of a pediment. The building it adorned has yet to be identified and, although earlier dates have been suggested for it, what is known of the development of such roofs in East Greece suggests that a date very much before the middle of the sixth century is unlikely. The evolution of these continuous reliefs and their relationship to the Ionic frieze has been dealt with elsewhere. It has been suggested that, when complete, the scene may have shown Heracles fighting the centaurs; if so, we may have come full circle, back to the myth mentioned at the outset in connection with the Lefkandi centaur.

BRONZES

Theodora Karaghiorga

In the field of art, the term bronze *(chalkos)* refers to an alloy of different metals, primarily copper and tin, widely used in spite of the difficulties in obtaining the raw materials. Its popularity is due to the fact that it is durable, yet well-suited to technical processes: casting, bending and twisting, beating out, hammering and cutting, engraving, smoothing, and polishing. Although stable in dry air, with pleasing warm tones, a bronze object when exposed to dampness becomes covered with a greenish patina, likewise pleasing to the eye, which protects it from further damage.

The exceptional properties of this material were first recognized and exploited in Greece in the workshops that made bronze sculpture in Archaic and Classical Greece. All the greatest sculptors of the fifth century B.C. worked in bronze, the most celebrated figural works of the ancient world were bronze, Greek sanctuaries and public places from the sixth century on were filled with bronze statues of gods, heroes, and famous men; the very few of these monumental works that have survived to our day are, with their beauty and radiance, the principal attractions of the museums that contain them: the Charioteer of Delphi, the god from Artemisium in Athens, the heroes from Riace in Reggio Calabria, southern Italy.

The route to that peak of technical and artistic expression that is monumental bronze sculpture of the fifth century is illustrated by the bronzes of this exhibition. They also illuminate the fascinating periods of apprenticeship, experimentation, and rapid achievements to which they belong.

The bronzes here are of two categories, cast statuettes and hammered sheets with relief decoration (repoussé). All the statuettes are solid, made by the lost-wax process. In this process each figure is originally formed in wax. The wax model is then enclosed in a fire-resistant clay (a matrix or mold) of a texture fine enough to take the full impression of even the most minute details of the model. The entire piece is heated and the wax runs out through specially made

channels. A molten metal alloy is then poured into the closed clay mold through the same channels. Melted at around 1000° C, this white-hot material replaces the wax model. At the end, the clay mold too is destroyed to get at the bronze figure inside. No Greek bronze statuette had a second copy made from the same model; each one is unique. This technique should not be confused with the indirect lost-wax process in which a negative matrix makes it possible to produce many copies, a method usually used from Roman times until today, and much earlier in some centers, such as Egypt. The direct lost-wax technique, in which the positive model, as well as the mold, is destroyed, is a characteristic of Greek bronzes and guarantees their authenticity, originality, and uniqueness.

For large-scale figures, solid casting was uneconomical, and created technical problems. For these works, Greek bronze sculptors had initially used the techniques of *sphyrelaton* (hammering), sheathing wooden statues with sheets of metal nailed together over a wooden core. From the seventh century onward, however, they began to manufacture even large statues in the lost-wax process, but hollow inside, a revolutionary technique learned in the Near East and also probably in Egypt. In it, a reinforced clay core is built first, which has the general shape of the work. This is covered with a uniform layer of wax on the surface of which details are worked. (Large statues are worked in pieces, generally six or seven, and the greatest thickness of their walls barely exceeds one centimeter.) Over the wax, a mold of clay is nailed to the core; then the entire piece is placed in an oven and heated. The wax melts and molten metal is poured into its place between the clay core and the mold. When cool the mold is broken and the core removed.

At this stage, the bronze figure undergoes what was considered in antiquity the most important work of all: the cold-working of the surface of the piece. Hammering, chasing, and engraving give bronze sculpture its typically hard, metallic appearance, with vast, primarily convex surfaces, low relief, and clear, sharp lines.

One can easily see the technical differences in the first stage of development from a clay technique to that of bronze by comparing various statuettes exhibited here: the flute player from Sparta (cat. 7), the man leading a now-missing horse, from Olympia (cat. 8), and the warrior from Olympia (cat. 9). The flexible cylindrical limbs of the seated flute player retain all the texture of the handmade wax model; in contrast, the compressed torso and flat, stiff arms of the man leading a horse reveal the blows of the hammer, the hair and distinctive face the work of the point. On the other hand, the torso and bulging cylindrical legs of the warrior recall the convex, sheet-metal limbs of contemporary *sphyrelata*. The techniques, still constraining the form to a great degree, here dictate the appearance of the works.

The second category of bronze works in the exhibition is represented by two hammered reliefs from Olympia (cats. 25, 35). Such reliefs decorated all kinds of surfaces—wooden implements, furniture, even parts of buildings. The work is done freehand on a thin sheet of cold metal: repoussé, in which hammering on the back of the sheet raises in relief the figures on the face, and tracing and engraving, which mark their outlines and decorative details. This relief technique also had an eastern origin. It soon broke away from its eastern models, however, and developed with particular originality, imagination, and richness in Crete and in Aegean Island and Ionian workshops during the seventh and early sixth centuries.

A combined technique of casting and *sphyrelaton* relief, which was applied to thick cast-metal plaques, creates the relief by heavy hammering of the front of hot metal. The exceptional quality of the piece made in this technique (cat. 10, the tripod leg in the Olympia Museum) demonstrates to us that by the end of the eighth century the Greek bronze worker had total control over his material, using fire and hammer.

Greek bronze was an alloy of copper and tin combined at a ratio of 9:1. Because these metals are not found in Greece, except for small quantities of copper in

Euboea and on some Aegean islands, production of bronze objects was dependent upon finding sources for the raw materials. For the Greeks, these sources were the Near East and Cyprus, southern Italy and the Iberian Peninsula, the Atlantic Coast and the British Isles—these last primarily for tin. Thus, when the great upheavals in the eastern Mediterranean from the twelfth to the tenth centuries cut off traffic to and from these countries, the bronze-working sector suffered. For the same reason, metalworking in Greece began to develop anew from the ninth century on, reaching full flower from the middle of the next century, the period when Greek trading posts were established on the Syrian coast and the first colonies were founded in southern Italy. The search for the ore was surely one of the motives of the Euboean merchants who pioneered in exploring the Mediterranean. At that time, objects, craftsmen, and techniques poured into all of Greece along with abundant supplies of raw materials, starting in Crete and the islands near the coast of Asia Minor. Thanks to the fruitful contact with the East, the eighth century became a period of renaissance for bronze technology as well as for all sectors of Greek life.

After the Dark Ages the first Greek human figures in bronze appeared at the beginning of the ninth century, and they are simple figurines. They recall clumsy children's playthings, little different from their counterparts kneaded freehand in clay. Earliest and perhaps most important for the history of the human figure are those that were offered in the sanctuary of Zeus at Olympia, representing a naked man with upraised arms. Because of their provenance, their nudity, which generally characterizes superhuman beings, and their specific gesture, which is descended from the Minoan-Mycenaean civilization, these statuettes are thought to represent the Epiphany of Zeus.

At the next stage of development, from the middle of the eighth century to the beginning of the seventh, this schematic conception of the human figure became more specific: a warrior was created by the addition of a helmet, belt, spear, and shield. The well-known example in the exhibition (cat. 9) was a dedication in the sanctuary of Zeus at Olympia. Therefore, it could allude both to Zeus and to its wealthy dedicator: the social model of the aristocrat in these early periods of constant warfare (the first Messenian war, the Lelantine war) is automatically transferred to the god who protects the clan.

The Archaic bronze statuette, which was valued both for its material and for its technology, was the private dedication par excellence. All the statuettes in the exhibition were dedications in some sanctuary: that of Zeus in Olympia (cats. 8, 9), Apollo at Delphi (cat. 28), Hera on Samos (cats. 39, 42), and Athena on the Athenian Acropolis (cat. 6). Whether as independent figures on their own bases (cats. 7, 39–42, 45, 47) or as decorative elements of a vessel, generally a large vase (cats. 6, 8, 9, 46), they were made specifically to be offered to a deity. They were not used in daily life; unlike terracottas, no bronze statuette has ever been found in a grave. Given this practice, it is possible to identify the person portrayed whenever other external information such as an inscription is lacking, on the premise that this person is closely connected to the dedicator, to the god who receives the offering, and to the reason for the dedication.

In the representation of the human figure in Late Geometric times, next to the warrior is the horseman who is a warrior as well. One example of this type of statuette is present in this exhibition (cat. 8). Tripod cauldrons, which reached a height greater than six feet, of the sort represented on the tripod leg (cat. 10), carried statuettes of human figures on their rims. These vessels, as known from Homeric texts and finds from excavations, were awarded as prizes in contests or offered in sanctuaries, especially Olympia, out of gratitude for a victory. Their dedicators, as depicted in the statuettes, belonged to the wealthy, powerful class of nobles, those horsemen and horsebreeders of the community Homer described who, when not fighting, participated in the aristocratic custom of athletic contests, perhaps even raising horses for the chariot races that actually began in Olympia. On the relief on the tripod leg, two Homeric heroes fight over one such tripod, each trying to claim the prize for himself. The theme of their contest is repeated,

46

like a Homeric simile, in two rampant lions battling in the lower panel. It is the same period when fighting warriors and lion hunters make their appearance on Attic vases, and horse-feeding men on those of Argos.

The statuette of the ripe Geometric period is a creation whose daring only the abstract art of the present century can approximate. The human figure, as in the man leading a horse, from Olympia (cat. 8), is first of all a clear, firmly built structure. The parts of the body are regarded as architectural elements which, in their structural function, need to be presented as clearly and expressively as possible; for the same reason bodies are shown nude. Initially the figure appears to be analyzed and separated with exactitude into three parts: legs, upper body with arms, head. Each of these is reduced by abstraction to a simply defined shape. The figure is recomposed of these shapes, which are arranged along vertical and horizontal axes, and tightly bound by the outer contour. The man leading a horse from Olympia, with his solid frame, clear outline, well-proportioned parts, and overall harmony, presents exactly those characteristics which from now on are typically Greek in the history of art.

The three-dimensional quality of human bodies is approximated in the ripe Geometric art with similar originality and daring. The artist begins by observing that legs present their most expressive image in profile, the body from the front, and the head again in profile. Without hesitation he goes ahead and fashions his figure thus, with alternating views, just as they are depicted on vases. By obliging the spectator to move around the figure in order to understand it as a whole, he establishes the sense of three-dimensional space. The wonderful seated flutist from Sparta (cat. 7), without clear distinction between front and back, primary and secondary viewpoints, and suggesting even by the shape of his base the idea of circular movement, is a perfectly three-dimensional sculpture, viewable from all sides. It further shows why the human form in Geometric Greece avoided becoming a solid, closed stereometric structure (as is nearly the case in Egypt): it is because the dynamics of figures in space, a thoroughly Greek problem, prevailed in the end. With an explosion of vitality, the statuettes on the handles of some Attic tripods at the end of the eighth century broke the bonds of Geometric forms, grew tall and thin, almost disjointed, but were poised for motion. Nevertheless, the combined forces of the East on the one hand and of monumental stone sculpture on the other turned in another direction the evolution of expressing the human figure.

The Early Archaic period (700–620 B.C.), characterized as Orientalizing in pottery and Daedalic in sculpture, is an exciting transitional period where a great number of influences and currents, both local and foreign, old and new, collide. At the beginning of the period, the statuette from Olympia (cat. 9), for example, combines the old theme of warrior with a Daedalic coiffure and a new understanding of bodily mass. Nonetheless, the combination being unevenly distributed and inorganic, the body seems weightless and the instability of the figure is only accentuated.

Toward the end of the period, however, the old and the new come into balance and find their synthesis in the human type that is represented in the exhibition by the unique bronze *kouros* from Delphi (cat. 28). It represents a giant step forward toward natural reality. The tendency of the period is toward naturalism and away from abstraction, toward organic unity of bodily parts and away from separate articulation, and this is the direction in which Greek sculpture will steadily move thereafter. Most important, however, is that the Delphi statuette is no longer a generic male figure. He now stands as an individual: a young man of splendid bearing, with a full, flexible, trained body and, most important, a lively and expressive face. The most significant contribution of Daedalic sculpture to the history of the human figure is the expressive quality of the face. Side by side with other expressions of awakening identity, such as names of artists and dedicators on works of art and the introduction of lyric poetry, the accentuation of the head and features of the face draws attention to human individuality.

One of the manifestations of individualization in the art of the seventh and

sixth centuries is the multiplicity of styles in painting and sculpture and the creation of local traditions, schools, and workshops in various city-states.

The workshops in bronze sculpture produced ever more numerous and better-quality works. The series of bronze statuettes throughout the sixth century never ceases to be characterized by an amazing originality and wealth of themes. Human figures are used as independent dedications and as handles or supports for vases, mirrors, etc. Among the first are the deities Zeus, Apollo, Athena, Artemis, Demeter, Hermes, mythical figures such as Heracles, satyrs, silens, mortal *korai* and *kouroi*, riders, hoplites, banqueters, flutists, athletes pouring libations or praying, young women, and simple shepherds.

From one workshop to another the human figure differed in body type, facial expression, and the formal dialect that was used in the modeling of the final product. In the Ionian (eastern Greek) workshops, and in the best of these, that of Samos, which is richly represented in the exhibition (cats. 39, 40, 42), the bodies are fleshy and tender, almost soft. In the relief of the Centauromachy (cat. 25), they have a uniformly elastic roundness as if filled with the same juices as the plants that surround them. On the later relief (cat. 35), the same bodies, slenderer and more supple, take the movement of their curved contours, but have an unstable equilibrium. The body of the Samian *kore* from Olympia (cat. 40) gives a sense of a fragile young shoot. In lesser works, however, such as the small *kore* from the Acropolis (cat. 41), the elasticity of the surface does not affect the general impression of eastern immobility.

Ionian heads are round and too large for their bodies, an indication of the influence from neighboring eastern arts. The faces are broad, with puffy cheeks and large, somewhat slanted eyes. They exude fullness of life, but not without a certain apathy. From the mid-sixth century onward, they wear a distinctive, voluptuous smile (cats. 41, 42). In Samian works the eyes are particularly accentuated and bright, as they are generally inlaid with a different-colored material: ivory, silver, glass (cat. 40).

Just as typically Ionian as the rounded elastic forms of the bodies are the sensitively decorated surfaces, enlivened by a wealth of detail. Profuse fine incision, which suits both the material and the techniques of bronze work, portrays fabric and embroidered designs on the multipatterned garments of mythical heroes in scenes on the Olympia relief (cat. 35). The finely woven linen cloth of the chiton is rendered with close-set parallel lines and a very few fine raised folds. The studied elegance of Ionian female dress is displayed in two *korai* (cats. 40, 42). Even the shoes of two *kouroi* (cats. 39, 45) are designed in the same subtle, decorative fashion.

The typical Ionian garment of the sixth century, a multifolded long chiton with sleeves and a diagonal mantle, was worn in Ionia also by men, an ancient eastern custom. Generally it caused surprise, as an indication of Ionian luxury. Nonetheless it became a fashion in aristocratic Athens during the period of the Peisistratids' rule. The *korai* of the Acropolis (cats. 56, 57, 59) wear it with coquettishness, taking from Samian women (cats. 40, 42) even the gesture of lifting the chiton.

Beginning in the seventh century, bronze had been one of the major bases of the wealth of Samos. Around 560, when Samos reached the zenith of its prosperity, the Samians Rhoikos and Theodorus constructed the first large-scale cast statues with technology that they brought from Egypt. The *kore* (cat. 42) from the Heraion on Samos, from exactly the same time, confirms the story by the Egyptianizing appearance of her hairstyle and stance, and brings to life those voyages of Samian traders and artists, so rich in the importation of articles and ideas. Likewise the other Samian girl (cat. 40), the gesture of whose left hand has ancient roots in the religion of the neighboring East.

Different geographical and historical conditions also produced different human models in other regions of Greece, particularly in the Doric centers of the Peloponnesus. It is extremely hard to find some common denominator between the refined, fashionable, and delicate ladies of Samos and the hardy, almost wild

running girl from Sparta (cat. 46). One of the well-known peculiarities of the Spartan state was to send young women to exercise in the palaestra, especially for the footrace, together with boys of the same age. Whereas in Ionia the female figure sets the tone for the appearance of the male figure, imbuing even the depiction of a man with obvious effeminacy, especially in marble statues, in Sparta the representation of the female body and female appearance are influenced by the male athletic model.

In Laconia a series of bronze workshops flourished from Geometric times on. During the sixth century these workshops produced statuettes of exceptional quality, especially in certain exclusively Laconian types such as the heavily armed hoplite, the nude girl, and the running female athlete. In all Laconian statuettes the bodies are either thin and sinewy or sturdy with muscular legs. They have a sure step and a solid frame on which muscles are articulated with tension and power. The legs are long, with short bodies, wide shoulders, and narrow waists. The faces have intense, very expressive features; they radiate vigor, and the wide-open eyes have a characteristic steady gaze. The dynamism of these figures occasionally has something animal about it.

Generally speaking, in all Peloponnesian workshops, which were many and active, the human figure was sturdily built and cleanly articulated, sometimes more compact, heavy, and squarish as at Argos, other times more dry, thin, and clean-lined as at Corinth.

Athens finally achieved the balanced development of all elements: tall bodies with good proportions, sinewy and firmly modeled, with fine lines and sensitivity to movement, faces that radiate nobility and spirituality in all their features. The jumper from the Acropolis (cat. 47) is in many respects, not only because of its technical perfection, the high point of the entire section.

To understand this one need only compare the jumper to the *kouros* from Samos (cat. 39), with his inarticulated and stiff body, in spite of the radically free movement of his arms, and to another *kouros* from the Acropolis (cat. 45), with his relaxed outlines and general lack of movement, in spite of the advanced modeling of his body. The comparison shows that the young jumper from the Acropolis is at the end of a continuous development and that with him one period closes and the next opens. He holds jumping weights, and he has so much compressed power within himself, so much intensity in his stance, his outline, and the expression on his face, that you would expect him to burst into motion at any minute. Notice how the figure is concentrated on its dynamic center marked by the line separating the abdominal muscles and the thorax: the shoulders are pressed downward, the waist bends, the body leans slightly forward. Shins and thighs seems shorter, as if contracted and drawn upward by their powerful muscles; the arms bend at the elbows, and they too are raised. Even the hair is pulled together and fastened by a wreath. The chest swells and the power compressed within is driven out through the strong neck to the high-held head. The modeling of the face is rendered with numerous small, closely set undulations, asymmetrically placed, running in all directions. The face is alive and sparkles with a flash of intelligence.

The momentary nature of the bodily movement and facial expression gives such immediacy and individuality to the appearance of this boy that one wonders at once which specifically named jumper he is. Which Olympian or Isthmian victor of those we know from texts and inscriptions can he be, and in which sanctuary of Panhellenic games can his bronze statue have been placed?

Perhaps it will never be known. It is nonetheless important, by closely observing this splendid image and comparing it with the other examples of earlier date in the exhibition, to understand how the human figure in early Greek art started from an abstract human scheme in Geometric times, passed to the narrative but generic human types of the Archaic period, and arrived at a living, self-conscious, and named person by the beginning of the fifth century. It is one of the most important moments in the history of European art: the change from Archaic to Classical.

SCULPTURE IN STONE

Evelyn Harrison

Stone sculptures of young men and women include some of the most radiantly beautiful works of early Greek art in human form. Much remains mysterious about them, but by now we do know a little, and can reasonably guess more, about how, why, and when they were made, as well as how and when they came to be destroyed.

Large-scale sculpture in stone begins in the seventh century B.C., at roughly the same time as sacred buildings began to be constructed wholly or partially in this hard, durable material. In both cases the aim was to produce something that would be not only admirable, but also lasting, a monument to future generations. As the poverty and isolation of Greece in the so-called Dark Ages were replaced in the eighth century by growth in wealth and population and lively contact with the outside world, Greeks looked back to their ancestors and sought to emulate those richer and more powerful people of earlier times, whose stone monuments could still be seen in ruins here and there about the country. Tales about them were elaborated and woven together into a rich body of legend from which epic poetry emerged. Scenes from these stories were depicted on vases before the middle of the seventh century.

The stone walls of the early seventh-century Temple of Poseidon at Isthmia, near Corinth, had exterior paintings, whose few surviving bits suggest animals and Orientalizing monsters like those in the vase paintings from Corinth of the same period. It could be that, as on the vases, scenes from myths were also represented. Sculptured reliefs on sacred buildings appear first in Crete from around 700 on, not yet in the framework of a Greek architectural order, but often placed at the base of the walls and around the entrances like Near Eastern reliefs of the ninth and eighth centuries. In time, the Greeks came to concentrate the figured decoration of their temples on and just below the roof, as if to insure divine protection for this most vital element of the structure. Early in the sixth century, the low-pitched gables that had become usual in seventh-century temples began to be filled with sculpture, at first with a combination of myths and monsters, later with mythical events in a unified composition of human figures adapted to the triangular space. A fine Late Archaic group of Theseus carrying off Antiope (cat. 66) comes from a pediment of the temple of Apollo at Eretria.

The metopes of Doric temples contained figures at a still-earlier date, in the second half of the seventh century. Those at Thermon, in northwestern Greece, which are painted terracotta plaques, were certainly set between triglyphs in a

normal Doric frieze. The stone reliefs from Mycenae, one of which is the earliest stone sculpture in this exhibition (cat. 29), may have been so too, though some have suggested that they were placed low, like the early Cretan reliefs.

Continuous sculptured friezes in Ionic architecture developed slowly. The treasury of the Siphnians at Delphi is the first full-fledged, well-preserved representative. There is no example in the present show, but the fragment of a terracotta *sima* (edging of the roof) from Thasos (cat. 30) with a galloping centaur illustrates one of the forerunners of the continuous sculptured frieze.

The series of reliefs to which the metope from Mycenae belongs includes armed men in active poses and a corpse being carried off by supernatural beings. This suggests that a heroic legend such as the tale of Troy was depicted. Thus the woman with a veil over her head may be Helen, who became a bride again when her husband Menelaus took her back from Troy. About a generation earlier than these reliefs, the sack of Troy was portrayed, wooden horse and all, on a clay relief jar in Mykonos, and the tale of Odysseus' adventures in the Cave of Polyphemus appeared on painted vases not long after (cats. 21, 22).

The U-shaped face of the woman in the Mycenae relief, with its heavy frame of hair and strong, horizontally placed features, shows the style that has been nicknamed "Daedalic" after the mythical Cretan artist Daedalus. At home Cretan artists made limestone statues and reliefs in this style, as well as many smaller figures in terracotta, bronze, wood, and ivory, and it is likely that they also traveled to Ionian Samos as well as to Dorian Sparta, Corinth, and Argos, where the Daedalic style was adopted by local artists. The little bronze youth from Delphi (cat. 28), whose face is like that of the veiled woman from Mycenae, was probably made in Crete.

In the second half of the seventh century Crete also gives us the earliest Greek funerary stelai with representations of the deceased. The figures are engraved and painted rather than being carved in relief like those on the Attic stelai of the sixth century (cat. 38), and unlike these the Cretan stelai did not stand alone, but were set into the face of a built tomb. All these Cretan stelai were made in limestone, as were the Cretan freestanding statues in Daedalic style, women in long straight dresses like that worn by the girl on the jug from Arkades (cat. 20).

White marble, the noblest and most characteristic material of ancient Greek sculpture and architecture, was most plentiful in the Cycladic Islands, and these soon took the lead in making large figures in stone. Around the middle of the seventh century a tall maiden in Daedalic style but made of Naxian marble was offered to Artemis on Delos by Nikandre, a rich Naxian lady. Perhaps it represents Artemis herself, perhaps one of her nymphs. The inscription carved on her skirt names the donor's distinguished father, brother, and husband, but does not mention the artist. On Delos in the last quarter of the seventh century, however, the Naxian sculptor Euthykartides dedicated to Apollo a marble *kouros* that he himself had made. One could think that he was advertising his skill to visitors to the sanctuary as well as thanking the god for his prosperity. A Naxian quarry also supplied the stone for a colossal *kouros* set up on Delos by the Naxians around 600 B.C. The battered fragments that survive show it was around four times life size, nude but with a broad belt like the little Daedalic bronze from Delphi (cat. 28). Probably both the statuette and the colossus represented Apollo. As he was the god who more than all others presided over the growing up of young men and over the assemblies by which they were accepted into citizenship, it was natural for him to take their youthful image.

We use the term *kouros* for the sculptural type of a nude youth who stands with his hands at his sides and one foot, usually the left, set somewhat forward. The pose recalls Egyptian male statues and was almost certainly influenced by them, but the tensile strength of the Greek marble and the daring of the Greek craftsmen allowed them to dispense with the supporting mass of stone that the Egyptian sculptors left attached to the legs of their figures.

So these *kouroi*, for all their look of permanence, have a lightness and seeming

mobility that Egyptian stone statues never had. Slight variations in the separation of the feet and the poise of the torso above them suggest standing at ease, walking, or even, as in one figure from Naxos, running. Very slight rotations on axis of heads, torsos, and legs moderate the overall symmetry. The hands were left attached to the thighs for security, with enough marble removed between arms and torso to give clear contours to both. In general, earlier sculptors were more cautious in separating arms and body, but the difference is exaggerated in the two *kouroi* in this show. The one from Thera (cat. 52), made around 570–560 B.C., is exceptional for shallow carving and reluctance to penetrate the block. Earlier *kouroi* from Thera are actually more adventurous. The hands of the Ptoon *kouros* (cat. 53), c. 530–520 B.C., are almost free, attached only by little round struts to the thighs. Both statues are made of Parian marble, generally preferred to Naxian because of its finer grain.

Around 600 B.C., the broad belt of the Daedalic figures was left off, and the torso became an organic unit. Gradually, and in differing local fashions, the details of the body and face were expressed with increasing plasticity and apparent truth to nature. The various physiques of later archaic *kouroi* have been compared to those of different classes of athletes: runners, boxers, wrestlers, discus throwers. This need not mean that all these statues represent such athletes, only that the Greeks tended, as we do, to think in terms of athletic types.

The Thera *kouros* was a funerary statue and the one from the Ptoion a dedication. Both uses were common, and it is not possible to tell simply by looking at a *kouros* which purpose it served. As the image of a young male on the threshold of sexual maturity, the *kouros* represents human generative power in pure, undiminished form. For one who died before he could marry and have children, the statue constituted immortality in the memory of survivors. To his family it gave a kind of continuity. The epigrams inscribed on the bases of Attic funerary stelai are like those of the funerary *kouroi* and *korai*, and indicate that these monuments in the Archaic period were mostly dedicated for young people by their grieving parents.

Kouroi of colossal size were found in sanctuaries. The Delian colossus seems to have been an Apollo, but another explanation is needed for those offered in the sanctuaries of Poseidon at Sounion and Hera at Samos. Hera as goddess of marriage and Poseidon as protector of those who fought at sea (cat. 18) were both concerned with young males. These tall statues may have represented heroic ancestors of the donors, imagined as taller and better than contemporary men. Another reason for their great size may have been the location of these particular sanctuaries by the sea, where the colossi could be spied from far off by mariners coming in to land.

Kouroi, with their total nudity and actionless hands, could not be so specific about age and status as could the relief stelai, which allowed for attributes. Hair cut in front indicated puberty or adulthood. The much rarer indication of pubic hair showed that manhood had been attained. Hair cut short all over the head (practical for athletes) became common in the late sixth century.

Since practice in hunting and athletics came before training for warfare in the education of young men, we could think that a youth shown as an athlete or hunter on a gravestone died younger than one shown as a warrior. But one fragment of an Attic stele depicts a bearded boxer with a broken nose. He may have been a victor in the men's competition in one of the great games. Such victors were felt to be heroes, bringing glory to their cities and their families.

A few male figures on gravestones are neither nude nor armed, but wear a draped mantle. One could think that they are shown approaching a divinity, for they carry wreaths, flowers, or green twigs. So perhaps the few draped *kouroi* (cat. 54) represent youths who had been honored with some cult office or distinguished participation in a festival.

Dances were an important part of festivals and also had their competitive aspect. The grave stele of a helmeted youth (cat. 64) is best explained as showing one of those who danced in armor. The receipt of the first arms marked the

emergence of the youth as a man, and the armed dances were a much admired spectacle. The pose of our youth's elbows and hands, his bowed head, and even the way he sinks down on one knee can be paralleled in vase paintings of dancers, though not all in the same figure. The kneeling boy of the plastic vase (cat. 48) may be a younger dancer, and the vase his prize.

Stelai provided the opportunity to portray two persons together, but this rarely happens in works of the Archaic period. In every case we must assume that the two belonged to the same family and that both have died: a mother and baby in Athens, a brother and sister in New York (a second pair is attested by an inscription only), and pairs of warriors, presumably brothers, two in Athens and one in Copenhagen.

Relatively few Attic *korai* were set over graves. The epigram for a *kore* of whom only the feet survive names the artist, Phaidimos, and calls the statue "beautiful to look at." Two others, remarkably well preserved, are indeed unusually fine works. One is in Berlin; the other, named Phrasikleia, is in Athens. Her epigram declares that the gods allotted eternal maidenhood to her instead of marriage. Since her red dress and flowered crown are like those of the Berlin *kore*, we might guess that both are wearing bridal attire. Phrasikleia may be younger; she carries a bud instead of a fruit and has no veil draped over her shoulders.

The vast majority of archaic *korai* were set up in sanctuaries, mostly of female divinities. The earliest in actual date as well as the first to become widely known in modern times were those dedicated to Artemis in Delos and rediscovered by French excavators in the 1870s, but the Greek excavations of the Acropolis of Athens in the 1880s yielded the richer harvest, astonishing for the bright colors that many still preserved. Three of these (cats. 55, 56, 57) and the head of a fourth (cat. 58) are in this show. The sanctuary of Hera on Samos contained exquisite examples from the second quarter of the sixth century, after which the production declined. Athenian dedications of *korai* became numerous only in the last decades of the sixth century and continued until the Persians sacked the Acropolis in 480 B.C.

Beginning in the 530s, Attic *korai* adopted the costume of the East Greek girls, a fine linen dress with a short mantle worn diagonally over it and fastened by a row of buttons on one shoulder. This seems to be a festival dress of the more grown-up maidens (the youngest ones have the linen chiton without the mantle). The bronze statuette from Samos (cat. 42) shows the East Greek form, the *korai* (cats. 55, 56, 57) the Attic adaptation.

It is a tragedy that no faces of the Samian stone *korai* have survived. The faces of the Acropolis maidens show the same development as those of the *kouroi*, plastically rich and vivid in the late sixth century (cat. 58), increasingly solid in form and sober of mien in the early fifth (cat. 57), presaging the classical style. The drapery of the maidens remains intricate, the folds becoming more delicate as in late archaic vase painting, but stress on the vertical lines lends an overall simplicity (cat. 56).

In Samos the *korai* are sometimes identified as real girls. In one case statues of a whole family, father, mother, three daughters, and a son were set up on a common base, all made by the sculptor Geneleos. The Acropolis *korai* are never named, only their donors, who are often men. Some of these, like the potter Nearchos who dedicated one of the largest and finest, specify the *kore* as a "first fruit" of their labors. This is something different from the aristocratic, almost dynastic motivation for the expensive funerary sculptures, and it is not surprising that the *kouroi* and grave reliefs taper off and disappear in the early years of the democracy, while the *korai* on the Acropolis become more numerous and more uneven in quality.

There seems to have been a law passed at some point to put a stop to the funerary pretensions of powerful families, and some of the monuments set up in the sixth century may not even have stood long enough to be knocked down by the Persians, as the Acropolis maidens seem to have been. In the turbulent years after Athens had expelled the last Peisistratid tyrant in 510 B.C. and before

the new constitution was established, a great many families were exiled from Attica, and we are told that even their graves were dug up and the bones thrown out.

The poet Simonides may have witnessed such destruction when he wrote that no one in his right mind could approve of the epigram by Kleoboulos of Lindos on a monument that promised it would stand as long as the rivers flowed and the trees had leaves and the sun and the moon went on shining. "All things are less than the gods," says Simonides, "but a stone even the hands of mortal men can smash."

As the unnamed Acropolis maidens seem not to have represented mortal girls but rather nymphs who served Athena, perhaps daughters of the mythical earliest kings who were treated as common ancestors of all Athenians in the new constitution, so we could think that figures of youths set up in Athena's sanctuary in the early fifth century are more likely to have represented young gods or heroes than actual members of contemporary society. The so-called Kritios Boy with his long hair could well be Theseus.

In democratic Athens the youthful deeds of Theseus became a symbol of all young Athenians on their way to citizenship. After the confrontation with Persia, Theseus' battles with the Amazons became also a symbol of Greek victory over barbarian enemies. Eretria was an ally of Athens against the Persians in the 490s, when the pediment of the Temple of Apollo at Eretria was probably made (cat. 66). Like the Acropolis *korai*, the group in this exhibition owes its freshness to its early destruction, for the Persians sacked Eretria in 490 before going on to meet defeat at the hands of the Athenians at Marathon. As the abduction of the Amazon Antiope was already popular in Attic art before the enmity with Persia arose, being a romantic tale of war and marriage suitable to celebrate a young man's coming of age (which also made it appropriate for a temple of Apollo), we cannot be sure whether or not the pediment is already linked to contemporary events.

The narrow escape from Persian domination brought the Greeks a new sense of pride in their common Hellenism. Together with this came a sober and realistic assessment of man's place in the universe. The relief of a young athlete putting on the wreath of victory (cat. 67) is the only Early Classical sculpture in the show. The lost inscription may well have identified him by name and offered his thanks to Athena, in whose sanctuary at Sounion the relief was found. His hair knotted over his forehead shows that he is still a boy, and the sculptor knows how to show this also in the forms of his body. His pride in his victory is tempered by an air of reverence, as if he understands that it does not belong to him alone.

54

SUGGESTIONS FOR FURTHER READING

Beazley, J. D. *The Development of Attic Black-figure*. Berkeley and Los Angeles, 1986.

Boardman, J. *The Greeks Overseas*. New and enl. edition. New York, 1980.

Boardman, J., and N. G. L. Hammond, eds. *The Cambridge Ancient History*, 2nd ed., vol. 3, part 3. *The Expansion of the Greek World, Eighth to Sixth Centuries B.C.* Cambridge, England, 1982.

Desborough, V. R. d'A. *The Greek Dark Ages*. New York, 1972.

Guthrie, W. K. C. *A History of Greek Philosophy*. Vol. 1. *The Earlier Pre-Socratics and the Pythagoreans*. Cambridge, England, 1962.

Hampe, R., and E. Simon. *The Birth of Greek Art*. New York, 1981.

Hesiod: Theogony, Works and Days. Translated and with introductions by D. Wender. Harmondsworth: Penguin Books, 1973.

Higgins, R. A. *Greek Terracottas*. London, 1967.

History of the Hellenic World: The Archaic Period. University Park, Pa., 1975.

Huxley, G. L. *Greek Epic Poetry*. Cambridge, Mass., 1969.

Jeffery, L. H. *Archaic Greece: The City States, c. 700–500 B.C.* New York, 1976.

Jeffery, L. H. *The Local Scripts of Archaic Greece*. Oxford, 1964.

Karageorghis, V. *Cyprus from the Stone Age to the Romans*. London, 1982.

Lattimore, R. *The Iliad of Homer*. Chicago, 1961.

Lattimore, R. *The Oddysey of Homer*. New York, 1967.

The Oxford History of the Classical World. Edited by John Boardman, Jasper Griffin, and Oswyn Murray. Oxford, 1986.

Richter, G. M. A. *The Archaic Gravestones of Attica*. London, 1961.

Richter, G. M. A. *Korai, Archaic Greek Maidens*. London, 1968.

Richter, G. M. A. *Kouroi, Archaic Greek Youths*. 3d edition. London, 1970.

Richter, G. M. A., and M. J. Milne. *Shapes and Names of Athenian Vases*. New York, 1935. Reprint 1973.

Snodgrass, A. M. *The Dark Age of Greece*. Edinburgh, 1971.

Snodgrass, A. M. *Archaic Greece. The Age of Experiment*. Berkeley and Los Angeles, 1980.

The World of Athens: An Introduction to Classical Athenian Culture. Cambridge, England, 1984.

CATALOGUE

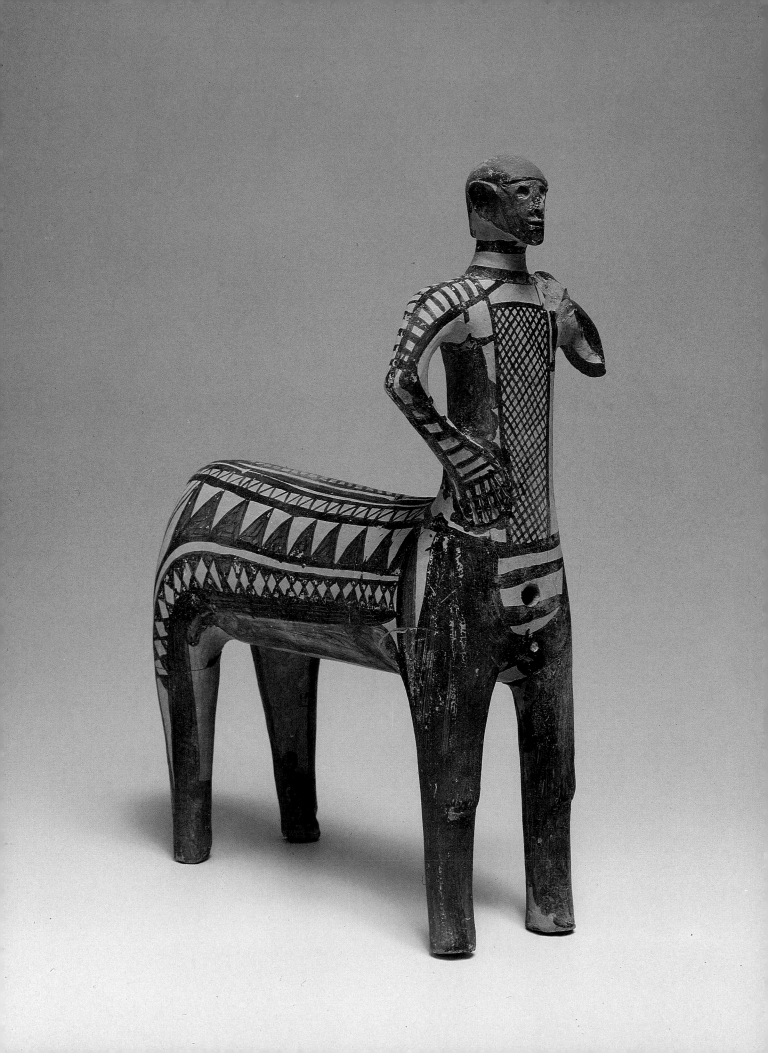

Terracotta Statuette of a Centaur

Found in Lefkandi, Euboea, in 1969
End of the tenth century B.C.
Height 36, length of the body 26
 (14⅛, 10¼)
Eretria, Archaeological Museum, 8620

This centaur, the product of a Euboean work-
shop, is not only one of the earliest represen-
tations of a centaur from the Aegean area,
but also is the largest example in terracotta.
It is a sculpture of bold and stark power, a
unique and remarkable creation from the Dark
Ages that followed the decay of the Myce-
naean civilization. The centaur seems to have
been a highly valued family possession, for
the head was found in one tomb and the body
in another. The separate parts of the already
broken centaur were preserved, evidently, and
taken by two different members of the same
family to their final resting places.

In making this exceptional work, the an-
cient artist, faithful to a Mycenaean tradition,
used the potter's wheel for the hollow, cylin-
drical horselike body, but formed the solid
human torso and the legs by hand. The ex-
cellent condition of the work is due not only
to careful burial, but also to the fine-grained
clay of which it is made and the light brown
slip of the same material, which sets off the
rich dark-to-reddish-brown paint. Two vents,
one about where the human navel would be
and the other in the horse's back, insured
proper firing in the kiln.

Definitely male, even though the genitals
are not represented, the centaur stands
squarely on all four legs. His forelegs, ren-
dered in more human fashion above the knees,
are consciously differentiated from the hind
legs. The horse's tail is no longer preserved.
The centaur's right arm rests on his right hip,
the six fingers painted and accentuated by
incision. The small additional piece of clay on
his left shoulder indicates the resting place of
an object, most likely a branch or a tree (see
cats. 25 and 30), once held in his now missing
outstretched left hand.

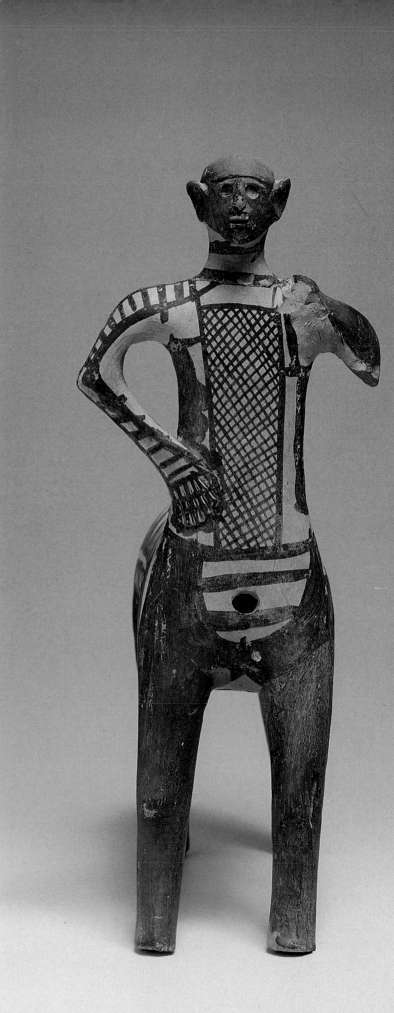

59

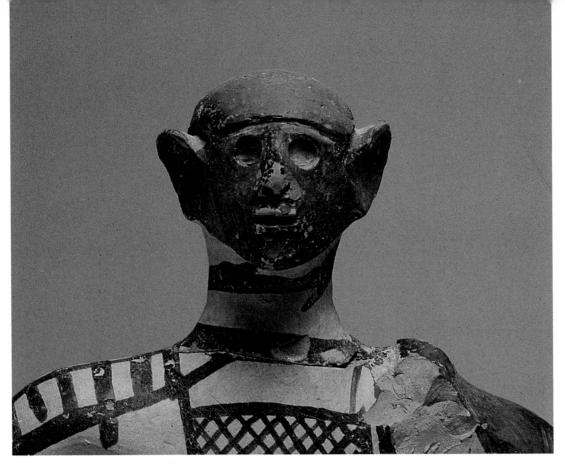

The centaur's face gives a primitive and otherworldly impression. The eyes are rendered by two impressed cylindrical hollows, perhaps once inlaid with another material, bone or shell. The hair is modeled in the round both over the eyes and in back above the neck. The well-modeled nose projects in a straight line from the forehead, and two holes, impressed while the clay was still damp, indicate the nostrils. The mouth is defined by an indented line. The prominent chin is not bearded. The ears, large and not at all human, impart a strange demonic look. Holes have been made in the ears as in the nostrils, but it is not certain whether these holes are a simple anatomical detail or have religious significance; similar holes are found in the ears of earlier statuettes that clearly served a cult purpose.

The face, hair, belly, back, and forelegs of the centaur are painted with bold decorative designs: horizontal lines around the neck and across the lower belly, latticework on the chest, bands of lozenges, dogtooth, and zigzag on the cylindrical body. This seems not to be an artist's attempt to represent dress, but is purely decorative.

Though many scholars maintain that the Lefkandi centaur is derived from comparable ritual objects of Crete or Cyprus, it can be argued that this piece from Euboea, a region strongly influenced by the art of Athens, is closer to the wheel-made statuettes of animals of the Mycenaean period that have been found in various parts of Greece. This centaur should be considered therefore a local, purely mainland development, running parallel to that of Cyprus or Crete. Beyond its morphological or technical classification, this masterpiece can be seen as a manifestation of high art, the representation of a mythical being created by the rich Greek imagination. In the centaur from Lefkandi, regardless of whether it represents the wise, kindly centaur Chiron, as is suggested by the gash on his left knee, or one of the wild centaurs—Melaneus, Mermeros, Teleboas, Erigdoupos, or Dryalos—the battle for its human element is fought and won despite its animal features. The human figure dominates here more that in any other similar example from the period. This centaur foreshadows the artistic achievements and the renaissance of the eighth and seventh centuries B.C.

Bibliography

V. R. d'A. Desborough, R. V. Nicholls, and M. Popham, "A Euboean Centaur," *BSA* 65 (1970): 21–30, pls. 7–11.
P. G. Themelis, *Frühgriechische Grabbauten* (Mainz, 1976), 101, pls. 16, 17.
M. R. Popham, L. H. Sackett, and P. G. Themelis, eds., *Lefkandi, the Iron Age*, vol. 1 (London, 1979), 168–170, 344–345, pls. 251–252.
LIMC 3(1986): 238, no. 1.

D. T.

2

Protogeometric Skyphos

Found in Athens, Kerameikos, Grave 15
Attic, end of the eleventh century B.C.
Height 15.5 (6⅛)
Athens, Kerameikos Museum, 547

Made on the fast potter's wheel in Athens, a city that had suffered no break in tradition from Mycenaean times, this typical example of Protogeometric art is characterized by a strictly coordinated structure of shape and decoration. Two black bands mark off the lip, and directly below them is a freely drawn scribble in dilute glaze. The roundness of the body is emphasized by three sets of concentric circles, drawn not by hand but with the multiple-brush compass that is characteristic of the era. This principal zone is bordered below by a broad black band between two narrow ones. The foot is black, and slashes of black paint set off the handles from the decorated area.

Bibliography
V. R. d'A. Desborough, *Protogeometric Pottery* (Oxford, 1952), 80–81, pl. 10.
R. M. Cook, *Greek Art* (London, 1972), 31–32, pl. 1a.

D. T.

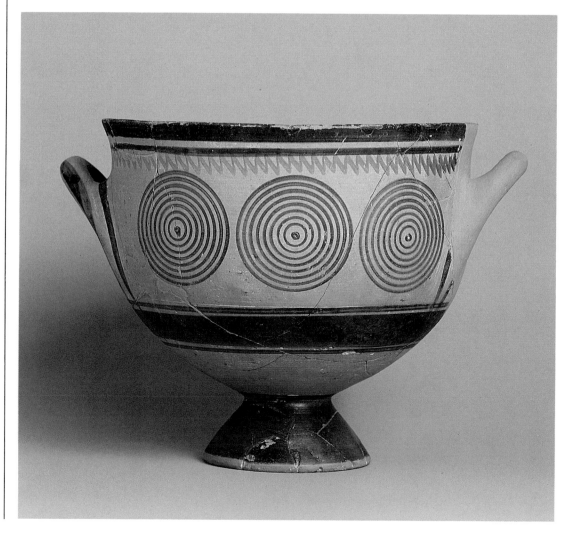

Clay Skyphos

Found in Eleusis (south cemetery)
Attic, c. 770 B.C.
Height 6.4 (2½)
Eleusis, Archaeological Museum, 910

In the Geometric period the Protogeometric skyphos (cat. 2) lost its high conical foot and became a wide shallow cup with offset rim.

The first narrative representations on which man dominates the scene appear in Attic vase painting at the end of the Middle Geometric period. One of the first experiments is this skyphos (drinking cup) from Eleusis. The mental and spiritual turmoil of the early seafarers in search of a new land is represented in a fresh way on the two panels. On one side, bold sailors are beaching their boat, as men armed with spears and figure-eight shields await them on land. The commander steadies the steering oar, ready to coordinate the vessel's maneuvers with the course of the battle. Beside him an archer has already drawn his bow. On the other side of the vase, a confrontation is taking place on land: archers and men with javelins are engaged in a battle that has claimed victims on both sides, as is clear from the bodies between the two enemy parties.

The vase painter had a sure hand. Restricted to the style of the period, he rendered the human figures in silhouette; what interested him was not so much the faithful representation of the human body as an expressive depiction of life and movement. Three-dimensionality did not seem to occupy him so much as the difference in proportions of the two fallen soldiers; perhaps it was his personal attempt and his personal emphasis on the rendering of distance, something that did not interest his contemporaries at all.

This small work of art heralds the monumental painting of Attic workshops, which blossomed in the following years.

Bibliography
ArchEph (1898), pl. 5, 1 and 1a.
Coldstream, *Geometric Pottery*, 26–28.
Coldstream, *Geometric Greece*, 110, with previous bibliography.

M. P.

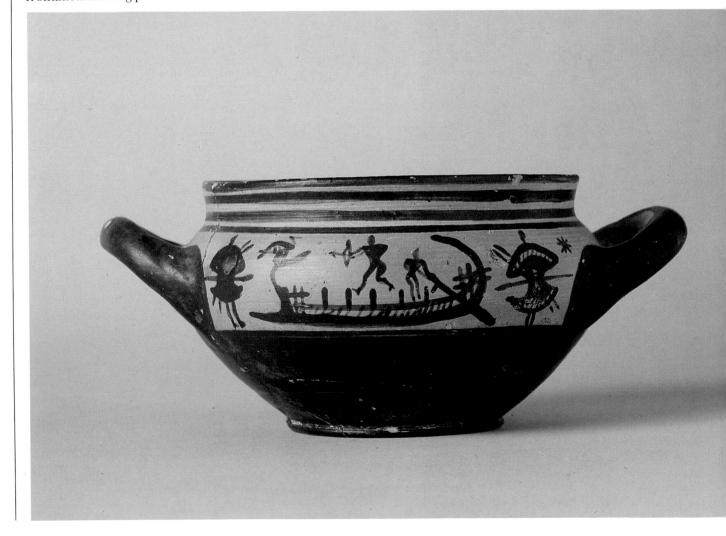

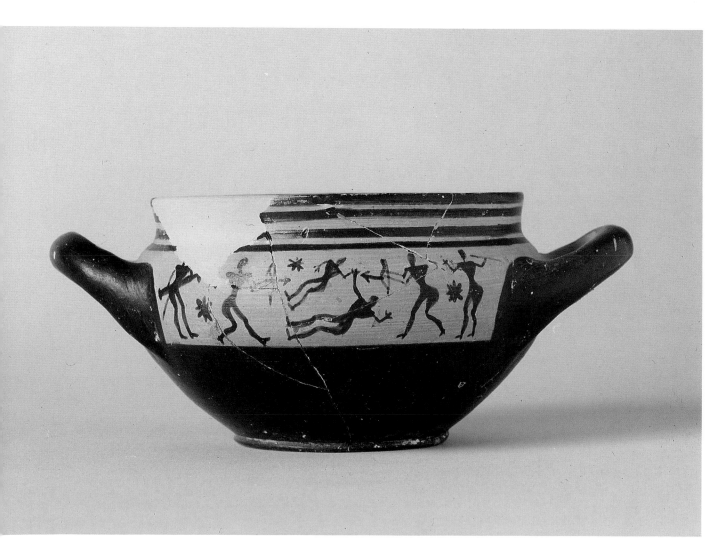

4

Clay Kantharos

Found in a tomb south of the Acropolis
Attic, attributed to the Burly workshop,
 third quarter of the eighth century B.C.
Height 11.6 (4½)
Athens, First Ephoreia of Prehistoric and
 Classical Antiquities, ERK 630

Restored from many fragments, this kantharos was among the numerous vases in the richly furnished tomb of an Athenian noble. It is one of the most characteristic examples from the Athenian pottery workshop of the Burly Painter, so named because of his sturdy figures.

The wide panel of the belly of the vase, framed by two large quatrefoils, depicts the "master of the horses" wearing a sword and holding the bridles of two proud, large-bodied horses. The lower part of the vase is covered with black, above which runs a zone of parallel lines whose uniformity is broken by a row of black dots. Similar dots adorn the neck.

The high, elegant handles of the kantharos make its body seem less broad. The figural representation, in its simple decorative frame, accords perfectly with the balanced shape of the vase.

The theme of man and horse is known from many pottery workshops even outside Attica, primarily in the Argolid. The scene probably derives from rites of the cult of the dead, though other hypotheses have been offered that attempt to trace the type to a deity, either chthonic or Olympian.

Bibliography
M. Brouskari, "Apo ton Athenaiko Kerameiko tou 8ou p.Ch.ai." (Athens, diss., 1979), 38, pls. 22, 44.

M. P.

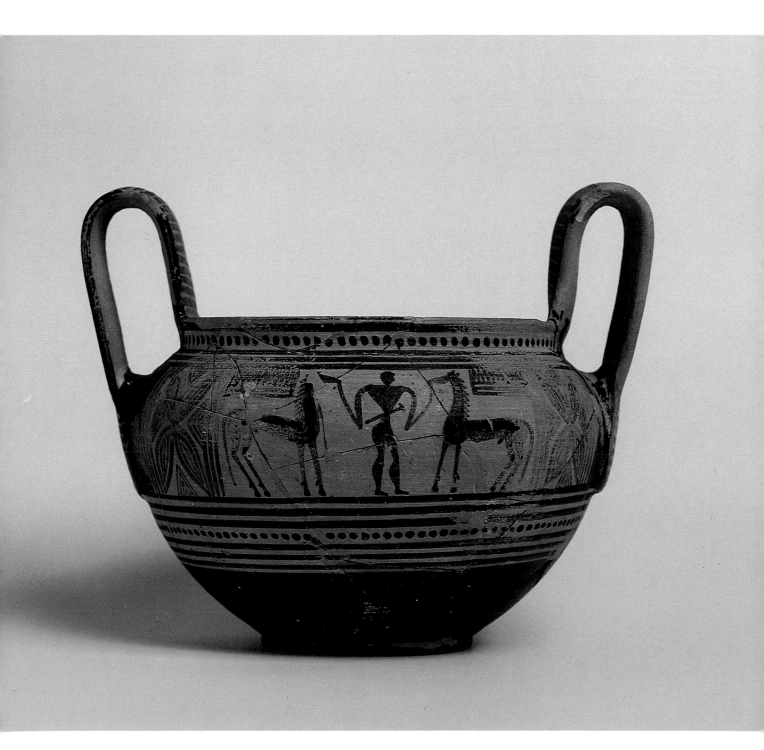

65

5

Clay Oinochoe

Found in a grave on the south side of the Acropolis
Attic, attributed to the Burly workshop, third quarter of the eighth century B.C.
Height 12.4 (4⅞)
Athens, First Ephoreia of Prehistoric and Classical Antiquities, 1955 ERK 643

This intact oinochoe was an offering in the same grave as the Burly kantharos (cat. 4). Its shape first appears in Geometric pottery during the last decades of the eighth century B.C., with the tall thick neck dwarfing the flattened body.

From the same workshop as the Burly kantharos, this little oinochoe is the work of a talented painter of miniatures. The figural decoration shows a nude man struggling with his sword against a lion, while another lion behind him is poised to devour him. On the shoulder of the vase two birds face a pattern of stacked chevrons. Saltires and dot rosettes fill the rest of the field, and black horizontal lines and a row of dots complete the decoration of the body. The mouth of the vase is covered with black glaze, which dissolves into a row of black dots on the lip.

The depiction of lions enriches the repertoire of Geometric art from about the mid-eighth century on. We cannot doubt the heroic character of such scenes of lions devouring men, whether or not the subject has eastern origins or mythical symbolism.

Bibliography
M. Brouskari, "Apo ton Athenaiko Kerameiko tou 8ou p.Ch.ai." (Athens, diss., 1979), 24, pls. 10–11.

M. P.

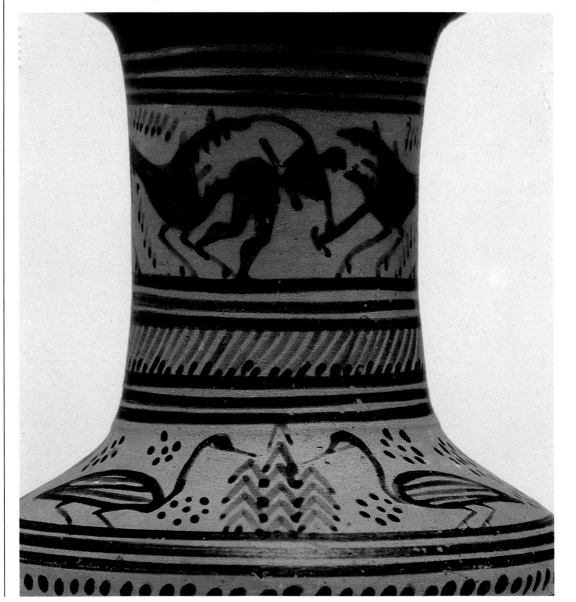

66

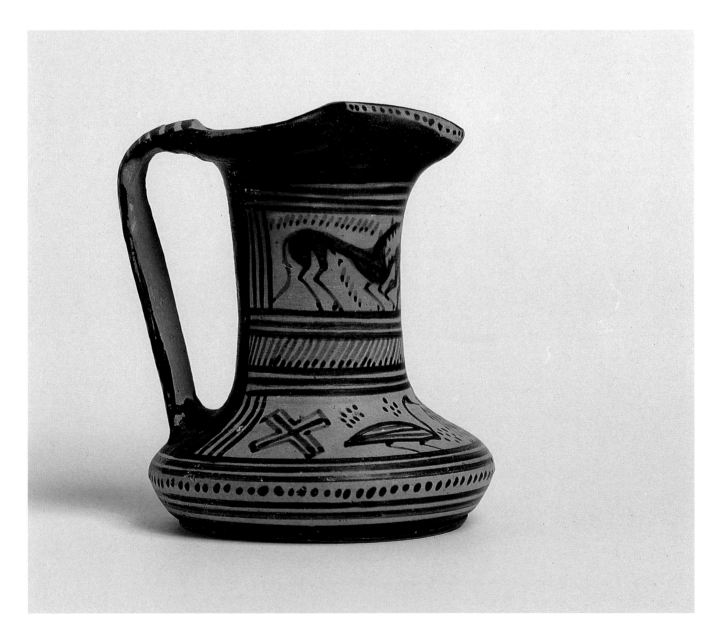

6

Bronze Statuette of a Warrior

Found on the Athenian Acropolis
Attic, third quarter of the eighth century
 B.C.
Height 21 (8¼)
Athens, National Archaeological Museum,
 x 6616

This early bronze by an Athenian artist may once have decorated one of the broad, flat, circular handles of a votive tripod cauldron (see cat. 10). The figure was cast solid in a mold, but the lower arms were subsequently reworked by hammering so that the raised right hand could hold a spear, the left a shield, both now lost. The contour of the nude, youthful body is reminiscent of the silhouette figures painted on vases of the same period. The artist is still experimenting with the rendering of a three-dimensional human body. The head is small but in correct proportion to the rest of the body. Eyes and ears, which project unnaturally from the head, are schematically rendered; nonetheless, the way the chin sticks out with an abrupt change of planes gives the face a kind of individual physiognomy. The torso is conventionally rendered, without special modeling, flat on the back and chest; but the hips, thighs, and calves are given substance. A slight asymmetry in the legs gives the impression that the figure is raising its left knee just a little. The work demonstrates the beginning of a desire to show movement.

Bibliography
Coldstream, *Geometric Greece,* 128, fig. 40b–40d.
Schweitzer, *Geometric Art,* 131, pls. 132–135.
Rolley, *Greek Bronzes,* 60–61, fig. 38.
 M. P.

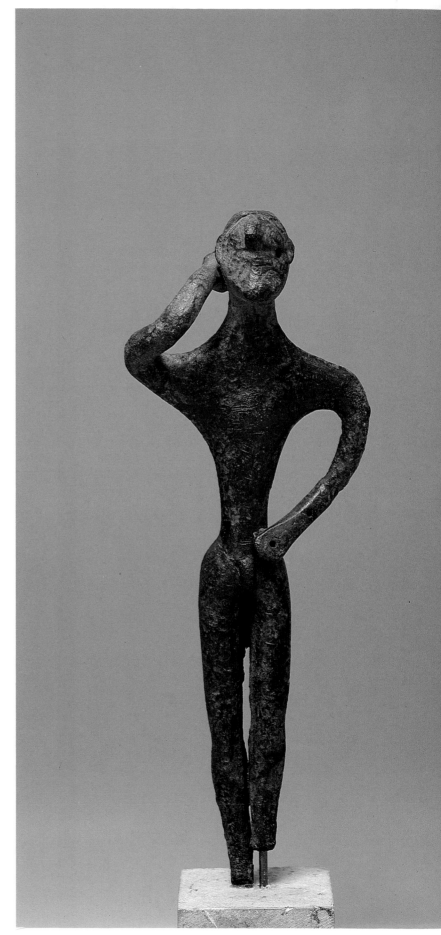

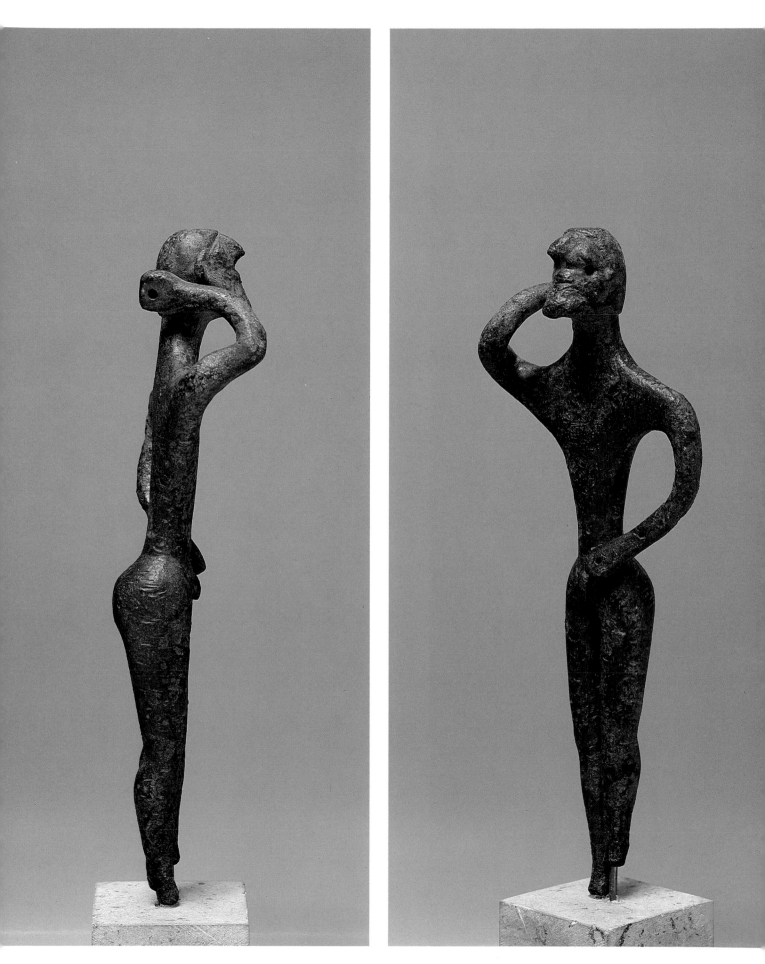

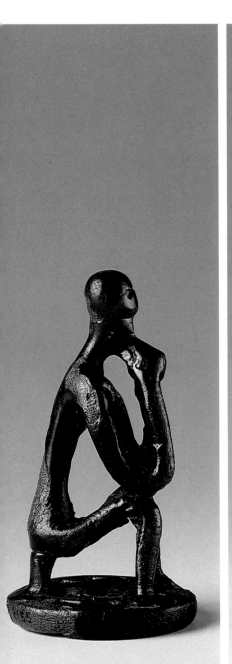

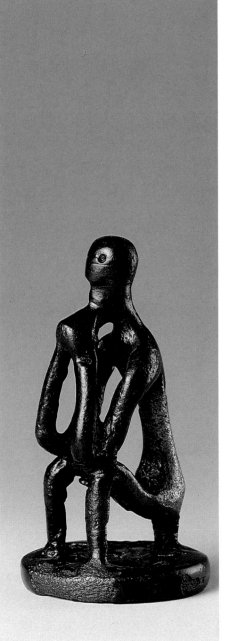

7

Bronze Statuette of a Flute Player

Found in Sparta in the sanctuary of
 Artemis Orthia in 1907
End of the eighth century B.C.
Height 7 (2¾)
Sparta, Archaeological Museum, 2155

This dynamic, solid cast statuette, with all the abstraction of its primitive technique, speaks to us of the early stages in the astonishing adventure of bronze working in Greece. A flute player, or drinker as some scholars maintain, remote in time but amazingly contemporary in form, the small figure provides one of the rare examples of bronze human statuette-offerings found in the region of Sparta.

The figure is supported at three points—its two feet and a sketchy seat—while the circular perforated base forms the bottom of an imaginary cone whose apex is the head of the statuette. The limbs and especially the body of the figure create a wonderful assemblage of triangles to complete the sense of geometricality. Even though the body, arms, and legs are nothing more than cylindrical sticks, the work is intensely three-dimensional and bold. The forward slant of the body allows the weight to be distributed through the arms to the legs, which spread downward to create a broader base.

The figure tilts its head back to play the double flute, while its eyes—two hollows in the polished metal, the single modeled detail in the work—heighten the expressiveness.

Bibliography
R. M. Dawkins, *The Sanctuary of Artemis Orthia at Sparta* (London, 1929), 197, pl. 77a.
Coldstream, *Geometric Greece,* 160, fig. 53c.
Rolley, *Greek Bronzes,* 68, fig. 217.

D. T.

8

Bronze Statuette of a Nude Warrior

Found in Olympia in 1960
Argive workshop, second half of the eighth
 century B.C.
Height 14.4 (5⅝)
Olympia, Archaeological Museum, B 4600

This cast statuette of a nude warrior is the
work of a bold artist from Argos. The accu-
rate proportions of the head and body, the
anatomically correct lower extremities, and
the belt that binds the warrior's narrow waist
all evince a revolutionary conception. The se-
rious face with its strong, straight nose, the
thick arches of the brows that spring from its
bridge and emphasize the heavy-lidded eyes,
and the stern mouth with slightly pursed lips
reproduce individualized, recognizable hu-
man features, considerably advanced from
earlier concepts of generic and abstract form.
The hair, cut short and straight across the
forehead, falls behind the ears and down to
the nape of the neck in incised locks. A barely
perceptible movement in the back is pro-
duced by the soft modulation of surfaces
rounding into the shoulders. The right arm
is raised straight up to hold a spear, but the
left hangs down, probably once holding the
reins of his horse.

The artist has conceived the relationship of
his work to space in a revolutionary way.

The figurine was attached to a vessel of
some kind, as is clear from the tang attached
to its base.

Bibliography
Schweitzer, *Geometric Art*, 131–132, pls. 136–139.
Coldstream, *Geometric Greece*, 150, fig. 49a–49c.
H.-V. Herrmann, "Werkstätten geometrischer
Bronzeplastik," *JdI* 79 (1964), 46, figs. 31, 32.
Rolley, *Greek Bronzes*, 68, fig. 37.

M. P.

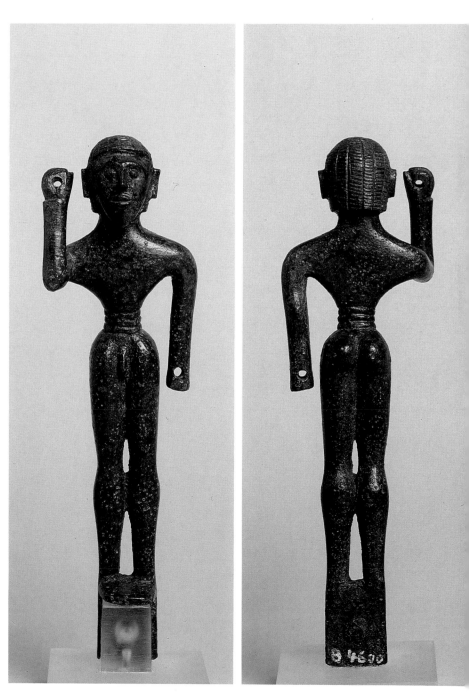

Bronze Statuette of a Warrior

Found in Olympia below the foundations of
the Temple of Hera
First quarter of the seventh century B.C.
Height 23.7 (9¼)
Athens, National Archaeological Museum,
x 6178a

A young man, nude except for a broad belt,
stands with his right hand raised, originally
holding a spear. The raised arm and the slight
separation of the legs, with the left foot for-
ward, make him appear to be between motion
and rest, as if in midair. A crested helmet rests
on his head, his abundant hair falling in hor-
izontal waves typical of the Daedalic style. This
cast statuette must have been the dedication
of a warrior.

Bibliography
Rolley, *Greek Bronzes*, 72, fig. 220.
R. Hampe and E. Simon, *The Birth of Greek Art*
(London, 1981), 256, figs. 416–417.

I. T.

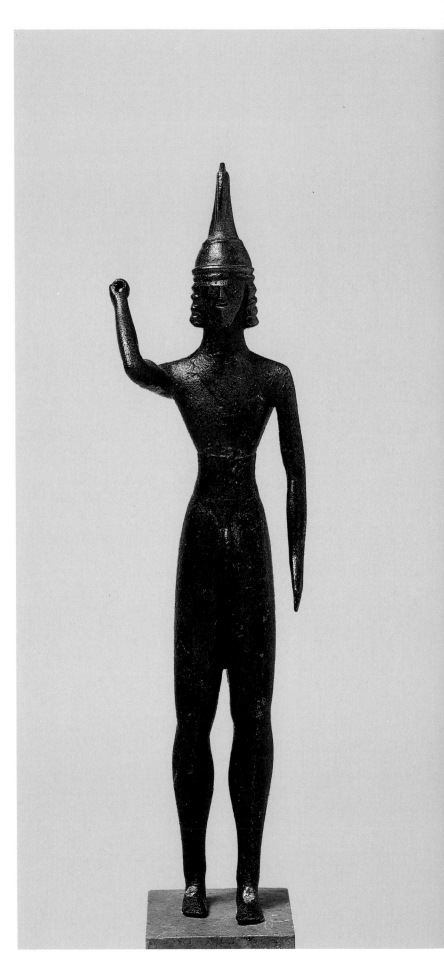

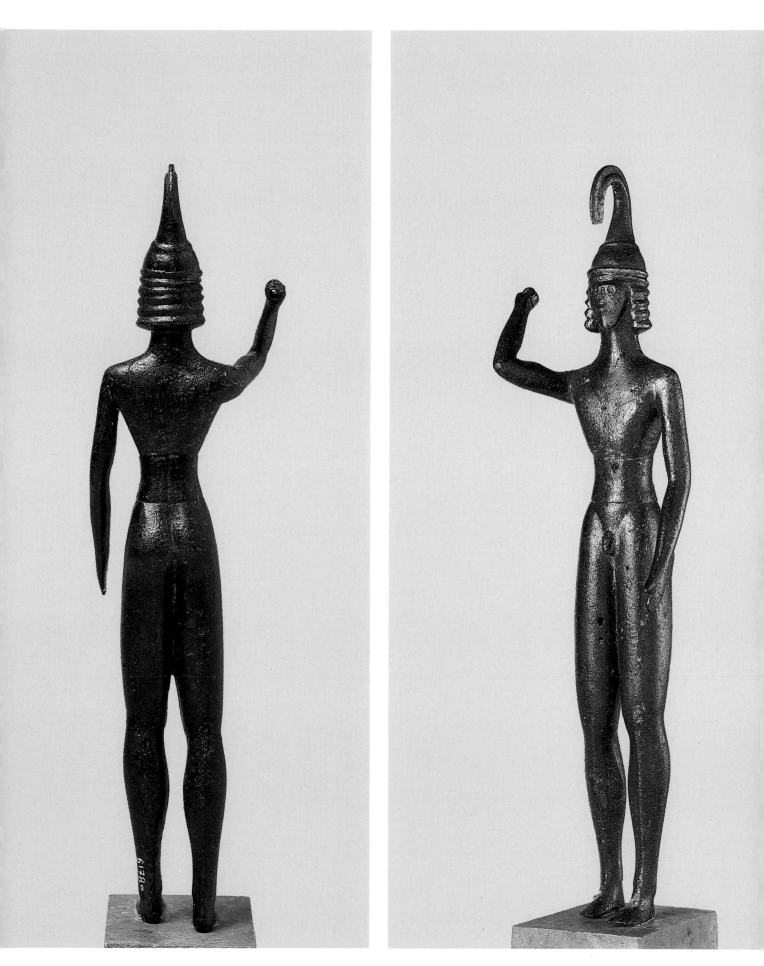

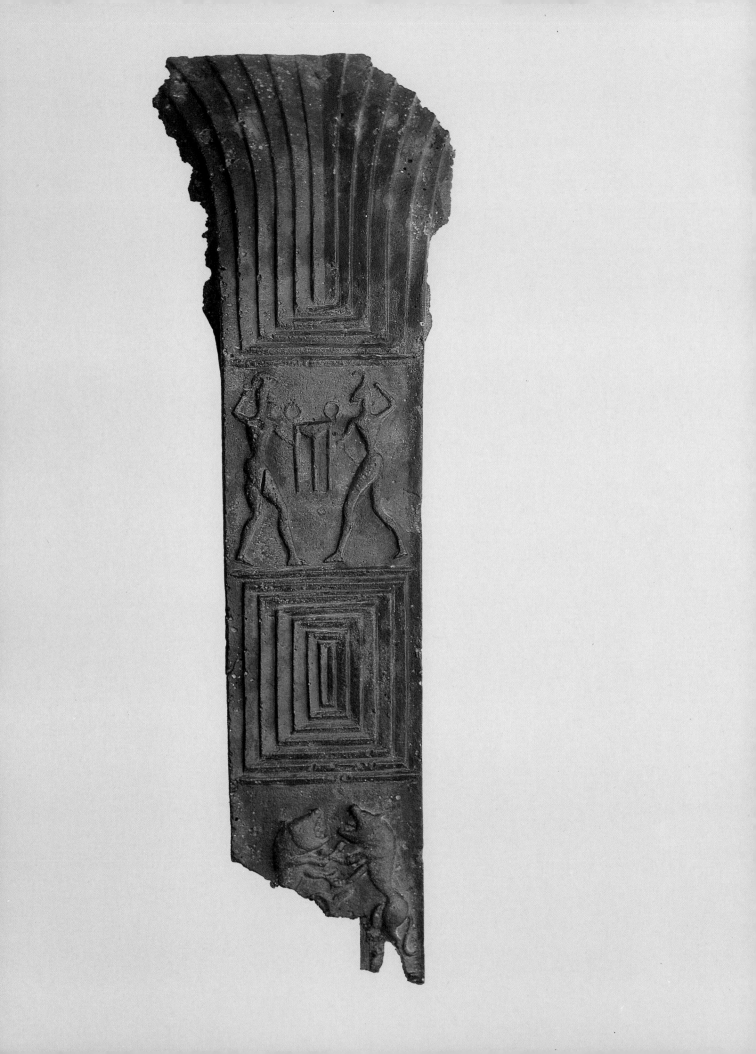

10

Bronze Leg of a Tripod Cauldron

Found in Olympia (excavations in the
 stadium)
Cretan, end of the eighth century B.C.
Height 46.5 (18¼)
Olympia, Archaeological Museum, B 1730

This fragment of a bronze tripod is a typical example of the transition from the Geometric to the Archaic style. Between the severe linear patterns of closed graduated rectangles or open fan-shaped designs are panels with scenes from the world of man and animal, myth and symbol. At the top, two warriors, in heroic nudity, possibly Heracles and Apollo, fight for possession of a tripod cauldron like the one on which they are depicted. Below, two rampant lions make trial of each other's strength.

Bronze tripod cauldrons, witnesses to the piety of their dedicators, have been found in all the major sanctuaries of ancient Greece, including Olympia, Delphi, and Dodona. These great vessels are a monumental form of three-legged basin, made to be set over a fire for cooking. Homer mentions tripods not yet touched by the fire as prizes in the funeral games of Patroclus (*Iliad* 23. 257–270).

The fights of men and animals in the picture panels on this fragment may express the intense competitive spirit at the core of the Olympic Games.

Bibliography
A. Mallwitz and H.-V. Herrmann, *Die Funde aus Olympia* (Athens, 1980), 44, no. 16, with bibliography.

I. T.

11

Clay Amphora

Provenance unknown. Gift of Damianos
 Kyriazis
Attic, attributed to the Hirschfeld Painter,
 750/735 B.C.
Height 55.5 (21⅞)
Athens, National Archaeological Museum,
 18062

The Late Geometric period in Athens, beginning with the Dipylon Painter, produces the first masters in the long history of vase painting whose work, together with that of their workshops, is recognized in many surviving pieces. One of these is the Hirschfeld Painter, named after the scholar who identified his hand in works such as the vase shown here.

The shape of this vase indicates that it comes from a man's grave. Larger amphoras of this type were placed as markers over Geometric period graves, but the small size of the present vase and its perfect preservation indicate that it was buried inside the grave, containing the ashes of the deceased.

The main scene on the amphora, in the panel of the handle zone, portrays the *prothesis* (laying out) of the dead noble before his burial. The dead man lies on a high bed rendered in perspective. The painter, unable to show the body in perspective, depicted it in silhouette. Around the man, women mourn, beating their heads with their hands. This custom, which continues today in many places in Greece, is meant to express ineffable grief. Three long-necked birds (omens?), one under the funerary couch and two below the handles of the vase, complete the primary scene.

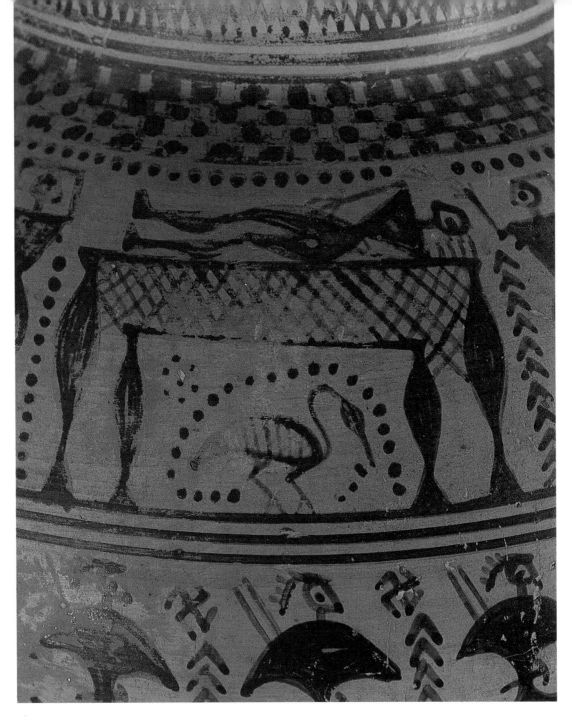

On the belly of the vase hoplites with figure-eight shields and two spears each, separated from one another by stacked filling ornament, pay silent tribute to the dead man. Their beak-shaped noses, the large eye that dominates the outlined head, and the fringed plumes of the helmets are typical of the Hirschfeld Painter. Even the linear ornament bears his personal stamp. Single and double meanders decorate the neck, while the painter's favorite motif, the single zigzag, is repeated in many rows from the belly to the base. The lozenge chain, a common Geometric ornament, is elaborated with black dots. The dotted plastic snakes that crawl along the handles reinforce the chthonic meaning of the representations on the rest of the vase.

Geometric man, made conscious for the first time of his tragic fate, helpless before the knowledge of his own mortality, and lacking the consolation of philosophy, mourns the common fate in moving scenes like this.

Bibliography
Coldstream, *Geometric Pottery*, 42–44, no. 6.
F. Villard, "Une amphore géométrique attique au Musée du Louvre," *Monuments et Mémoires*, Fondation Eugène Piot, L'académie des inscriptions et belles-lettres 49 (1957): 31–33, figs. 14-16.
G. Ahlberg, *Prothesis and Ekphora in Greek Geometric Art* (Göteborg, 1971), 36.
J.M. Davison, *Attic Geometric Workshops*, *Yale Classical Studies* 16 (1961): 38-39, fig. 28.

M. P.

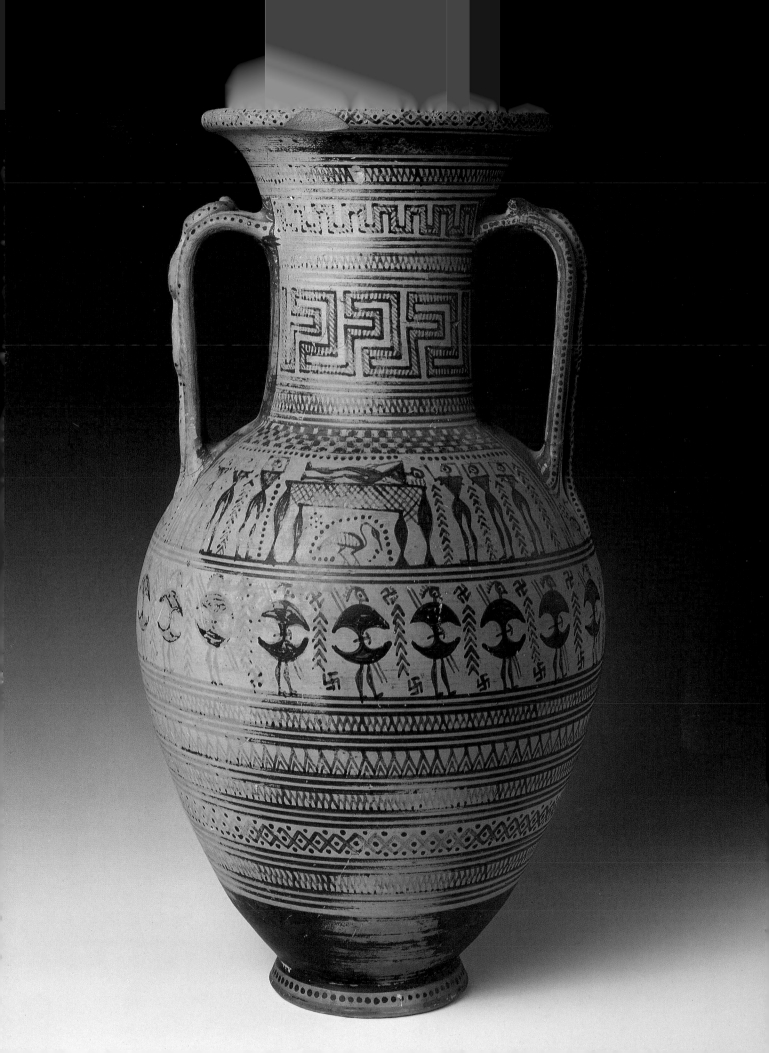

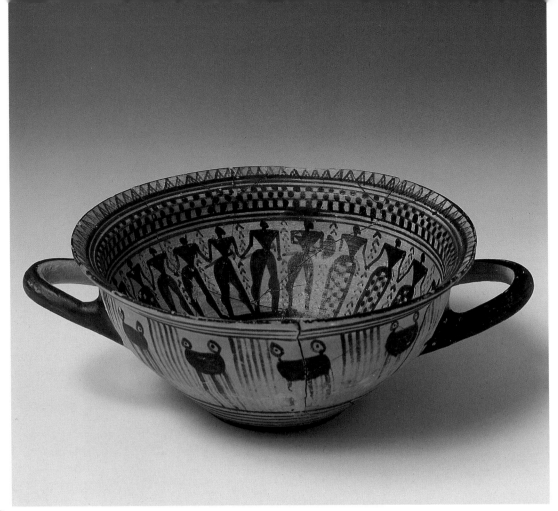

13

Clay Skyphos

Found in Athens
Attic, last quarter of the eighth century B.C.
Height 6.5 (2½), diameter 16 (6¼)
Athens, National Archaeological Museum,
 874

This type of deep bowl with horizontal handles and out-turned rim seems to have been the invention of Attic potters, for all known examples come from Attic workshops. In its interior, around a rosette with eight hatched leaves, runs a narrow zone of interlocking cross-hatched triangles. These triangles are repeated on the lip of the skyphos, above a checkered band.

In the area between the linear ornaments is portrayed a religious dance. Two male leaders, wearing swords, carry the earliest type of lyre, the chelys, made from a tortoise shell. Women and men (two of them armed) fill the circle of the dance. The women wear long, cylindrical skirts, recalling descriptions of early wooden statues of goddesses.

According to one opinion, the dance is a reference to the festival of Thargelia, which was celebrated in Athens in honor of the god Apollo during the month of Thargelion (May).

Victors in the contests on the second day of the festival traditionally dedicated the tripods they had won to the sanctuary of the god. That would explain four tripod cauldrons painted between wide triglyphs on the outside of the vase. Representations of tripods are not rare on vases of the Late Geometric period. They are thought to be related to the *athla*, trophies given to contestants in music, dance, gymnastics, and so on.

As Geometric art matured toward the end of the century, this artist was experimenting with a style that would be fully developed in succeeding years. Linear filling ornaments, light and playful, cover the surfaces. The human figures, though still drawn in silhouette, are rendered with a painterly touch, anticipating the new period. Having reached the highest stage of which their art is capable, Geometric artists now seek new means of expression.

Bibliography
B. Borell, *Attisch geometrische Schalen* (Mainz, 1978), pl. 14, no. 62.
CVA Athens 2 (1954): pls. 10–11.
Schweitzer, *Geometric Art*, 52–53, pls. 66, 68.
J. M. Davison, *Attic Geometric Workshops*, *Yale Classical Studies* 16 (1961), 85, fig. 134.

M. P.

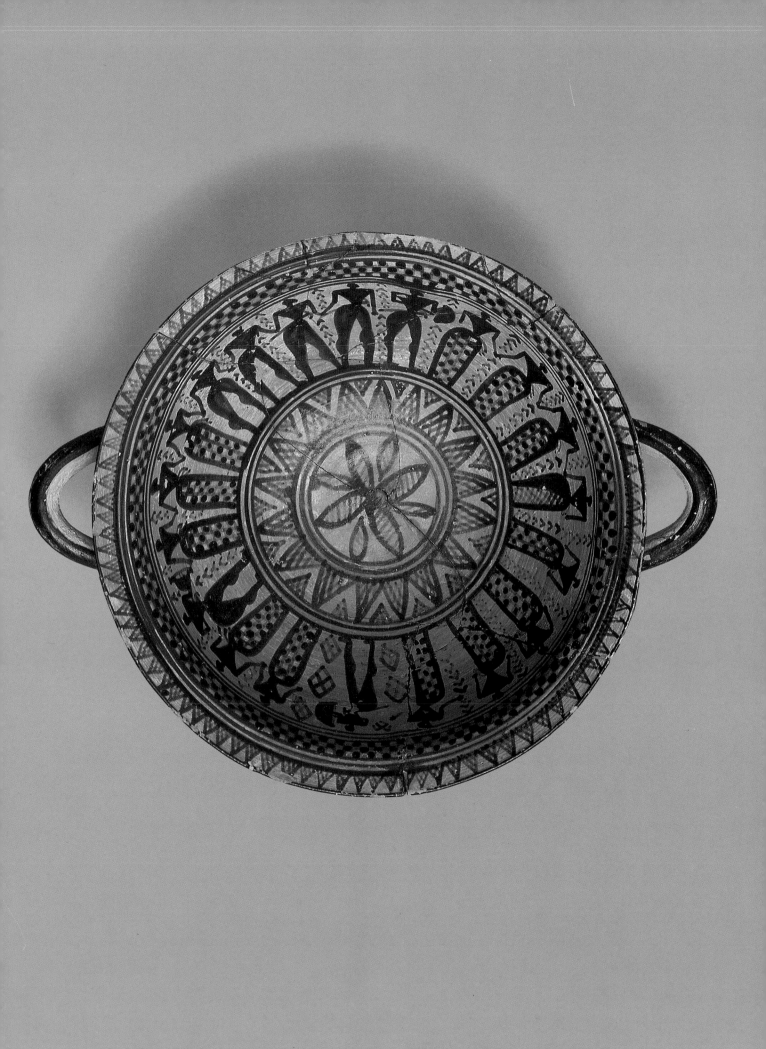

14

Clay Pyxis

Found in the sanctuary of Apollo at
 Amyclae (Sparta)
Laconian, third quarter of the eighth
 century B.C.
Height 29 (11⅜)
Athens, National Archaeological Museum,
 234

Although the Geometric pottery of Laconia
is only partly known through the few finds
from the ancient Dorian sanctuaries of Ar-
temis Orthia and Amyclaean Apollo, this pyxis
bears witness to the artistic activity that Sparta,
cut off from the rest of the Peloponnesus,
had developed in the Geometric period be-
fore the military character of its government
sapped its artistic vitality.

The figures are performing a men's round
dance. The round dance is a common subject
in Argolis and Corinth, but the Laconian
workshop represents the human figures in a
more harsh and awkward way. Their necks
are unnaturally long, and their arms project
at sharp angles from their shoulders. Their
chins and hair, which are silhouetted on the
profile heads, suggest the beaks and feathers
of birds. Perhaps the artist meant to depict
the crown of upright leaves that Laconian
dancers wear in later art.

The dance is of Laconian origin and prob-
ably religious, performed in honor of Apollo.
The god's presence is indicated by the lyre
painted amid the dancers. The scorpion in
the field is probably apotropaic, and the
branches held between the joined hands of
three figures must also have some religious
significance. Dances like this are part of cel-
ebratory observances in other Apollonian
sanctuaries as well, such as Delos, where the
long-robed Ionians danced the so-called Crane
Dance (Geranos) in the god's honor.

In spite of its ineptitude, this work has the
liveliness and naive simplicity of a child's
drawing. The artist has tried to capture a sense
of human presence with his paintbrush.

Bibliography
Schweitzer, *Geometric Art*, 66–67, fig. 28.
Coldstream, *Geometric Greece*, 159, fig. 52d.
Coldstream, *Geometric Pottery*, 217–218, pl. 46n.

M. P.

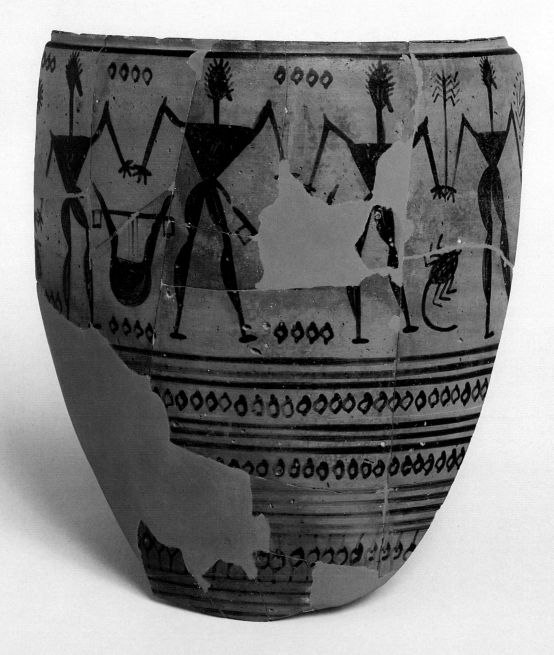

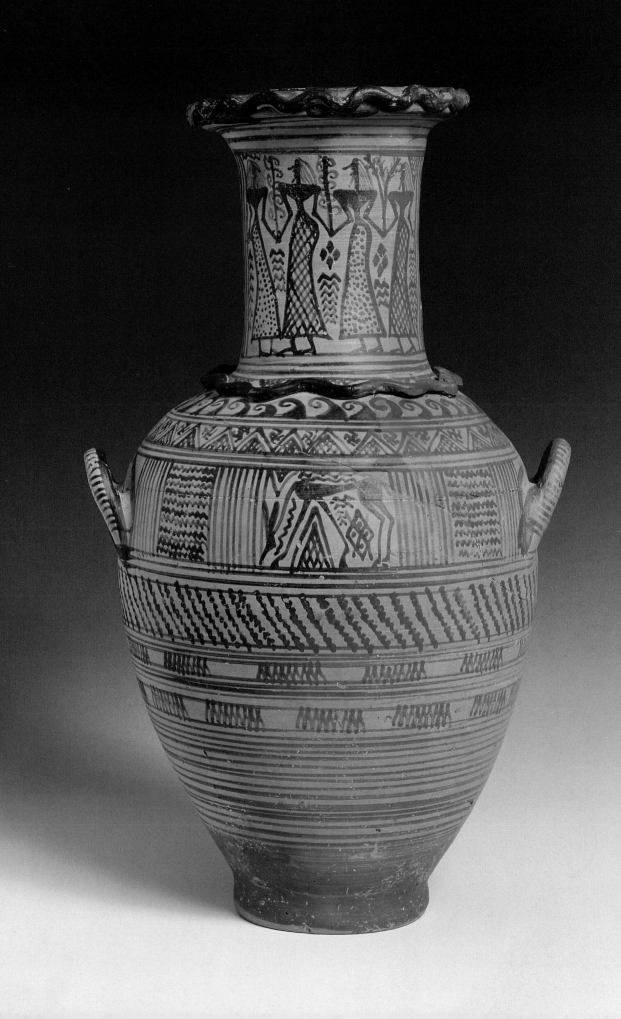

Clay Hydria

Provenance unknown. Gift of Gregorios
 Empedocles
Protoattic, last quarter of the eighth
 century B.C.
Height 42 (16½)
Athens, National Archaeological Museum,
 18 435

The first intimations of the Orientalizing style
of vase painting known as Protoattic appeared
in Attic workshops toward the end of the eighth
century. They occur on vases whose syntax
and subsidiary ornament are still Geometric
but on which the Geometric style has become
perfunctory and lost its inner drive. The Geo-
metric ornaments no longer express the firmly
structured world of the artist and are no longer
alive to him but are just something that he
repeats.

In this hydria, which must have been made
for a woman's grave, the neck and shoulder
herald the new style, while the decoration of
the body reveals the stagnation of the old. On
the neck, four women perform a dance, prob-
ably part of a religious rite. The theme had
been popular throughout the Geometric world,
but this representation shows a new spirit that
presages the works of the Analatos Painter,
the great pioneer of Protoattic. The inward
turn of the figure on the left shows that this
is a round dance: the sprigs in the joined
hands suggest its religious nature. Heads, arms,
and upper torsos are still in silhouette, but
there is an attempt to render the features of
the sharply drawn profile faces as well as the
strands of hair. The women's skirts, outlined
on the light ground, are patterned alternately
with dots and cross-hatching.

Black hook-spirals on the upper part of the
vase's shoulder are the only orientalizing ele-
ment to appear on the body of the vase. Below
these the linear decoration is repetitive, closely
packed, and confused. The single figure in
the central panel of the handle zone, a grazing
deer, belongs to an old type that disappeared
after 700 B.C.

The plastic snakes at the base of the neck
and on the lip are chthonic symbols that in-
dicate the funerary use of the vase.

Bibliography
BCH 77 (1953): 191, pls. 33b, 34.
G. Bakalakis, "Protogeometrische Hydria," *AM*
76 (1961): 65, pl. 38.

 M. P.

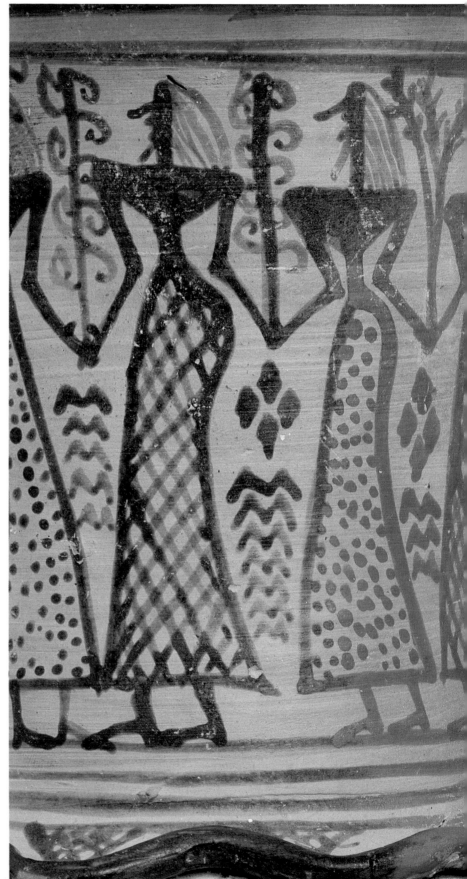

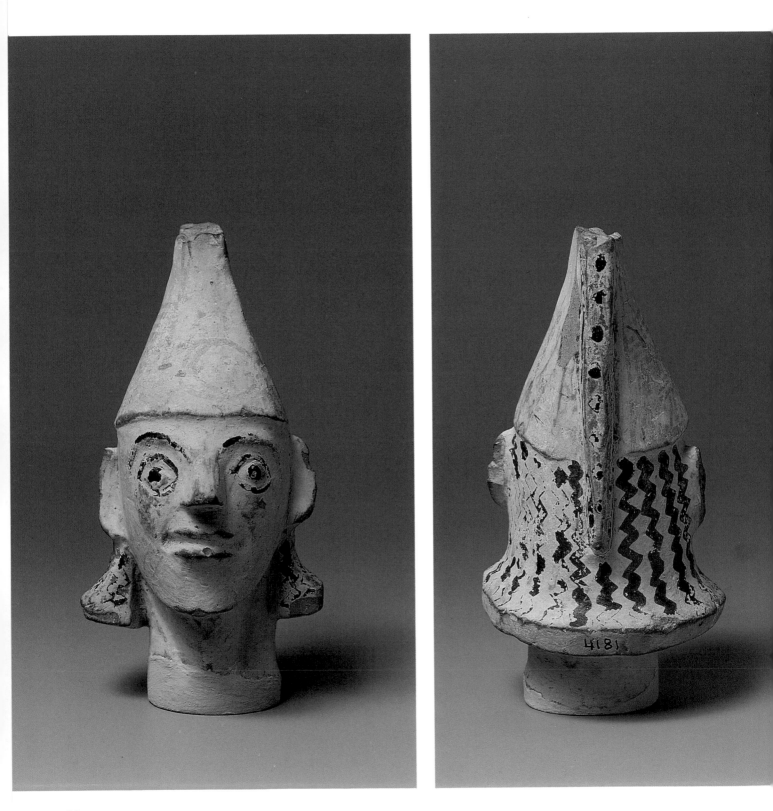

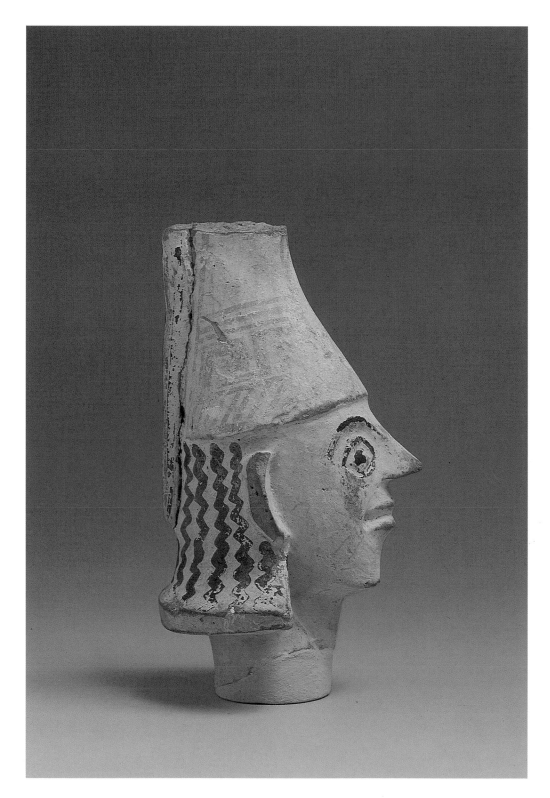

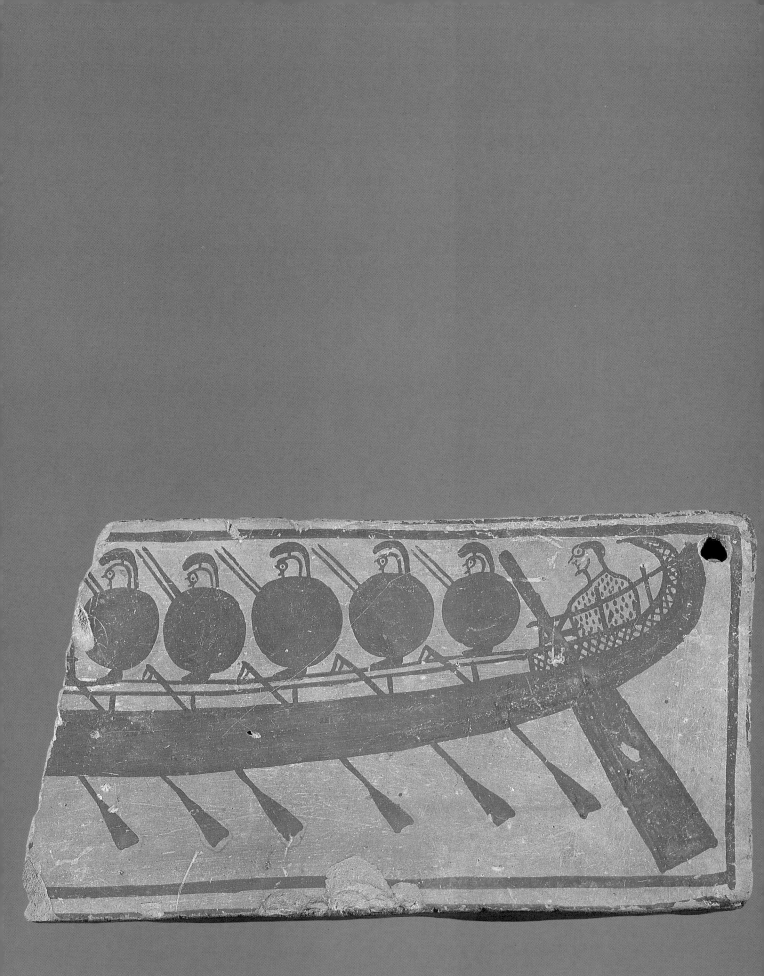

18

Fragment of a Clay Plaque

Found at Sounion
Protoattic, c. 700 B.C.
7 x 12 (2¾ x 4¾)
Athens, National Archaeological Museum,
 14935

In the turbulent period at the beginning of
the seventh century B.C., when political life
was being drastically reorganized, naval su-
premacy played a highly significant role. This
plaque by the so-called Analatos Painter shows
a warship with a complement of armed men:
five helmeted warriors with spears, shields,
and oars are on deck, while the helmsman sits
in the stern with a large steering oar. The
plaque was dedicated in the sanctuary of
Athena at Sounion, an expression of hope or
thanks by the donor for a favorable outcome
of the conflict.

 Despite its simplicity and abbreviated ren-
dering, the picture gives valuable information
about warships and the men who manned
them. It is one of the more eloquent testi-
monials to the conditions at the beginning of
the Archaic period.

Bibliography
B. Staes, "Souniou Anaskaphai," *ArchEph* (1917),
208–209, fig. 19.
J. S. Morrison and R. T. Williams, *Greek Oared
Ships* (Cambridge, 1968), 73, pl. 8b.
H. Abramson, "A Hero Shrine for Phrontis at
Sounion?" *California Studies in Classical Antiquity*
12 (1979): 4, pl. 1, fig. 1.

 I. T.

19

Clay Cup with High Fenestrated Conical Base

Found in Athens (Kerameikos excavations)
Attic, c. 680 B.C.
Height 17 (6⅝)
Athens, Kerameikos Museum, 1153

In contrast to the preferred scenes of *prothesis*
(lying in state) (see cat. 11) and *ekphora* (fu-
neral procession) on large Geometric style
craters and amphoras from the Dipylon cem-
etery, the scene on the cup from the Kera-
meikos lifts us to a higher intellectual plane.
The dead man, conceived as a hero in the
afterlife, is shown riding a horse. Enclosed in
a panel that separates him from the earthly
world, he receives expressions of reverence
and friendship from his bereaved friends,
whose gestures convey both despair and awe.
The thin limbs of the figures project from
beneath short tunics or shields, bringing to
mind the saying that describes man as "all
arms and legs."

Bibliography
K. Kübler, *Kerameikos* VI,2. *Die Nekropole des spä-
ten 8. bis frühen 6. Jahrhunderts* (Berlin, 1970),
422–423, pl. 7.

 I. T.

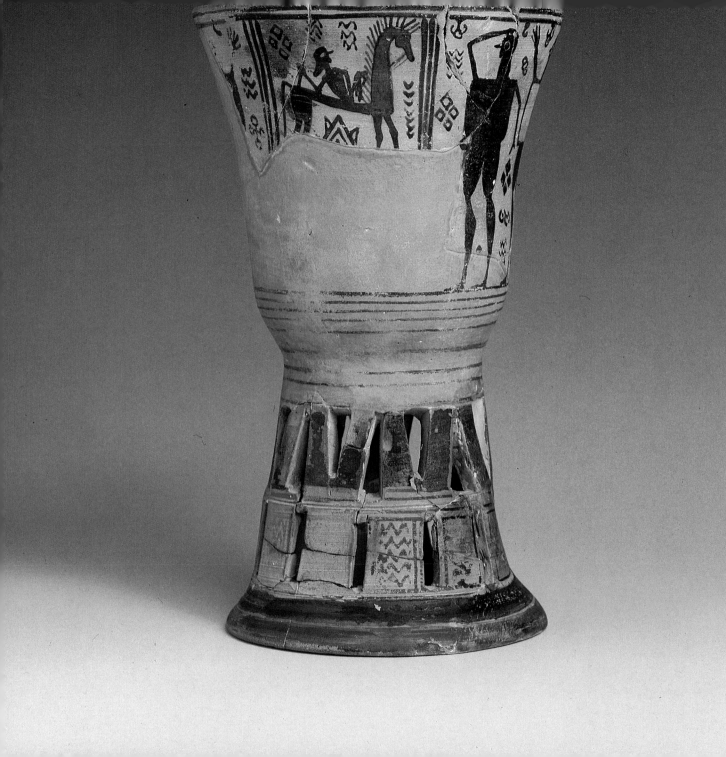

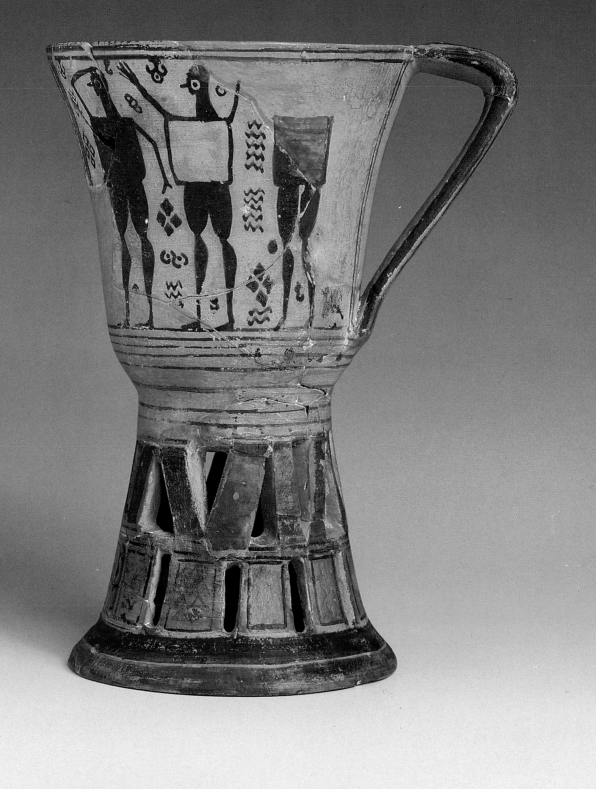

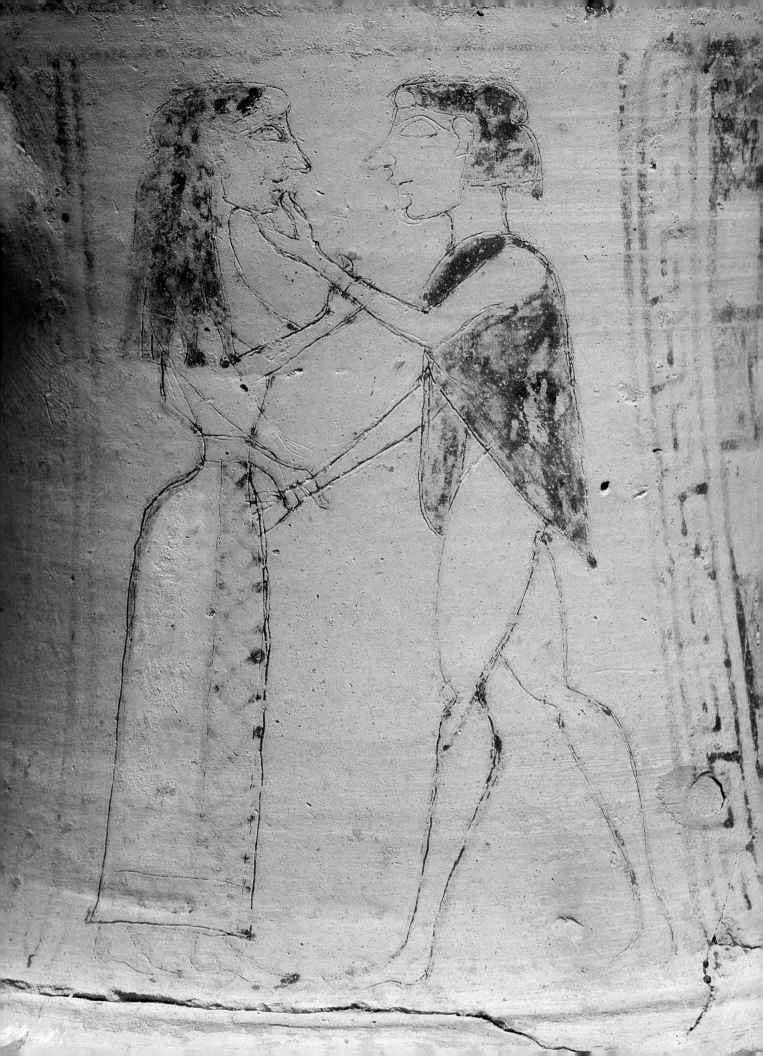

20

Oinochoe

From Tomb L at Arkades, Crete
675–640 B.C.
Height 31.8, diameter 26 (12½ x 10¼)
Herakleion Museum, 6971

This vase from Crete is one of the rare examples of vase painting from the so-called Daedalic period that forms the basis and framework for elements that compose Archaic art. It preserves, among other things, a unique love scene, depicted on the neck of the vase and framed by a meander, in which a young man caresses the face of his sweetheart as she tenderly holds his wrists. The figures have been called Theseus and Ariadne, but no inscription confirms the identification. The emotional charge and the warmth of this depiction of a universal human relationship give the work a characteristic immediacy.

The figures are rendered in outline for the most part, a technique that Protoattic vase painters adopted in the same period and used for nearly a century. This simple means of describing the figures gives them substance, roundness, and life, yet also severity and sure articulation.

Bibliography
P. Demargne, *The Birth of Greek Art* (New York, 1964), frontispiece and fig. 443.
Ancient Crete, A Hundred Years of Italian Archaeology (1884–1984) (Rome, 1984), 170–172, with bibliography.

N. K.

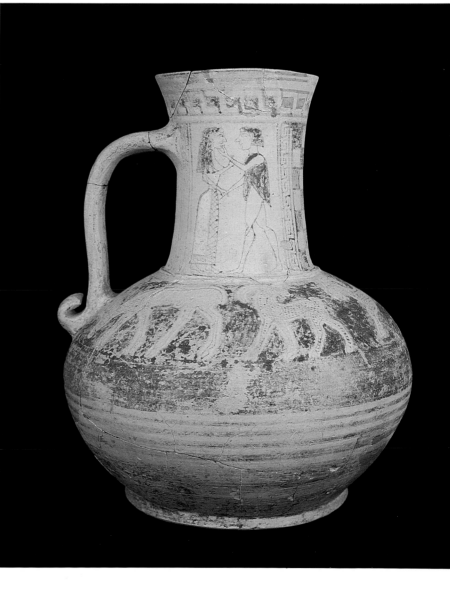

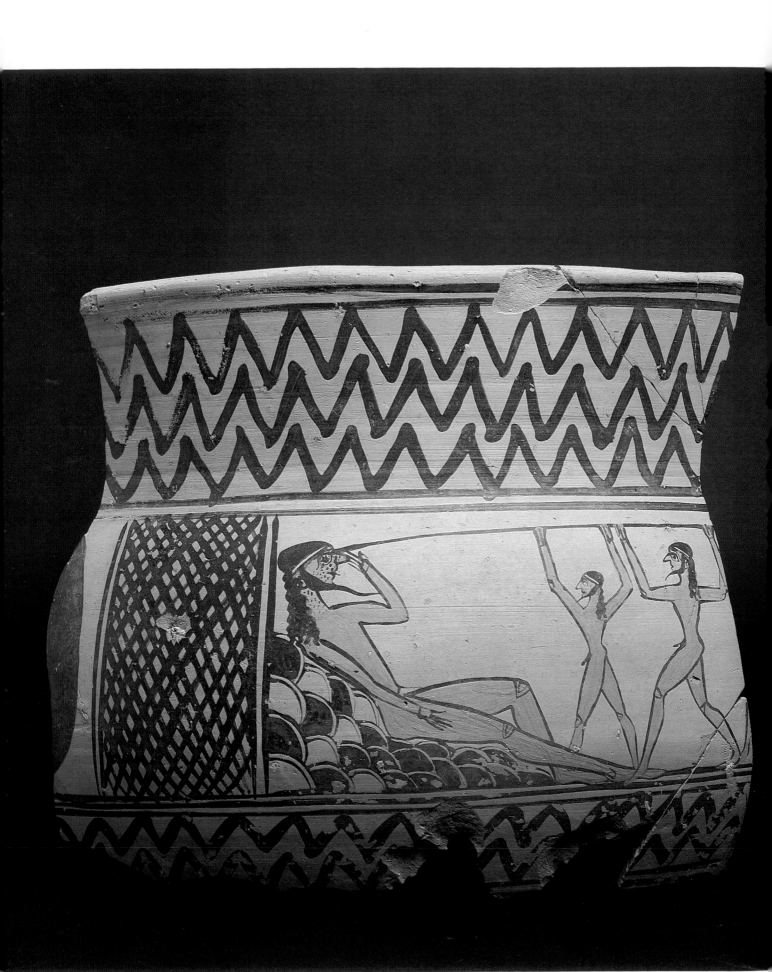

21

Fragment of a Clay Vase

Found in Argos in 1952
Middle of the seventh century B.C.
31 x 25 (12⅛ x 9⅞)
Argos, Archaeological Museum, C 149

Nearly all Greeks were brought up on the stories of Odysseus. Thus it is not surprising that the wanderings of this mythical king of Ithaca form the basis of many scenes painted on vases from early times. On this fragment, Odysseus and his men, held captive by the Cyclops Polyphemus, son of Poseidon, seize their one chance to escape by driving a sharpened pole into the single eye of the unsuspecting giant as he rests on his back in the depths of his cave. The panel is bordered above and below by zigzags and on one side by cross-hatching.

The schematic rendering of figures in this dramatic scene, using only outline, compares with the achievements of Attic workshops, while the use of polychromy in rendering rocks and bodies recalls Cycladic vase painters.

Bibliography
BCH 77 (1953): 265, fig. 58.
P. Courbin, "Un fragment de cratère protoargien," *BCH* 79 (1955): 1–49, figs. 1–4.
M. Robertson, *A Shorter History of Greek Art* (Cambridge, England, 1981), 13, 15, fig. 17.

I. T.

22

Clay Oinochoe

Found in a sanctuary at Colonna on Aegina
in the 1890s
Protoattic, perhaps from an Aeginetan
workshop, mid-seventh century B.C.
Diameter 22.5 (8⅞)
Aegina, Archaeological Museum, 1754

Though fragmentary, this unique oinochoe is an excellent example of the second phase of the Orientalizing style, in which white paint was added to figures drawn in black outline (the Black and White Style). The technique was first mastered by vase painters in Corinth and was then taken over by Athenian artists in Protoattic and later vase painting.

The artist who painted this vase filled the large frieze that runs around the shoulder with a mythical narration, a scheme adopted by Athenian vase painters in this period and in subsequent periods. Depicted here is the celebrated scene from Homer's *Odyssey* of the escape of Odysseus from the cave of Polyphemus after he had blinded the drunken giant (see cat. 21). Odysseus, featured in the main position on the jug opposite the three-lobed handle, clutches the underside of a great ram to avoid detection by Polyphemus, who passed his hands across the backs of the sheep as they left his cave to graze. Two other companions, portrayed on a smaller scale, use the same ruse to accompany him. All of the men

are depicted naked. What look like belts, bracelets, and anklets can also be interpreted either as anatomical details or as ropes with which they secured themselves to the sheep.

The figures have a primitive simplicity and power, and the drawing shows astonishing ease and assurance. This inspired, innovative artist illustrated the story by focusing on a vivid and dramatic element of the myth. In rendering his narrative, he completely ignored the base of the handle, which interrupts the picture field.

He depicted the rams with elongated heads and bodies and with large hooves and long tails. The heads are defined in outline technique, while the bodies are covered with parallel woolly lines; the legs and tails are completely black. The faces of the heroes have heavily lined eyebrows and pronounced noses, and their long hair is solid black. This is all characteristic of the style of the Ram-Jug Painter, as the artist is called from this vase.

The artist has also filled empty spaces with ornament, but without crowding the picture: radial dot rosettes, multiple lozenges, dotted triangles, and hook spirals, all characteristic of his style. On the flaring neck two decorative zones are set off by units of horizontal lines; in one are alternating black and white lozenges, and in the other is a meander. Incised lines, used in developed black-figure vase painting to outline figures and give interior details, are absent on this vase.

Bibliography
J. M. Cook, "Protoattic Pottery," *BSA* 35 (1934–1935): 189, pl. 53.
J. D. Beazley, *The Development of Attic Black-figure*, rev. ed. (Berkeley, 1986), 8–9, pl. 9, figs. 1–2.
S. P. Morris, *The Black and White Style: Athens and Aigina in the Orientalizing Period* (New Haven and London, 1984), 51–53, 123, no. 4, pl. 10, with bibliography.

D. T.

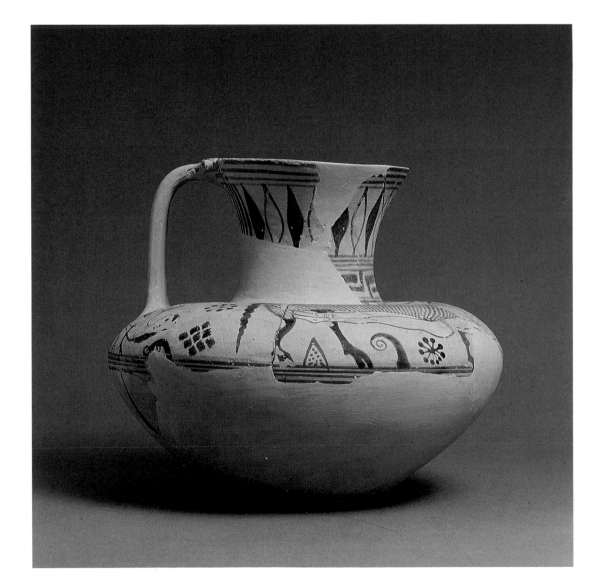

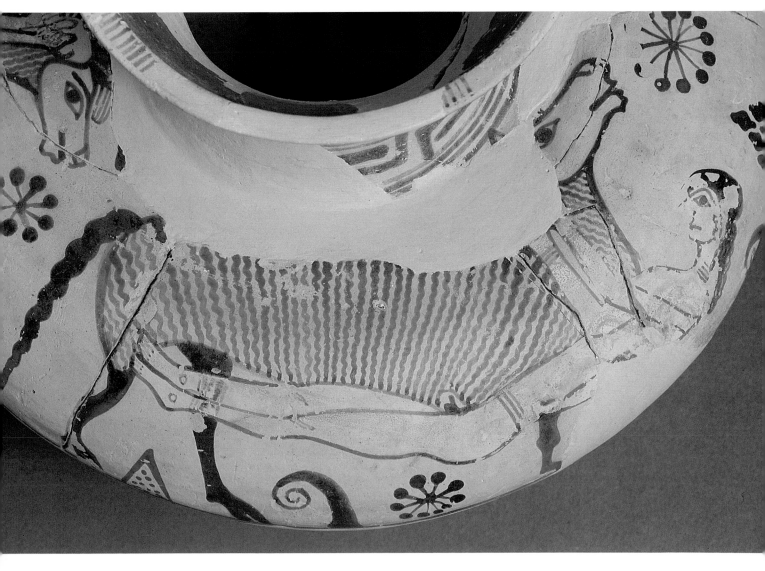

23

Terracotta Statuette of a Mourning Woman

Found on Thera (excavation of the Sellada
 cemetery) in 1896
Last quarter of the seventh century B.C.
Height 31 (12⅛)
Thera, Archaeological Museum, 392

This statuette, from a cremation place in the
cemetery of Sellada, is preserved in excellent
condition. Painted only on the front, the fig-
ure wears a black dress, belted at the waist;
the eyelashes, eyebrows, pupils of the eyes,
and the hair on the top of the head are like-
wise black. The skin of the face and arms is
white.
 Like the similar figure from Boeotia in cat.
24, the lower body of this statuette is wheel-
made, while the upper part is made by hand.
The head was formed using a mold.

Bibliography
Greek Art of the Aegean Islands, 139, no. 87, with
bibliography.

I. T.

24

Terracotta Statuette of a Woman

From Boeotia
Boeotian, c. first quarter of the sixth
 century B.C.
Height 15 (5⅞)
Athens, National Archaeological Museum,
 4157

Greek artists who modeled in clay, a medium
closely related to sculpture, produced many
vivid creations that reflect daily life and hu-
man emotions. The female figurine shown
here, dressed in a long black chiton tightly
bound at the waist, raises both hands to her
head in a gesture of despair, mourning for
her lost loved one—an unusually naturalistic
rendering of bereavement. The bell-shaped
bottom part of the statuette is wheel-made,
while the head, arms, and trunk were fash-
ioned by hand. Eyes and arms were painted
white, the face red, and the thick hair ocher.

Bibliography
Richter, *Korai*, 33, figs. 86–89.

I. T.

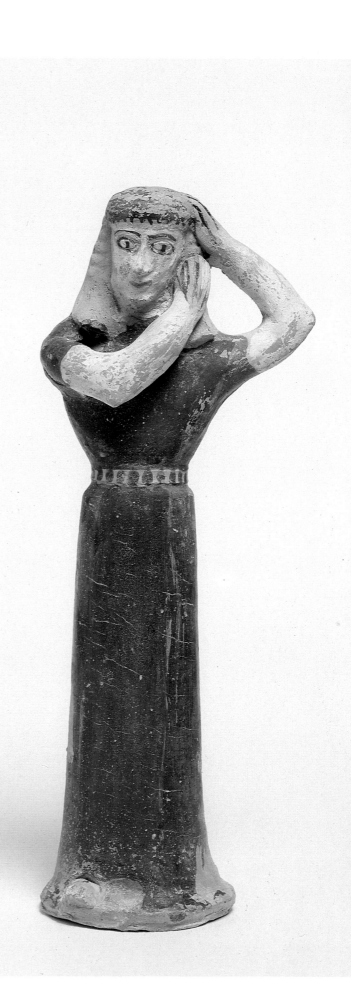

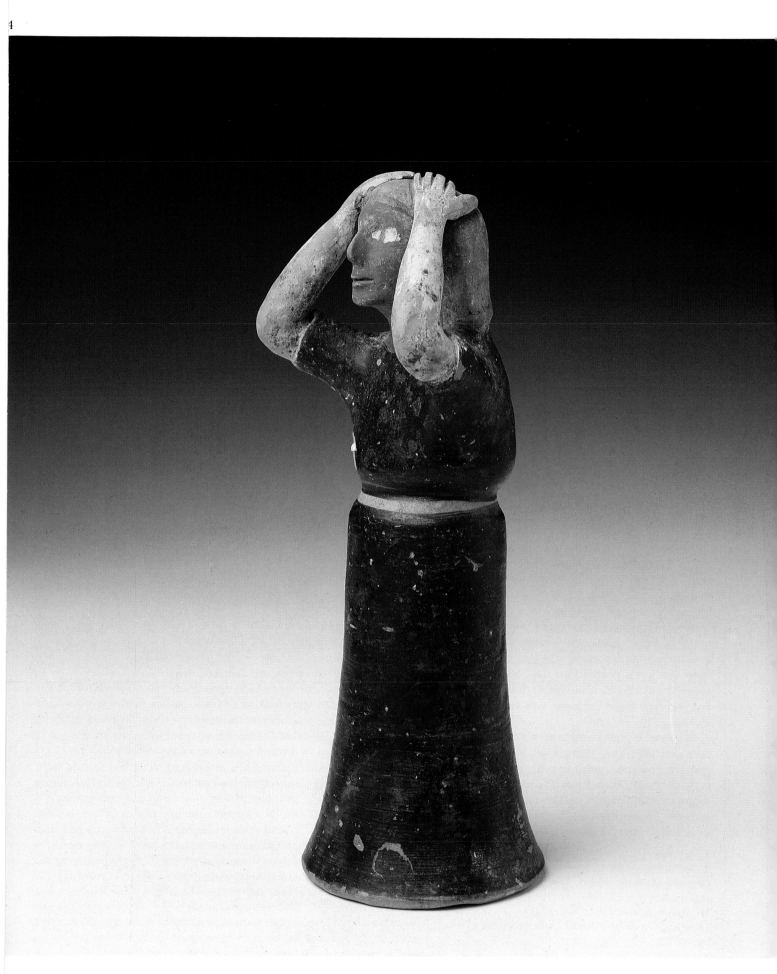

27

Clay Polychrome Plaque

Found in Athens (at the northwest foot of
 the Areopagus) in 1932
Attic, mid-seventh century B.C.
24.8 x 13.3 (9¾ x 5¼)
Athens, Agora Museum, T 175

This plaque, found buried with other objects
in a deposit of votive offerings, takes us into
the realm of mid-seventh-century B.C. cult
practice. Meant for display, it has two holes
for suspension in its upper corners. Front and
back a white slip covers the yellowish clay, and
on the front, which has a secondary coating
of dilute red, a female figure is depicted with
upraised arms, palms open. Only the head
and neck have been molded; the rest of the
figure is painted. White, red, green, and yel-
low polychromy makes a lively and cheerful
impression. This manner of decoration is
known in earlier Cretan orientalizing vases,
but for Attica in this period it is a novelty.

The figure wears an inner and an outer
garment belted at the waist. Above the waist
the red inner garment is seen at the left, dec-
orated with two sets of blue-green stripes; be-
low the waist it appears at the right decorated
with blue-green stripes, circles, and rows of
dots. The yellow outer garment appears at
the right above the waist and on the left below;
it is patterned with dot rosettes above the waist,
stripes, dot rosettes, and a hooked spiral be-
low the waist, all in red. One can imagine the
outer garment as a cloak with one end draped
over the left shoulder and passing diagonally
across the back to be caught up under the belt
in front. The representation of the garments
in this curious patchwork aims at decorative
effect rather than at reality.

The figure's red hair, arranged in short
curls over her forehead below a diadem and
in wavy tresses reaching her shoulders on both
sides, shows the typical coiffure of the Middle
Daedalic period. The triangular face with
arched eyebrows is dominated by almond-
shaped eyes with blue-green irises and red
pupils. In profile the face is reminiscent of
the heroes' faces on the Ram Jug (cat. 22); in
fact, the style as a whole, including the dec-
orative motifs, is characteristic of Middle Pro-
toattic art under eastern influence and recalls
the prime work of the Ram Jug Painter.

The figure is flanked by rearing snakes:
the one on the left is red with blue-green dots,
shown in a field of three-petaled flowers; the
one on the right is blue-green with red dots
accompanied by dot rosettes. The woman's
frontal pose with upraised arms and the pres-
ence of snakes recall the attitude of epiphany
of a divinity that is well known from Minoan
and Mycenaean art. The evidence is not suf-
ficient to identify the figure with a known
divinity, but the deposit where it was found
and the presence of snakes suggest that she
must be connected with some chthonic cult,
perhaps the Semnai (august goddesses), later
known as the Euminedes (kindly goddesses)
whose sanctuary was discovered near where
this plaque was found.

Bibliography
D. Burr, "A Geometric House and a Proto-attic
Votive Deposit," *Hesperia* 2 (1933): 604–609, no.
277, figs. 72–73.
E. Brann, *The Athenian Agora*, Vol. 8, *Late Geo-
metric and Protoattic Pottery* (Princeton, 1962), 87,
no. 493, pl. 30.
J. N. Coldstream, *Deities in Aegean Art before and
after the Dark Age* (London, 1977), 3–19, espe-
cially 14.

D. T.

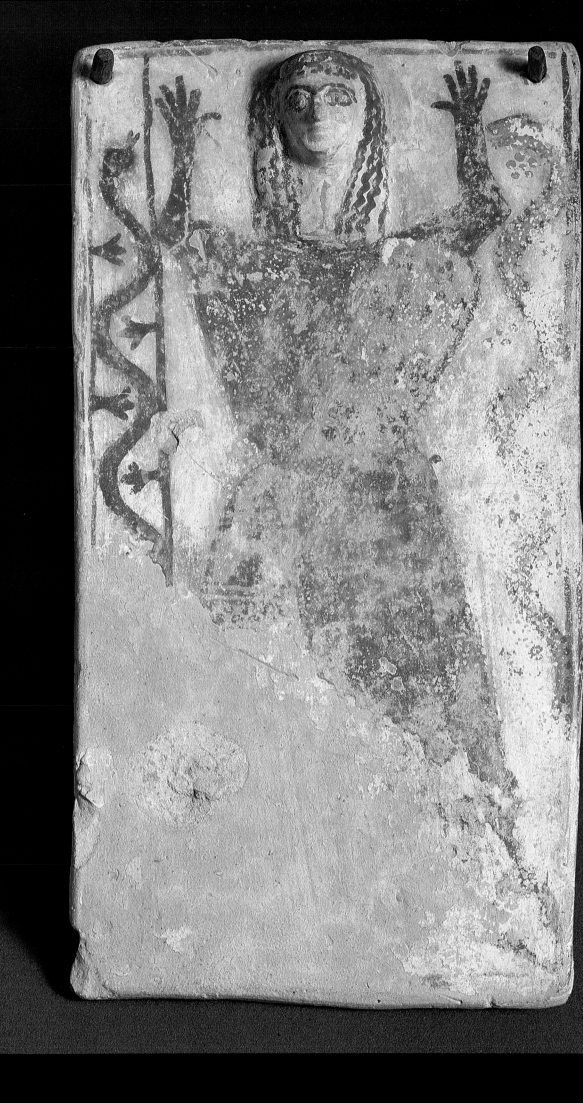

29

Fragment of a Poros Relief

Found in Mycenae in 1886 and 1897
Around 630 B.C.
Height 40 (15¾)
Athens, National Archaeological Museum,
 2869

One of the relatively few works of stone sculp-
ture from the period that created the style
known as Daedalic, this small Peloponnesian
relief belongs to the mature phase of the style.
According to the prevailing opinion, this re-
lief and three other fragments come from
metopes that would have decorated the tem-
ple of Athena built on the acropolis of My-
cenae around the second half of the seventh
century B.C.

The female figure, which probably repre-
sents a goddess (Hera?), or perhaps a heroine
(Helen?), is depicted with her head frontal
and her body turned slightly to the left. Her
right arm draws forward a mantle that covers
her head.

The geometric severity is accentuated even
more by the arrangement of the hair, which
creates a trapezoidal frame for the face. Yet
the vitality of youth shines through in the fine
features, the subtly varied planes of the face,
the open nostrils and the faint smile—a fore-
runner of the Archaic smile—that blossoms
on the lips.

Bibliography
R. J. H. Jenkins, *Dedalica* (Cambridge, England,
1936), 45–50, pl. 6, fig. 7.
Richter, *Korai*, 32, no. 19, fig. 84.
Boardman, *Greek Sculpture*, fig. 35.

 N. K.

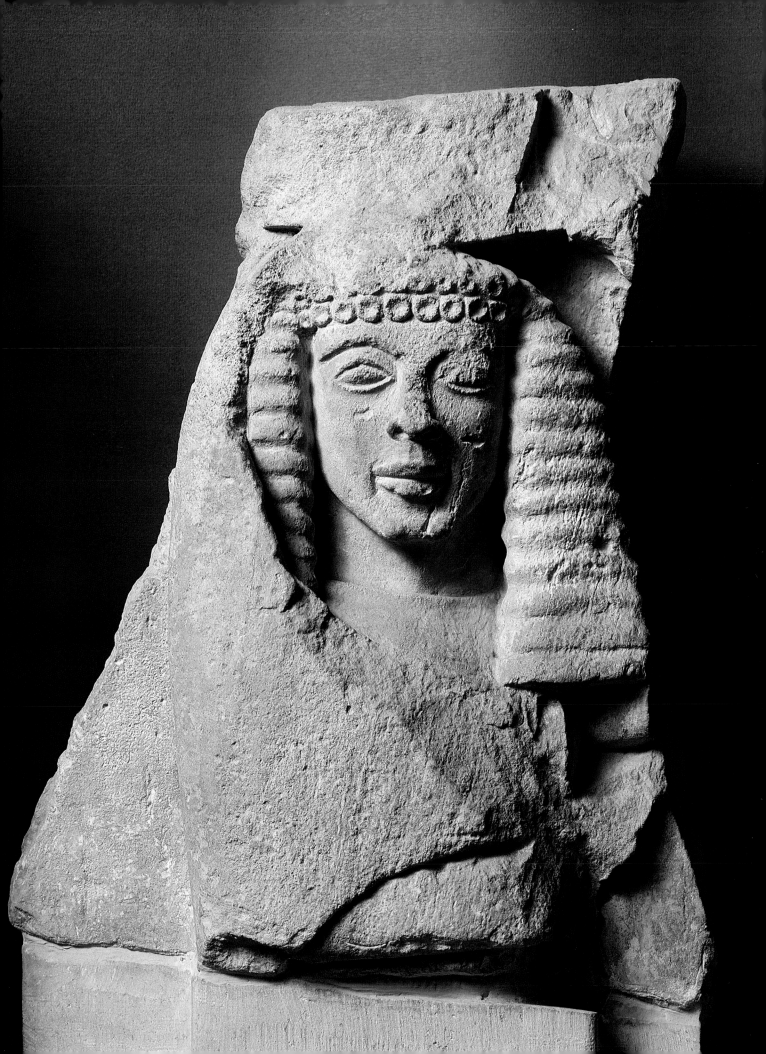

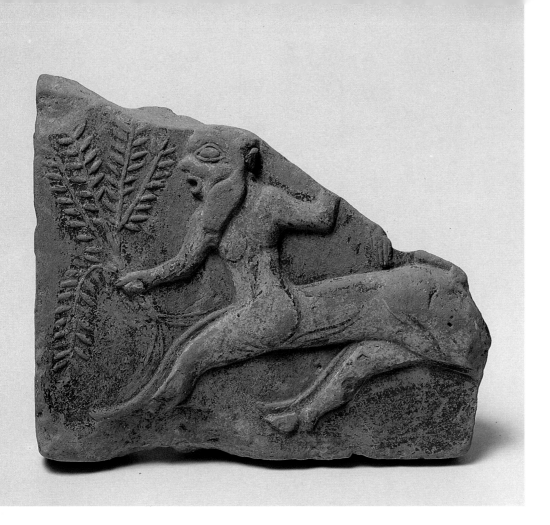

30

Fragment of a Terracotta Sima

Found on Thasos (in the settlement behind
the Silene Gate) in 1971
Thasian workshop, c. 560–550 B.C.
24 x 28 (9½ x 11)
Thasos, Archaeological Museum, 71-3295:
P 6641

Thasos, a colony of Paros, succeeded in be-
coming one of the richest and most populous
areas of Greece, thanks to its development of
industry and trade. The comfort, sensitivity,
and subtlety of Thasian society is reflected in
all sectors of its art, especially in the archi-
tectural remains, which are preserved on the
island and which show the influence of the
Aeolians of Asia Minor.

This fragment of a terracotta *sima* belonged
to the decorative architectural members of
the roof of some building. It has been sug-
gested that this may have been the polygonal
building in the sanctuary of Heracles, the pro-
tector of the city; however, the suggestion is
perhaps vitiated by the fact that it was found
some distance from there and that the struc-
ture had a *sima* with riders, close in style and
date to the Bellerophon antefixes from the
same building. Its theme must be the struggle
of the hero Heracles with the centaurs when
they attacked him with sticks and stones dur-
ing his visit to the cave of Pholos.

Two centaurs, full of passion and intensity,
are shown running at full gallop, their feet
not even touching the ground (only the front
legs and a small part of the body of the second
centaur are preserved). The better-preserved
centaur, with his disproportionately large, al-
most round head, enormous eye, thick nose,
and fleshy lips, seems to be endowed with all
of his wild, bestial, and primitive nature. He
brandishes an uprooted shrub with his right
hand, while he menacingly raises his left. One
can almost hear the loud yells from his wide-
open mouth.

This *sima*, with its variety of colors (reddish
brown, white, purplish red) and the liveliness
of the representation, is an admirable and
impressive example of the artistic sensitivity
and individuality of the artists of this north-
ern Greek island.

Bibliography
Greek Art of the Aegean Islands, 207, no. 165.
B. Holtzmann, "Une nouvelle sima archaïque
de Thasos," *BCH* suppl. 5, *Thasiaka* (1979),
1–9.

R. P.

110

Clay Aryballos

Found in Tanagra, Boeotia, in 1888
Corinthian, attributed to the Otterlo
 Painter, c. 590 B.C.
Height 14 (5½)
Athens, National Archaeological Museum,
 969

Already by the beginning of the seventh century B.C., the small Greek city of Corinth had succeeded in developing commercial relationships with all the then-known world, thanks to a strong system of government and a favorable geographical location. Examples of its pottery, made from the characteristic yellowish clay, reached as far as Egypt, the Near East, the Black Sea, Illyria, and the West.

The aryballos was a representative type of small Corinthian vase designed for perfumes and scented oils. The artist who painted the vase shown here, quite inventive, dared to cover almost the entire surface of the spherical body of the vase with the immense confronting heads of two bearded male figures. He made liberal use of purplish red paint, alongside and over brownish black, especially for the faces of the figures. He also employed incision for outlines and some details. In an attempt to produce portraits, he distinguished between the heads, making the eye of the figure on the right larger, his nose longer, and his beard shorter. Particularly striking is the rendering of certain details, such as the sockets of the large, expressive eyes, the fine, arched eyebrows, the deep cleft in the nostril of the right-hand figure, and the small spiral forms, an ultimate stylization of the ears, high up on the head. Fillets that bind the men's long wavy hair complete the overall effect.

Aquatic birds and rosettes fill the empty spaces of the picture. The painter of the vase, called the Otterlo Painter after another work of his in Otterlo, Holland, was a Corinthian artist with a versatile and lively genius, often traditional though sometimes quite innovative. He preferred human figures and was fond of detail.

Bibliography
H. Payne, *Necrocorinthia* (Oxford, 1931), cat. 844.
CVA Athens 2, pls. 2.1, 2.2, 2.6, 2.7.
J. L. Benson, "A Floral Master of the Chimaera Group: The Otterlo Painter," *Antike Kunst* 14 (1971): 15, no. 20, pl. 2, fig. 9, with bibliography.

R. P.

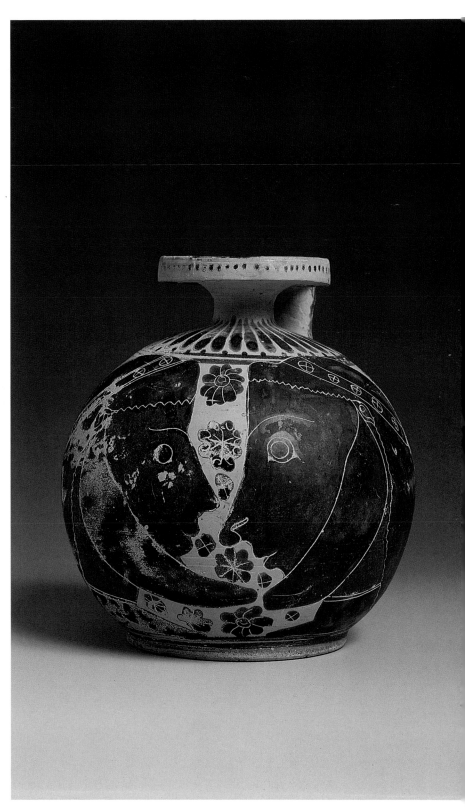

Terracotta Figurine of a Horseman

Found in Tanagra, Boeotia
Boeotian, sixth century B.C.
Height 26 (10¼)
Athens, National Archaeological Museum,
 4017

Makers of terracotta figurines (coroplasts) in
the Geometric period produced a large num-
ber of horsemen, both as additions to vases
and as freestanding creations. Some were used
as funerary objects, others as votive offerings.
In the Archaic period, to which the Tanagra
rider belongs, the descendants of the Geo-
metric equestrians reach an artistic peak, an-
imated by naturalistic rendering of volume
that is combined with lively painted decora-
tion. Certain details, such as eyes and mouth,
are emphasized by incised lines. These fig-
ures, popular throughout Greek lands, sig-
nified power, social standing, and prosperity.

Bibliography
P. Jamot, "Terres cuites archaïques de Tan-
agre," *BCH* 14 (1890): 221, pl. 13.

I. T.

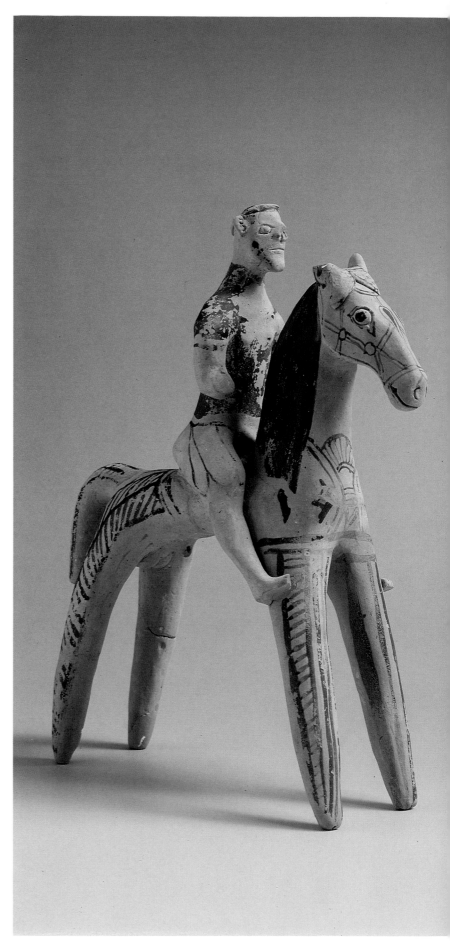

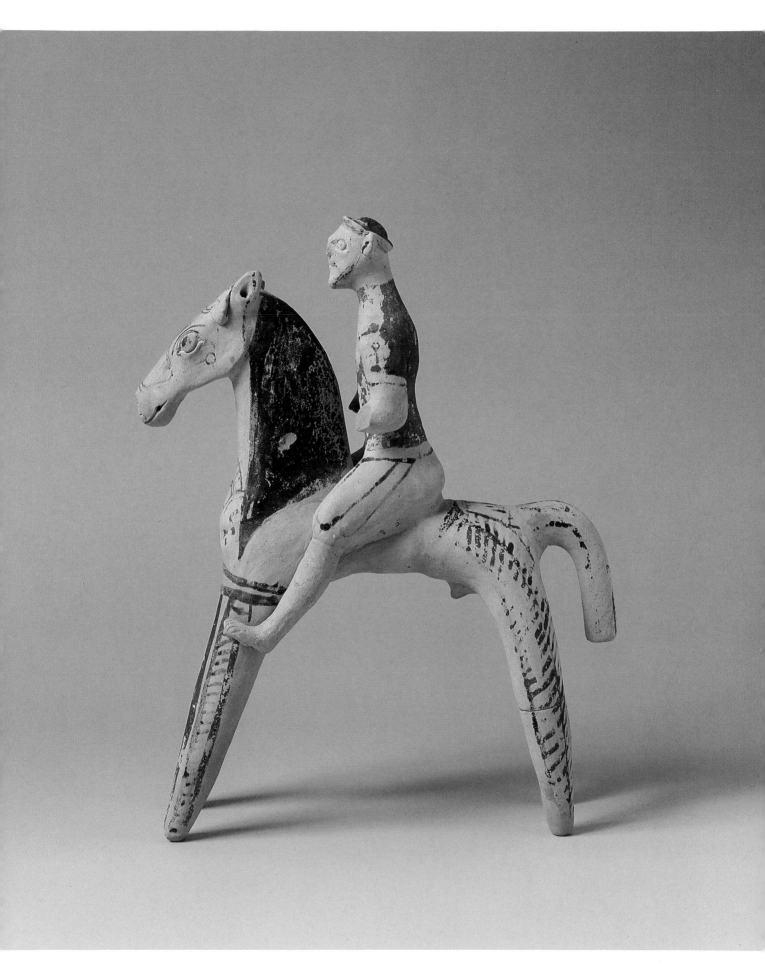

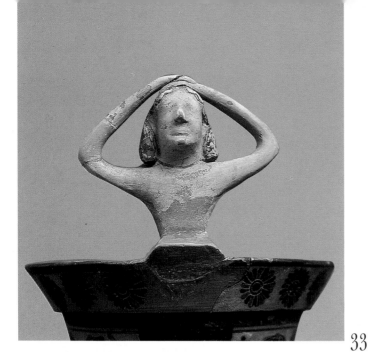

33

Clay Loutrophoros

Found in Athens (Kerameikos excavations)
Attic, attributed to the KX Painter,
 beginning of the sixth century B.C.
Height to rim 47 (18⅜)
Athens, Kerameikos Museum, 2865

A work by the so-called KX Painter, this lou-trophoros, a type of funerary vase made for young girls who died before marriage, is slender and elegant in contour, and provides an interesting example of early Athenian black-figure style. The artist contrasted the shiny black of the figures with the added red paint, and accentuated outlines and inner details by means of incision. The vase, fairly complete although restored from fragments, was found in the Kerameikos cemetery.

The decoration, in horizontal bands covering the entire surface of the vase, has a disarming simplicity and an abundance of themes and decorative motifs: processions or heraldic groups of birds, animals, mythical creatures, and floral elements. At the top of the vase is a tall frieze of mourning women who, with unbound hair and gestures of despair, lament their lost loved one. The funerary nature of the vase is further emphasized by the two clay protomes of mourners attached to the lip.

Bibliography
Deltion 19 (1964): Chronika, 41–42, pl. 37.
J. D. Beazley, *Paralipomena: Additions to Attic Black-figure Vase-painters and to Attic Red-figure Vase-painters, 2nd ed.* (Oxford, 1971), 15.

I. T.

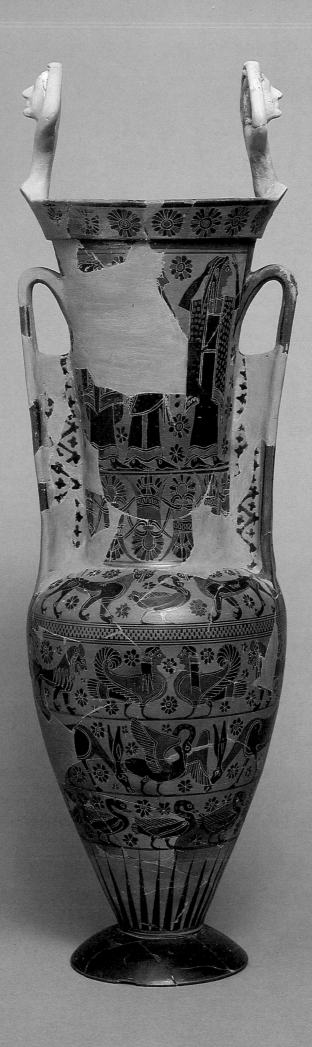

34

Clay Skyphos

Found in Athens (Kerameikos excavations)
Attic, beginning of the sixth century B.C.
Height 11.4, diameter 16 (4½ x 6¼)
Athens, Kerameikos Museum, 2869

At the beginning of the sixth century B.C., Attic pottery workshops found their true direction, although they remained to some extent under Corinthian influence. This skyphos (bowl for drinking wine) is attributed to the circle of the gifted KX Painter. It provides an interesting example of its type despite the poor state of preservation. The scene of revelry on it shows dancers with wine cups and a lyre. The black figures are embellished with red and incised outlines. At the bottom of the vase a painted ray pattern forms the transition from body to base.

Bibliography
Deltion 19 (1964): Chronika, 41–42, pl. 38c.
J. D. Beazley, *Paralipomena: Additions to Attic Black-figure Vase-painters and to Attic Red-figure Vase-painters, 2nd ed.* (Oxford, 1971), 15.

I. T.

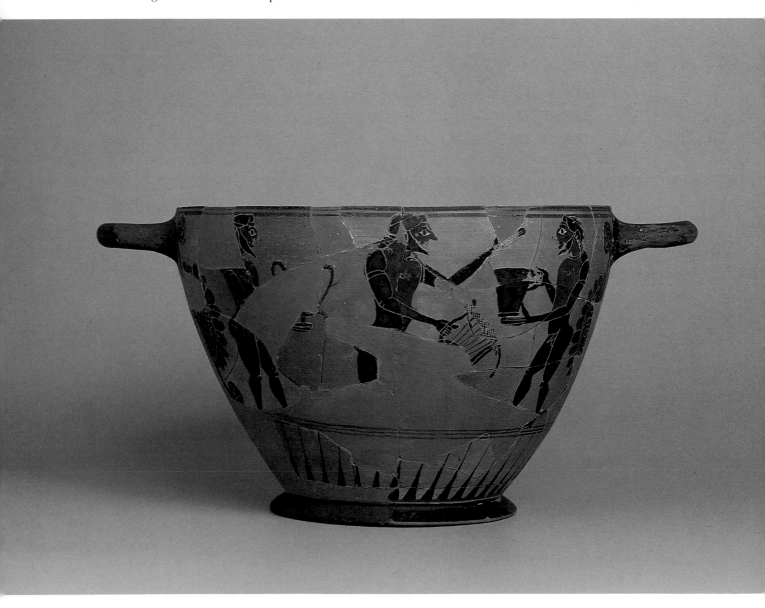

Hammered Bronze Relief

Found in Olympia (site of the new
 museum) in 1959
Probably Samian, c. 570 B.C.
31.3 x 15 (12¼ x 5⅞)
Olympia, Archaeological Museum, BM 77

The style of the figured decoration suggests
the hand of an artist trained in East Greek
workshops, probably a Samian. With great
artistic skill and unique narrative ability, he
has succeeded in presenting three different
myths on the small surface of this sheet by
dividing it with relief bands into three met-
opes or panels.

Only the lower halves of three figures on
the upper panel survive, two male and one
female, making it difficult to identify the sub-
ject represented.

The central panel illustrates the death of
Clytemnestra from the mythical cycle of the
sons of Atreus. A female figure, Electra, stands
at the left, encouraging her brother Orestes
to complete the terrible deed he has under-
taken. At the center of the composition their
mother, Clytemnestra, has already received
the blow from the sword of her avenging son,
and her knees are starting to give way. To the
right, in front of a wall indicated by incision,
another male figure, perhaps Orestes' com-
panion Pylades, or more probably Aegisthus,
looks over his shoulder as he flees from the
tragic scene.

On the bottom panel the duel between
Achilles and Penthesilea shows the Amazon
queen succumbing to the hero's deathblow.
At the right, two female figures look on.

This sheet must have been part of the
sheathing of a wooden box, as suggested by
the holes for nails.

Bibliography
Greek Art of the Aegean Islands, 185, no. 148, with
bibliography.
K. Schefold, *Myth and Legend in Early Greek Art*
(London, 1966), 95, pl. 80.
M. Andronicos, M. Chatzidakis, V. Kara-
georghis, *The Greek Museums* (Athens, 1975), 211,
fig. 24.

N. K.

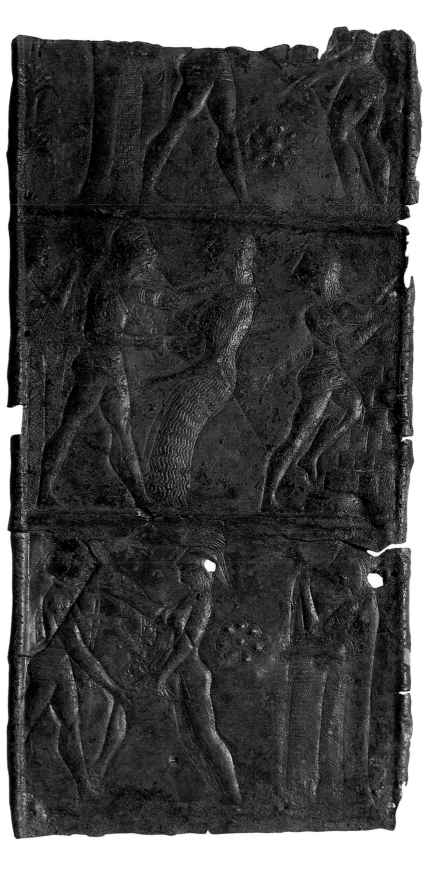

36

Black-Figure Siana Cup

Found in Corinth
Attic, attributed to the Taras Painter, c. 560 B.C.
Height 13.9, diameter 26.6 (5½ x 10½)
Athens, National Archaeological Museum, 530

Corinth was a worthy competitor of Athens in the production and exportation of clay vases, flooding the markets of the entire eastern Mediterranean world with masterpieces, especially miniature vases, throughout the seventh century B.C. By the beginning of the sixth century, Corinthian workshops had standardized the decorative schemes, and it was Athenian potters and painters who gradually took the lead, producing extraordinary works in the black-figure style.

This kylix (drinking cup) is a fine example of the type called Siana cup, after the place in Rhodes where the first examples were found. It is attributed to the Taras Painter, so named because of the exceptionally large number of his cups that were exported to Taras (modern Taranto).

The procession of horsemen on the exterior shows the skill of the artist in harmonizing the placement of the figure scene with the shape of the vase. The type is called an overlap cup because the figures overlap the change of profile from the convex body to the concave lip. Here the painted band that marks the change in shape sets off the heavy bodies of the horses from their necks and the strong thighs of the riders from their slender arms and torsos. At the same time it underlines the regularity of this trained cavalcade of young Athenian aristocrats.

The figure of Hermes running in the tondo inside the cup is a skillful miniature painting. Running figures were a favorite for these circular spaces because of their wheel-like motion.

Bibliography
J. D. Beazley, *Attic Black-figure Vase-painters* (Oxford, 1956), 54, no. 57.
H. A. G. Brijder, *Siana Cups I and Komast Cups* (Mainz, 1983), 250, no. 150, with bibliography.

N. K.

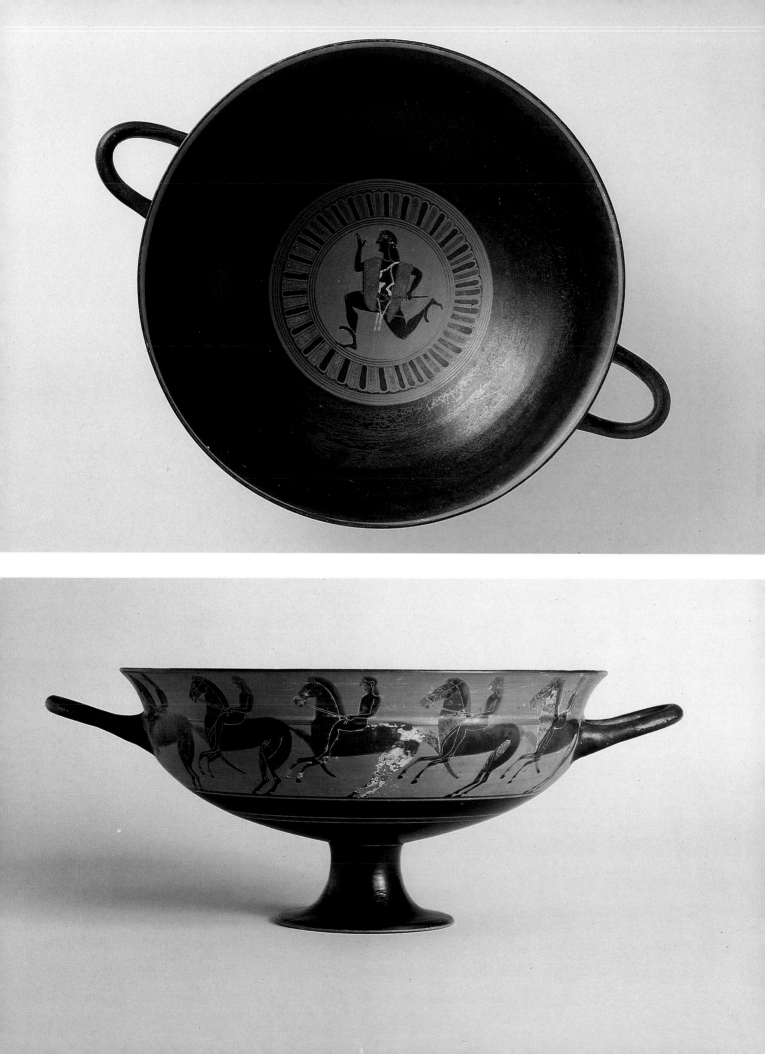

37

Clay Dish

Provenance unknown
Around 570 B.C.
Height 1.5, diameter 9.5 (⅝ x 3¾)
Athens, National Archaeological Museum,
 628

The association of the human figure and the horse, best-loved companion among animals, is depicted on the tondo of this dish with particular success. One of the pair of riders wears a crested helmet and carries two spears; the other has a soft, peaked cap. Incision accen-

tuates the outlines of men and horses, while added red color on the mane, helmet, and cap produces a pleasant transition from the black of the bodies to the terracotta background. The ring-shaped base at the bottom of the dish is decorated with concentric circles in purple paint against the natural color of the clay.

Bibliography
M. Collignon and L. Couve, *Catalogue des vases peints du Musée National d'Athènes* (Paris, 1902), 278, no. 856.

I. T.

120

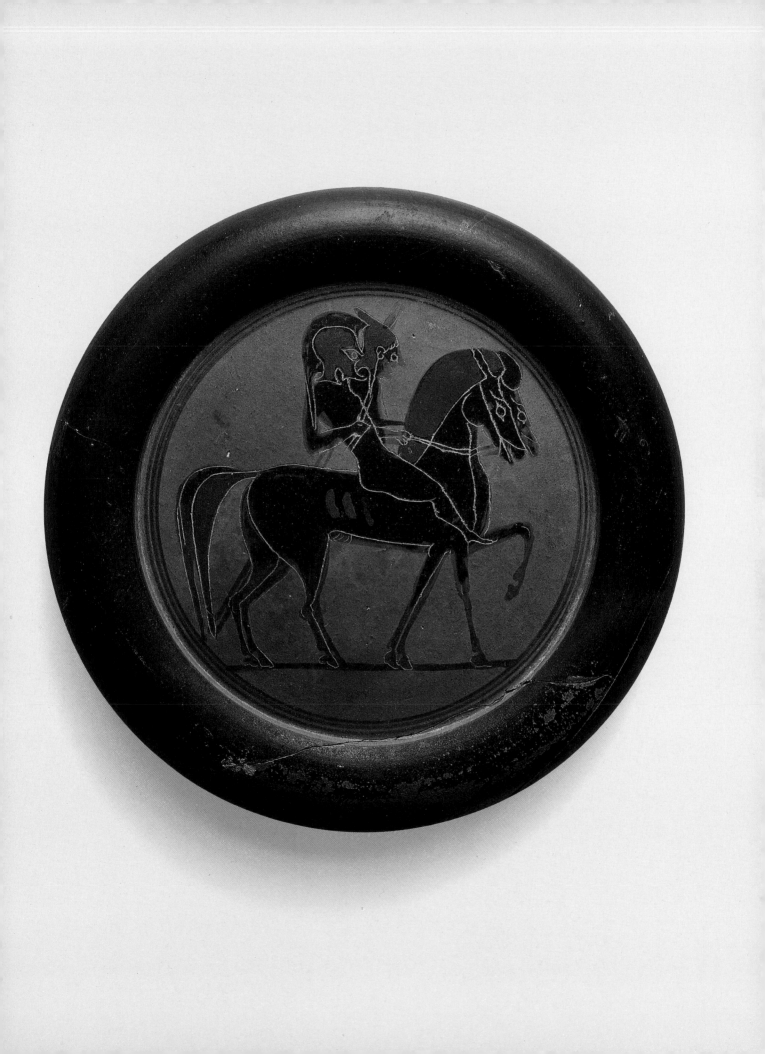

38

Fragment of a Marble Grave Stele

Found at the Dipylon in the Athenian
 Kerameikos in 1873
Attributed to the Master of the Rampin
 Rider, c. 560 B.C.
Height 35 (13¾)
Athens, National Archaeological Museum,
 38

Funerary reliefs, which decorated the stelai placed as grave markers, hold an important position in the artistic tradition of Greek sculpture. This fragment comes from one such stele. It preserves the head of a youth facing right, shown in strict profile. The entire figure was originally portrayed, for fragments of the lower legs survive.

The youth is depicted holding a discus in his left hand, which identifies him as an athlete, but also, thanks to the inspiration of the sculptor, functions as the ground against which the head is shown, encircled as with a halo.

His wavy hair is gathered at the back of his neck, and the ends are looped back and tightly bound with a thin ribbon or cord. The curve of the hair accentuates the graceful contours of the neck. The face is that of an aristocratic Athenian youth of the mid-sixth century B.C. who has won immortality through this work.

The individual qualities in the rendering of certain details such as the nose and chin could indicate that the sculptor to whom the relief has been attributed, the great Master of the Rampin Rider, has here tried to create a portrait.

Bibliography
C. Karouzos, "Notes on Some Sculptures in the Acropolis Museum," *BSA* 39 (1938–1939): 99–101.
E. Harrison, "Archaic Gravestones from the Athenian Agora," *Hesperia* 25 (1956): 31, pl. 7c.
G. M. A. Richter, *Archaic Gravestones of Attica* (London, 1961), 21, figs. 77–78.

N. K.

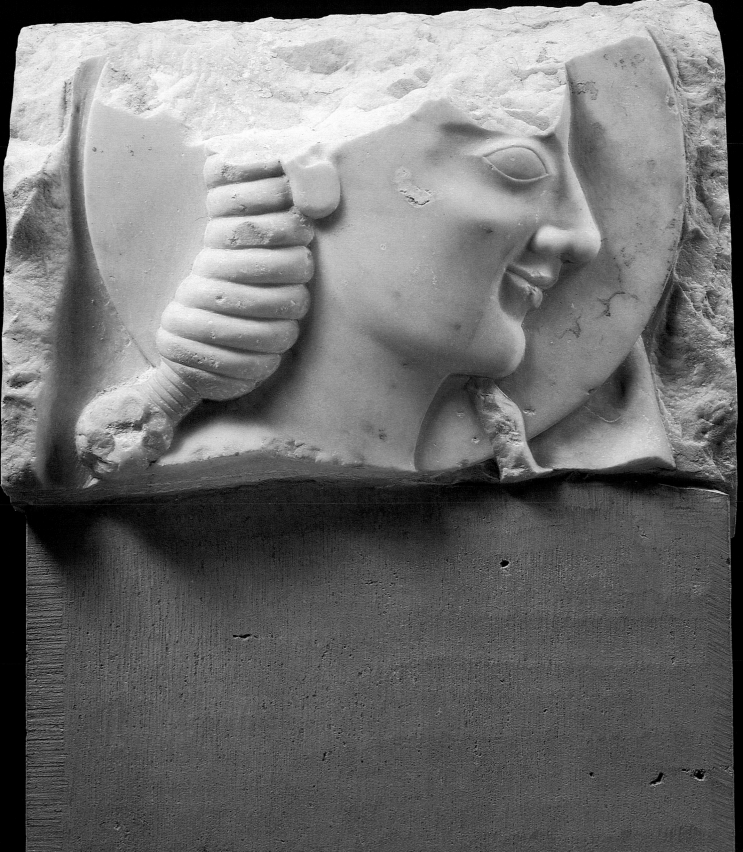

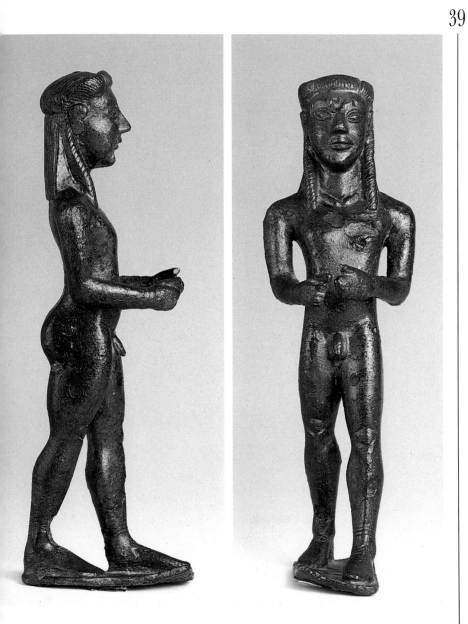

39

Bronze Statuette of a Kouros

From the Heraion on Samos
Samian, early sixth century B.C.
Height 19 (7⅜)
Samos Museum, B 1675

This small statuette, one of the numerous products of the Samian school during the Archaic period, provides one of the first examples of a *kouros* that breaks away from the standard pose. Contemporary figures of youths from the workshops of mainland Greece still show the hands attached to the thighs and one foot slightly advanced, whereas the Samian youth moves emphatically forward and extends both hands in a gesture of offering. His long hair is rendered by incision, with the short front hair brushed back in a uniform mass over the forehead and two shoulder-length tresses framing the face. The carefully drawn shoes, unusual for *kouroi,* are also incised.

These innovations, together with the full, soft flesh and the pudgy face with prominent eyeballs, mirror the art of the islands and of Ionia, where life passed amid wealth and entertainment. At the same time, they reflect the love of art and science.

Bibliography
Greek Art of the Aegean Islands, 180, no. 144, with bibliography.

N. K.

40

Bronze Statuette of a Woman

Found near the temple of Zeus in Olympia
 in 1878
Samian, first half of the sixth century B.C.
Height 22.5 (8⅞)
Athens, National Archaeological Museum,
 6149

Samos held an important place in the artistic
production of East Greece in the sixth century
B.C. Its artists employed unusual, often bold,
conceptions, as exemplified in this cast bronze
statuette of a woman. The figure here wears
a long linen tunic, belted at the waist, and a
finely folded, short diagonal mantle. She
gathers the front of her dress with her right
hand into a curved bunch of folds that break
the stiff, vertical lines of the narrow cylin-
drical body. This particular device may well
have been invented by the great Samian sculp-
tor Geneleos, who made a famous group of
life-size figures discovered in Samos. The
scheme was adopted by many contemporary
and later sculptors (see cat. 42).

The figure holds her left breast with her
left hand, a gesture characteristic of older An-
atolian fertility goddesses. Large, almond-
shaped eyes, originally inlaid with another
material, dominate her broad, fleshy face. Long
hair tied in a ribbon falls down her back, with
a curl at the temples on either side. Bracelets
complete her dress. The ring-shaped object
surmounting her head and the hole in its cen-
ter suggest that the figure once served as the
support for a vessel or utensil, which must
have been dedicated by Samians in the great
Panhellenic sanctuary.

Bibliography
W. Lamb, *Greek and Roman Bronzes* (London,
1929), 103, pl. 36c.
J. Charbonneaux, R. Martin, and F. Villard, *Ar-
chaic Greek Art* (London and New York, 1971),
137–138, fig. 167.
M. Robertson, *A History of Greek Art* (Cambridge,
1975), 84–85, 104, 142, pl. 15c.

 R. P.

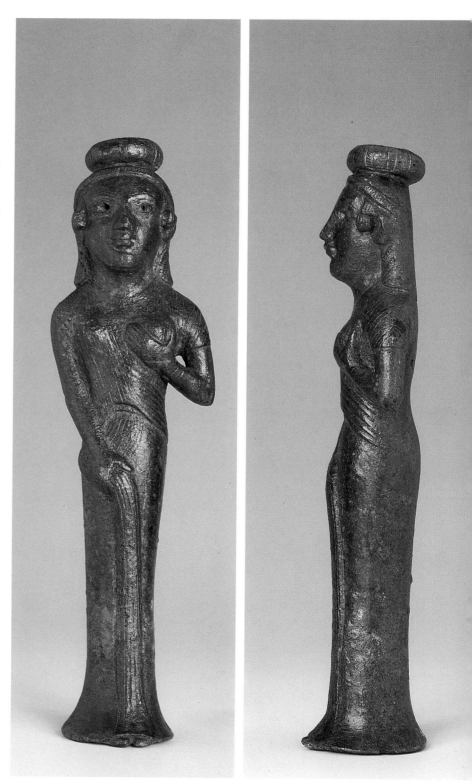

41

Bronze Statuette of a Woman

Found on the Athenian Acropolis
 (excavations of 1885–1889)
Milesian, before the middle of the sixth
 century B.C.
Height 11 (4⅜)
Athens, National Archaeological Museum,
 6493

The city of Miletus in western Asia Minor
became a prominent artistic center as the re-
sult of wealth acquired through extensive trade
during the sixth century B.C. Artists there
produced a rich series of works that take their
place within the tradition of East Greek
sculpture.

 This statuette of a woman is an example of
the small-scale sculpture attributed to Mile-
tus. She wears a long, belted linen tunic,
bloused low over her belt, with a bunch of
four vertical folds in the center front of the
skirt. Her large, round head crowns a solid
cylindrical body to which are attached thin,
fragile arms. The face is dominated by big,
bulging eyes and fleshy lips that curve in a
restrained smile. Her head covering falls to
the shoulders, leaving uncovered the short,
schematically rendered locks that symmetri-
cally frame the wide face.

 No details were added in the modeling of
the back surface of the statuette. A rectan-
gular opening piercing the figure from side
to side at the forearms probably served to
fasten it in place.

 In spite of its heavy, static character, this
statuette conveys a sense of joy and content-
ment, expressive of the easy, luxurious life of
the Asia Minor city from which it comes.

Bibliography
W. Lamb, *Greek and Roman Bronzes* (London,
1929), 103, pl. 36b.

 R. P.

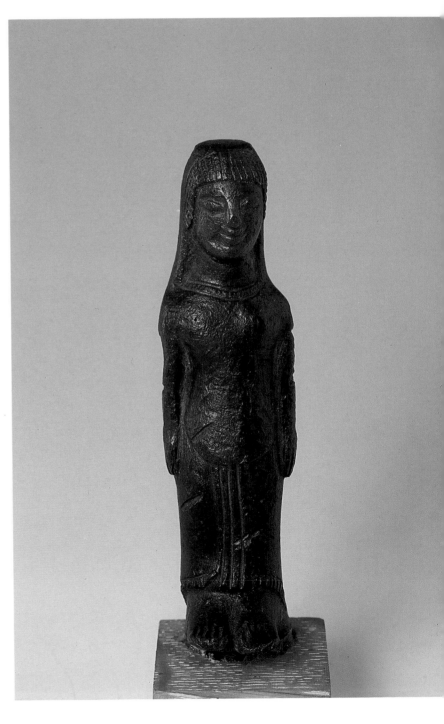

42

Bronze Statuette of a Woman

Found in the Heraion on Samos in 1963
Samian, 560–550 B.C.
Height 27 (10⅝)
Vathy (Samos), Archaeological Museum, B
 1441

This statuette, the product of a Samian metal workshop, represents a dedicant who offers a gift to the goddess Hera. The figure stands with legs together, and wears a long linen tunic with a short diagonal mantle on top. In her left hand she must have held an offering to the goddess. As if about to step forward, she gathers her tunic with her right hand, from which it falls in a cluster of vertical folds (see cat. 40).

Her hair, worn long in front and back, frames her full face, which is radiant with the characteristic Archaic smile. The style of the figure, with accentuated cheekbones, arched eyebrows, and almond-shaped eyes that were originally inlaid, confirms the East Greek origin of the work.

Bibliography
Greek Art of the Aegean Islands, 186–188, no. 151, with bibliography.

N. K.

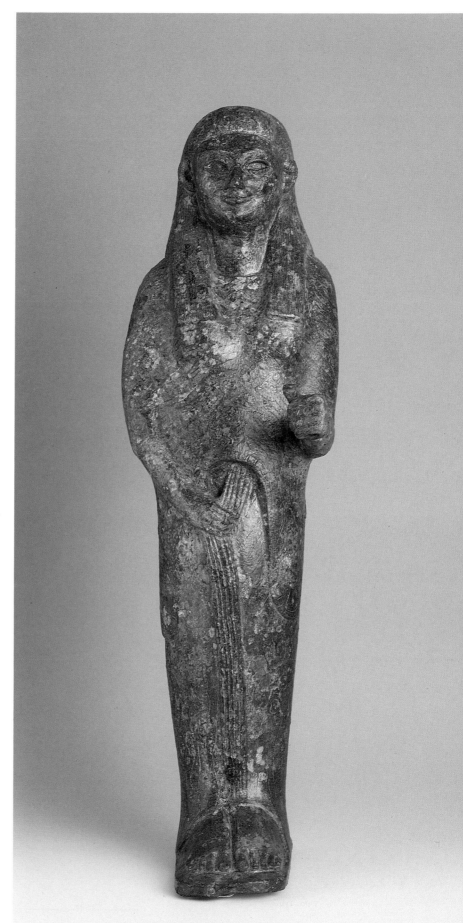

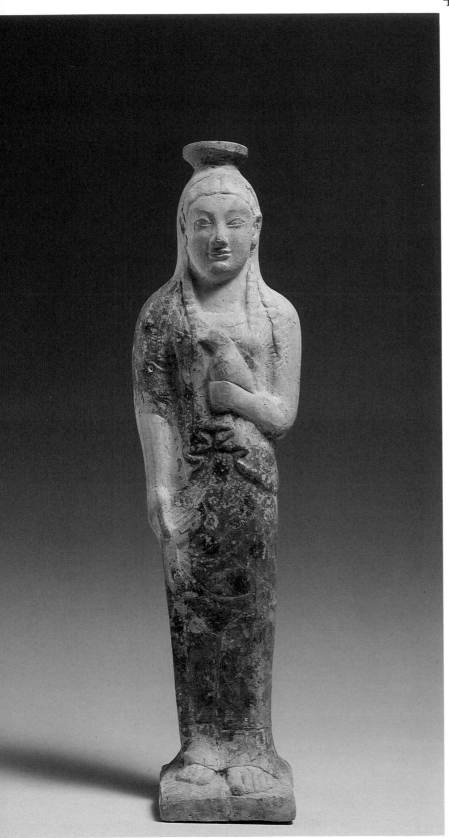

43

Terracotta Alabastron in the Shape of a Young Woman

Found in Thebes
Rhodian, c. 560/550 B.C.
Height 26 (10¼)
Athens, National Archaeological Museum, 5669

The young woman wears a long belted chiton on which traces of red paint survive, and a short diagonal mantle over it. The position of her left hand, holding a bird against her breast, and that of the right arm pulling her dress to one side break the symmetry of the static, frontal pose. The wide face with rounded surfaces, slanting slit eyes, and a slight smile on her taut lips radiates sweetness and joy. A fillet binds her hair, which hangs down in long tresses in back and in plaits in front on either side.

The island of Rhodes was an active artistic center in the sixth century B.C. Contact with other workshops, particularly that of Samos, contributed to the development of Rhodian terracotta sculpture and resulted in works of high artistic quality, popular throughout the ancient world.

One can discern in this work delicacy and tenderness as well as animation and artistic sensitivity, all characteristic of the Rhodians, on whom "the grey-eyed goddess herself bestowed every art, so that they surpassed all mortal men by their deftness of hand" (Pindar, *Olympian Ode VII*).

This terracotta statuette with a cylindrical mouth at the top of the head served as an alabastron, a type of plastic perfume vase widespread during the Archaic period. The popularity of the type may have been responsible for the frequent use of the same molds for both figurines and vases.

Bibliography
Greek Art of the Aegean Islands, 162, no. 119, with bibliography.
F. Croissant, *Les protomés féminines archaïques: recherches sur les représentations du visage dans la plastique grecque de 550 à 480 av. J.-C.* (Athens, 1983), 57, pl. 10.

R. P.

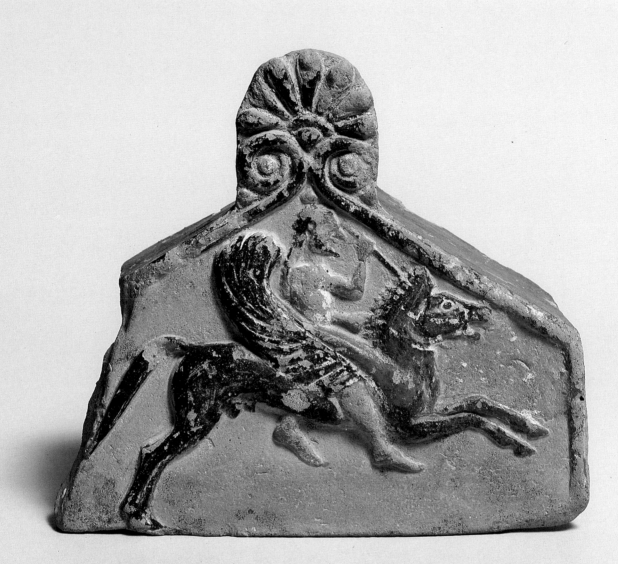

44

Terracotta Antefix with Palmette Finial

Found in Thasos near the sanctuary of
 Heracles
Thasian, second half of the sixth century
 B.C.
17 x 19.4 (6⅝ x 7⅝)
Athens, National Archaeological Museum,
 16004

Another example of Thasian artistic production is this antefix, which creates a vivid impression with the variety and liveliness of its colors (dark brown, white, bright red). Here too the love of Thasian artists for intense, vibrant depictions is apparent: Bellerophon is shown astride the divine Pegasus, who gallops to the right. The winged horse is represented in furious movement with his bushy mane blowing wildly in the wind, and with his eyes and mouth wide open from the effort.

The hero, with long hair and pointed beard, is majestically seated on Pegasus' back. He holds the reins in his left hand and determinedly grasps in his right the short spear with which he killed the horrible monster, the Chimaera.

This pentagonal antefix would have decorated the ends of the cover tiles on the roof of the polygonal building in the sanctuary of Heracles, possibly together with others that represented the Chimaera.

The depiction on the antefix found at Thasos of the myth of Bellerophon, a hero whose roots were predominantly in Lycia (southwestern Asia Minor), where he carried out his exploits, gives added proof of the influences that the island received from that region.

Bibliography
Greek Art of the Aegean Islands, 208, no. 166, with bibliography.

R. P.

45

Bronze Statuette of a Youth

Found on the Acropolis (excavations of
 1885–1889)
Attic, last quarter of the sixth century B.C.
Height 11.2 (4⅜)
Athens, National Archaeological Museum,
 6598

Ancient sanctuaries were full of bronze ded-
ications. This statuette of a youth from the
Athenian Acropolis is one of many piously
buried by the Athenians after the departure
of the Persians in 479 B.C. It is a fine study
of the human body by an artist who shows a
sensitive understanding of the human form.
The youth stands with his left foot forward,
arms bent slightly at the elbows, and hands,
in which he once held objects that are now
lost, clenched. The noble, serious face, with
fine, expressive features, is encircled by abun-
dant curly locks, which are bound with a fillet
over the forehead and fall lower in back. His
firm body leans slightly to the right. He wears
embades, the cheap and comfortable footwear
of everyday life. The figure rests on a stepped
base (cast in one with the statuette) that must
once have been secured to a more substantial
support by four nails at the corners.

Bibliography
C. Rolley, *Fouilles de Delphes* V, *Monuments Fig-
urés. Les statuettes de bronze* (Paris, 1969), 144–
145, with bibliography.

R. P.

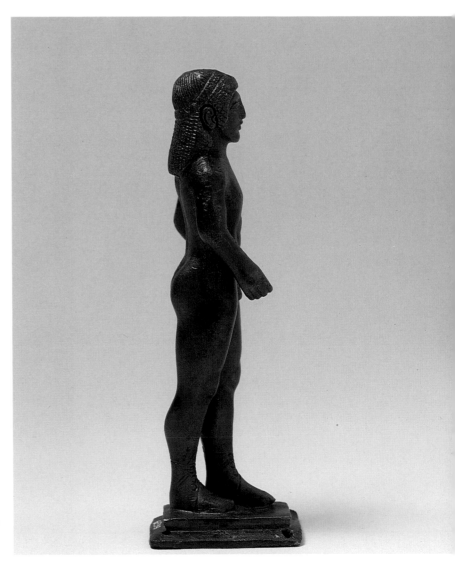

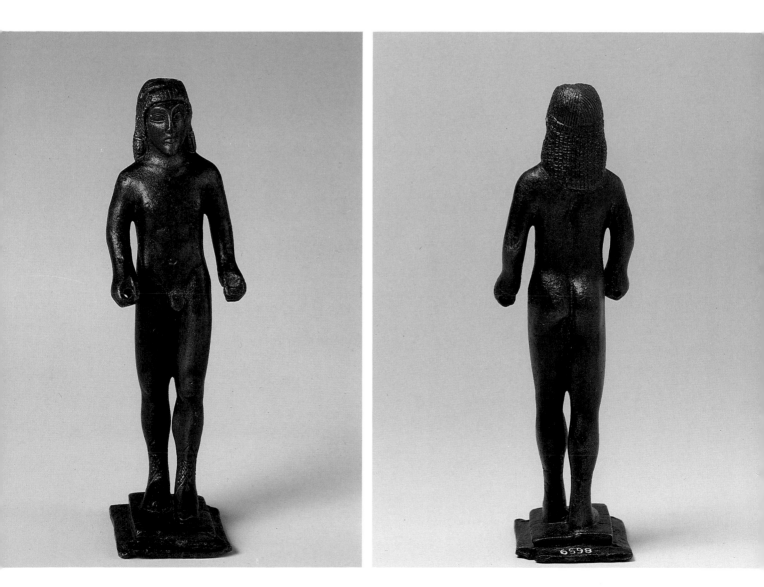

131

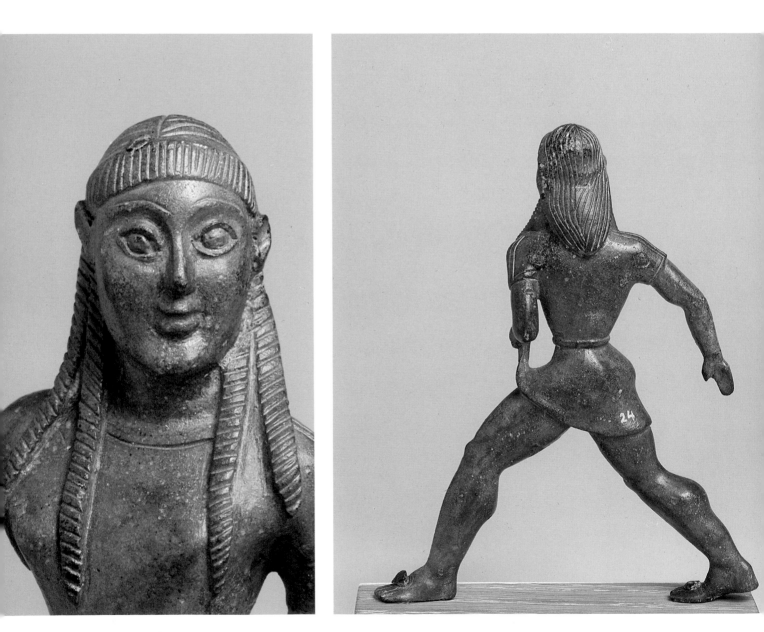

132

46

Bronze Statuette of a Young Girl

Found in the sanctuary of Zeus at Dodona
Laconian, mid-sixth century B.C.
Height 12 (4¾)
Athens, National Archaeological Museum
 (Karapanos Collection), 24

From the mid-seventh to the mid-sixth century B.C. Sparta produced exceptional figural bronzes. Its workshops gained fame even outside of Greece proper.

This statuette of a young, bare-thighed Spartan girl was produced shortly before Laconian bronze sculpture began to decline in quality. Her muscular, athletic body is vigorous and strongly modeled. Perhaps this almost male physique was the reason why formerly some scholars regarded the statuette as that of a youth. She wears a short, sleeved tunic belted at the waist and lifts the hem with

her left hand in order to run more easily. Evidently she is participating in one of the women's races in accordance with the Spartan ideal. Her expressive face has high-arched eyebrows and large, wide-open eyes. Her hair falls down her back and in two long curls on either side in front. The statuette would have decorated the rim of a large vessel; it was attached with two nails still preserved on the feet.

Bibliography
C. Carapanos, *Dodone et ses ruines* (Paris, 1878), 31, pl. XI, fig. 1.
I. Kouleïmane-Vokotopoulou, *Halkai korinthiourgeis proxoi* (Athens, 1975), 118, 142, pls. 53a–53b.
Rolley, *Greek Bronzes*, 108, fig. 79.
T. F. Scanlon, "The Footrace of the Heraia at Olympia," *Ancient World* 9 (1984): 79.

R. P.

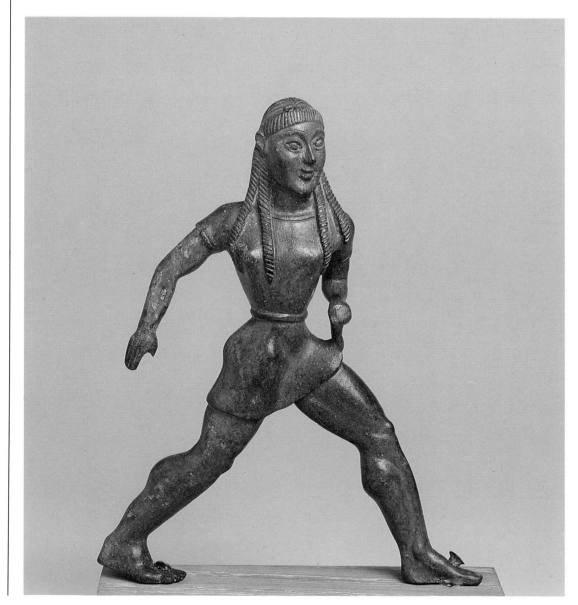

133

47

Bronze Statuette of an Athlete

Found on the Acropolis in 1888
Attic, c. 500 B.C.
Height 27 (10⅝)
Athens, National Archaeological Museum,
 6445

A fresh creation of a gifted Athenian artist, this statuette represents a young athlete with sturdy body, broad shoulders, and narrow hips. His short hair is finely rendered with a slight wave. He held jumping weights that swing backward as he jumps to give him extra distance. The athlete leans slightly forward, his vigorous body tensed, ready to take the great leap. His noble, expressive face shows absorption and self-confidence, but a touch of lightheartedness is also evident. The artist has succeeded in giving life, power, and intense concentration to the youthful body. The clear, compact articulation of the anatomical details suggests that the artist was influenced by works of the northeastern Peloponnesus.

Bibliography
W. Lamb, *Greek and Roman Bronzes* (London, 1929), 100, pl. 37c.
C. Rolley, *Fouilles de Delphes* V, *Monuments figurés. Les statuettes de bronze* (Paris, 1969), 142, 144, 145, 149, 152, figs. 51–53.
W. Fuchs, *Die Skulptur der Griechen*, 2nd ed., (Munich, 1979), 45, fig. 30.
J. Charbonneaux, R. Martin, F. Villard, *Archaic Greek Art* (London and New York, 1971), 280, fig. 322.
M. Robertson, *A History of Greek Art* (Cambridge, England, 1975), 142, pl. 44f.

R. P.

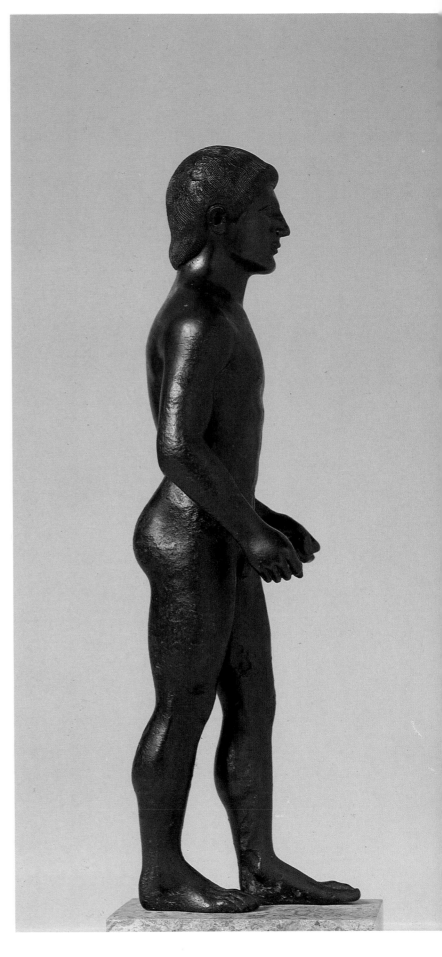

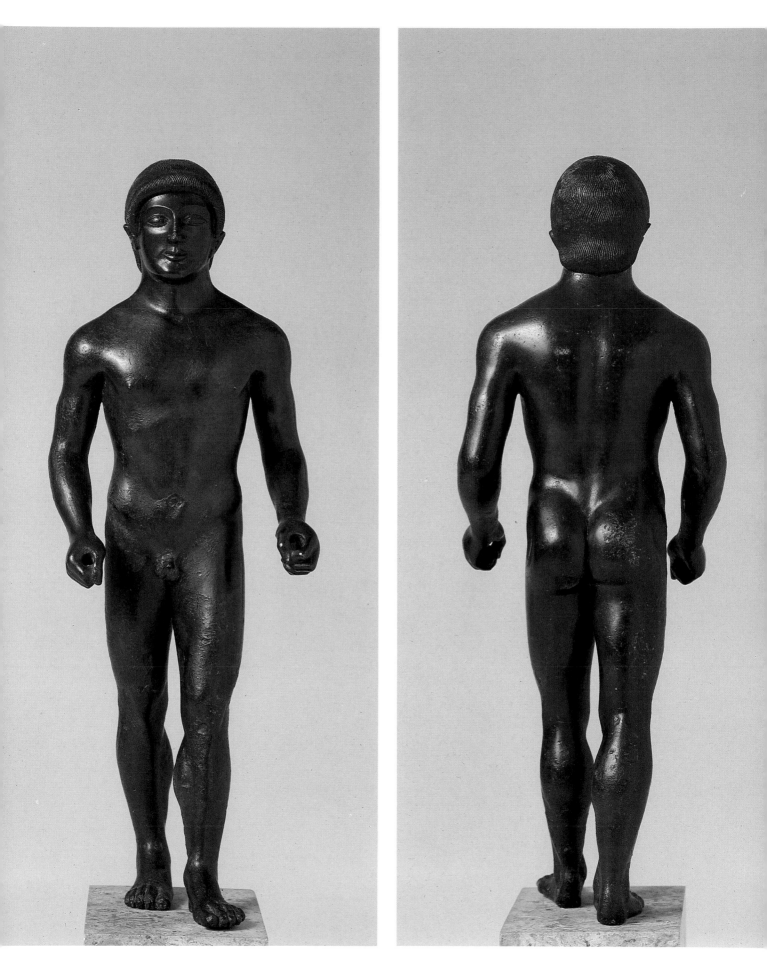

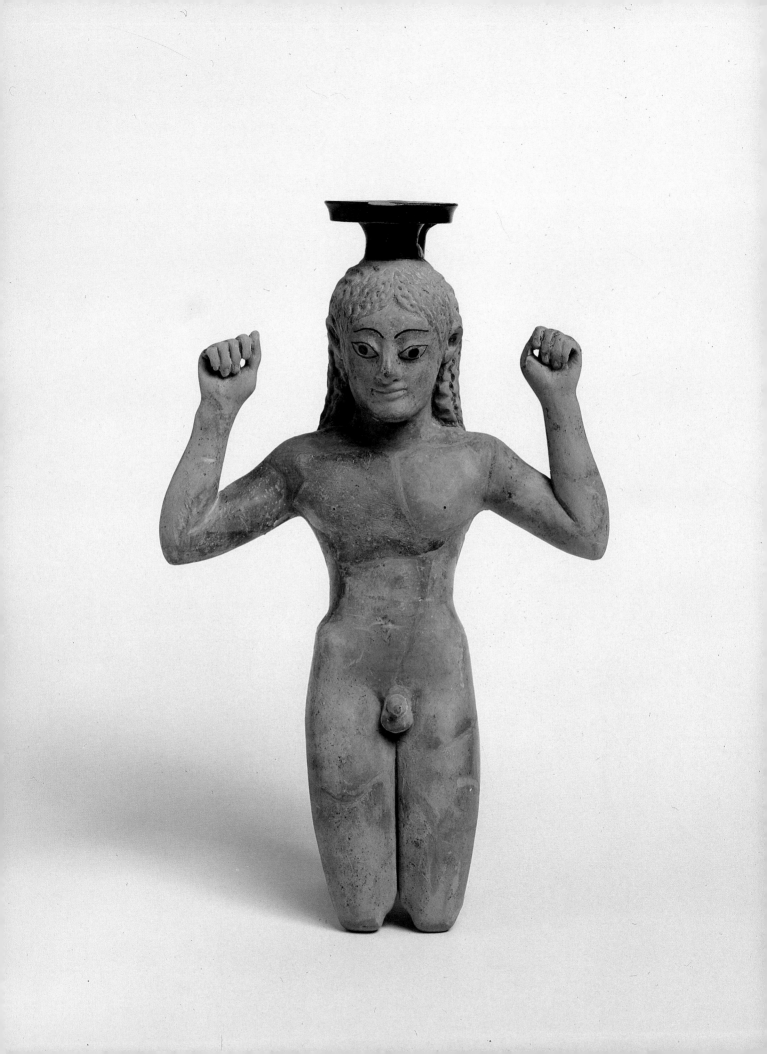

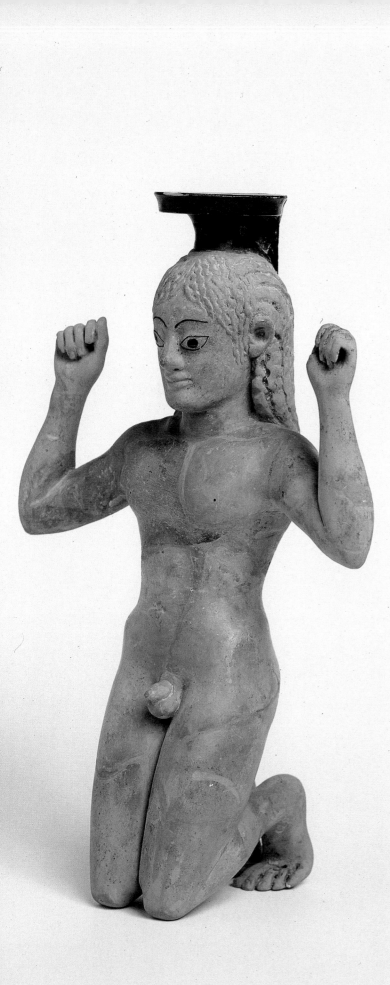

Clay Vase in the Shape of a Kneeling Boy

Found in the ancient Agora of Athens
Attic work, 540–530 B.C.
Height 25.5 (10)
Athens, Agora Museum, P. 1231

This small perfume container, unique in charm and inspiration, is probably the dedication of a contest victor to the deity of one of the many temples and sanctuaries in the ancient Athenian marketplace.

It represents a young boy, on his knees, with his arms symmetrically raised and his hands closed. It has been suggested that he is binding a fillet around his head. His long wavy hair is parted in the center and falls down his back in carefully formed tresses. The mouth of the vase, with a narrow vertical lip, is set on top of the head. Shiny black slip covers the mouth of the vase and accentuates the eyebrows, the pupils, and the outline of the youth's eyes. Red color, now missing, once covered his hair and mouth.

The body as well as the head of the youthful victor is cast in a mold, while his arms and lower legs were modeled separately. The mouth of the vase was thrown on a potter's wheel.

The general proportions of the work follow the canon of analogous works of the period. Thus the head is larger in relation to the rest of the body.

Vases in the form of kneeling figures are known in the seventh century as well as in the sixth. What makes this small work unique is its freedom of motion and the expressive power of the hands.

It has been suggested that he was modeled by an Ionian artist, because of his round face with large eyes and full cheeks. It is an established fact that one of the homes of statuette-vases is Ionia, whence they spread to other markets. Athens did not readily adopt the statuette-vase, but it seems possible that an Athenian artist who was captivated by the type was the author of this unique masterpiece.

Bibliography
E. Vanderpool, "The Kneeling Boy," *Hesperia* 6 (1937): 426–441.
Higgins, *Greek Terracottas*, 43, pl. 16.
H. A. Thompson and R. E. Wycherley, *The Athenian Agora*, Vol. 14, *The Agora of Athens* (Princeton, 1972), 186, pl. 93.

M. P.

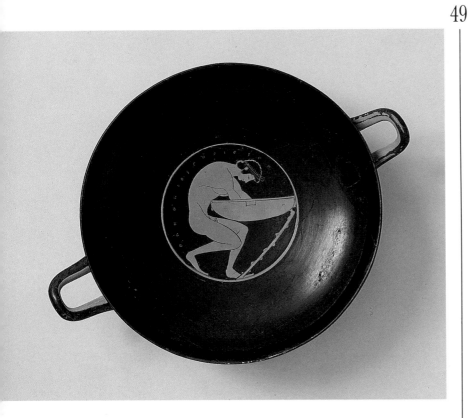

Clay Red-Figure Kylix

Found in Karditsa
Attic, c. 490 B.C.
Height 12 (4¾)
Athens, National Archaeological Museum,
 1409

This kylix, as yet unattributed to a painter, is covered with a famous shiny black glaze that is the product of centuries of technical experimentation. The potter who made it was justifiably proud of its elegant refined shape, because his name appears in the tondo around the painted design: *Pamphaios epoiesen* (Pamphaios made it). Pamphaios is known from red-figure as well as black-figure vases and from vessels decorated in both techniques. He regularly signed his works, often alongside the names of great painters of the period, obviously conscious of the high quality of his vases. This talented and versatile creator of kylikes inspired an elegant style that distinguished his work from that of the general run of workshops of the *kerameikos*, the potters' quarter of Athens.

The representation on the interior of the kylix reflects everyday life and scenes of the gymnasium and palaestra. A youth, nude but wreathed, washes himself in a basin that he holds on his left thigh. Continuous black lines render his well-developed chest, his stomach muscles, and his well-formed legs. The curves created by the circular shape of the picture zone and by the youth's body are balanced by the straight lines of the lip of the basin and of the stick leaning against it.

The kylix dates from around 490 B.C., a difficult time for Athens. With the Persians at its door, Athens had the courage to represent the simple peaceful life on its vases as if nothing had changed. Yet even the simple act of signing the vases, evidence of an individual's self-awareness, is a harbinger of the great and irreversible change that befell nearly all human values during the fifth century.

Bibliography
Beazley, *ARV²*, 130, no. 31.
CVA Athens 1, pl. 3.
H. Bloesch, *Formen attischer Schalen von Exekias bis zum Ende des Strengen Stils* (Bern, 1940), 64, 66, no. 13.
H. R. Immerwahr, "The Signatures of Pamphaios," *AJA* 88 (1984): 345, 351, no. 49.

M. P.

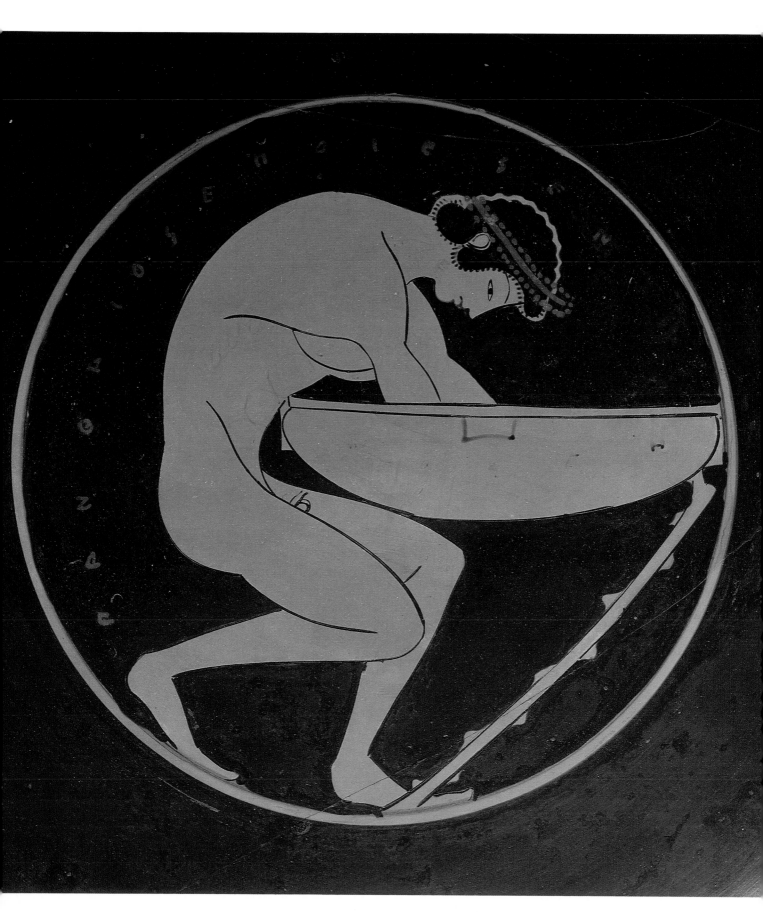

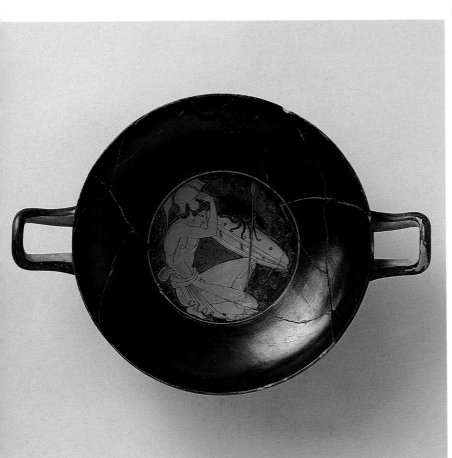

Red-figure Kylix of "Type B"

Found in Tanagra, Boeotia, in 1888
Attic, signed by Phintias as potter, c. 505
B.C.
Height 8, diameter 13 (3⅛ x 5⅛)
Athens, National Archaeological Museum,
1628

During the last decades of the sixth century B.C., a group of vase painters experimented with new techniques and tried new methods of representation. The painter of this kylix belongs among these pioneers, contemporaries of the generation that grew up to win heroic victories at Marathon and Salamis in the next century.

The artist, with fine, clear relief lines and precise detail, shows us a young soldier, noble and serious of mien, arming for battle. He has put on his greaves and is holding in his left hand, propped on his knee, his shield with an octopus as emblem. With his right hand he is putting on his long-crested "Chalcidian" helmet, under which his short, curly hair is visible. His short mantle is tied around the waist of his youthful, tense body. The spear stuck into the ground beside him, with its vertical line, contrasts with the curves that outline his bent back, the circular outline of the picture, and the outer edge of the shield.

To the right of the warrior is the signature of the potter: *Phintias epoiesen* (Phintias made me).

Bibliography
H. Bloesch, *Formen Attischer Schalen von Exekias bis zum Erde des Strengen Stils* (Bern, 1940), 61, pl. 16:2.
M. Robertson, "The Gorgos Cup," *AJA* 62 (1958): 62–63, no. 8.
Beazley, *ARV*,[2] 25, no. 1.
J. Boardman, *Athenian Red Figure Vases; the Archaic Period* (London, 1975), fig. 49.
C. M. Cardon, "The Gorgos Cup," *AJA* 83 (1979): 172, pl. 27, fig. 19.
G. F. Pinney, "The Nonage of the Berlin Painter," *AJA* 85 (1981): 156–157, pl. 35, fig. 22.
D. C. Kurtz, "Gorgos' Cup," *JHS* 103 (1983): 81.
B. Philippaki, *Vases of the National Archaeological Museum of Athens* (Athens, n.d.), 76.

R. P.

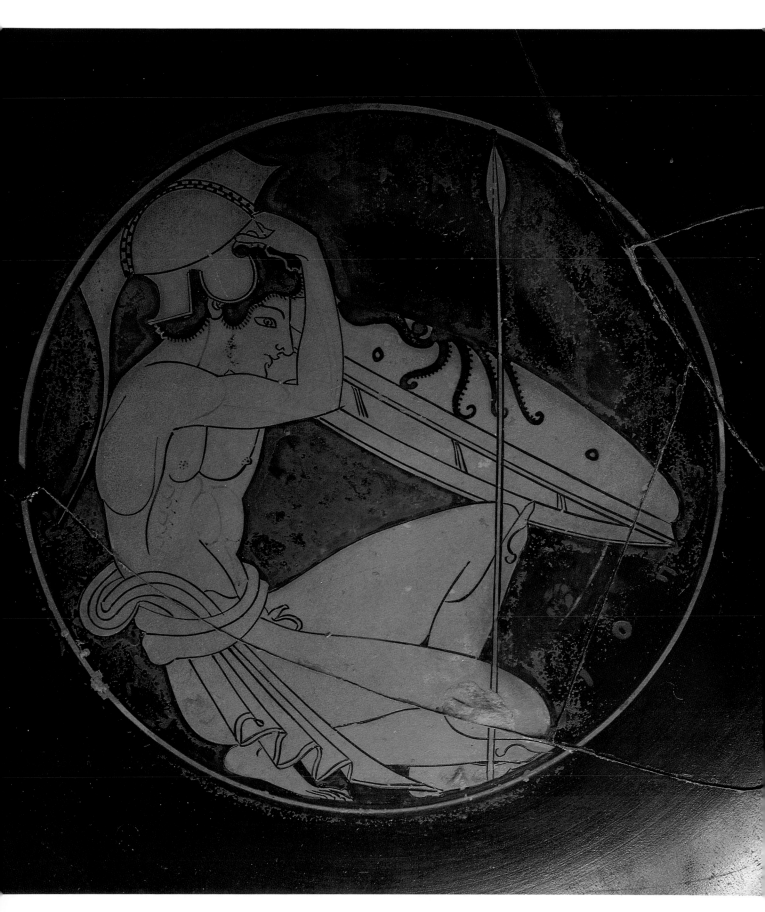

Red-figure Kylix

Found in the Athenian Agora in 1954
Attic, c. 500 B.C.
Height 7.4, diameter 18 (2⅞ x 7¹⁄₁₆)
Athens, Agora Museum, P 24113

This vase was found discarded in a well under the gutter of the Stoa of Attalos—a victim, so it seems, like many other works of art, of Xerxes' sack of Athens in 480 B.C. In the interior of the kylix a youth is shown half kneeling, steadying himself with a knotty stick and holding a hare, a gift of lovers, by the ears. Blue-eyed, with down on his cheeks, the youth wears only a short cloak thrown over his shoulders and a wreath of honeysuckle.

On one side of the exterior is depicted a duel between the Homeric heroes Achilles and Memnon. Memnon falls back as he struggles to free his spear, which is stuck in Achilles' shield. Thetis stands behind her son Achilles, and Eos behind her son Memnon. The subject of the other side of the exterior takes us into a different world: Dionysus and his cheerful company. The god, dressed in a tunic and mantle, sits on a folding stool holding a vine or branch of ivy in one hand and an empty drinking cup (kantharos) in the other. A maenad in a long chiton and fawn skin hastens forward with a thyrsus and an empty pitcher. Two lively satyrs bring in a he-goat. Above the battle scene is written the name *Krates,* and above the Dionysian scene *kalos* (handsome): thus "Krates is handsome," perhaps a reference to the beauty of the youth shown on the interior.

Written in red around the youth on the interior is the signature of the potter: *Gorgos epoiesen* (Gorgos made it). The painter, who may or may not be the same as the potter, is distinguished by the nobility and simplicity of line of his figures. To enliven his pictures, he has made use of all the techniques of red-figure vase painting in this period: heavy black relief lines for the outline of the body; incision for the outline of the top of the head; brown dilute glaze for the down on the youth's face, for the drawing of muscles, and for the fur of the hare; red for the wreath and the inscription.

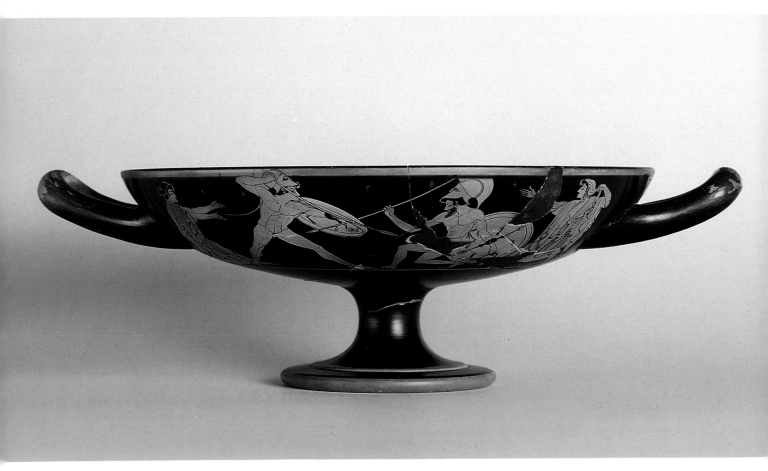

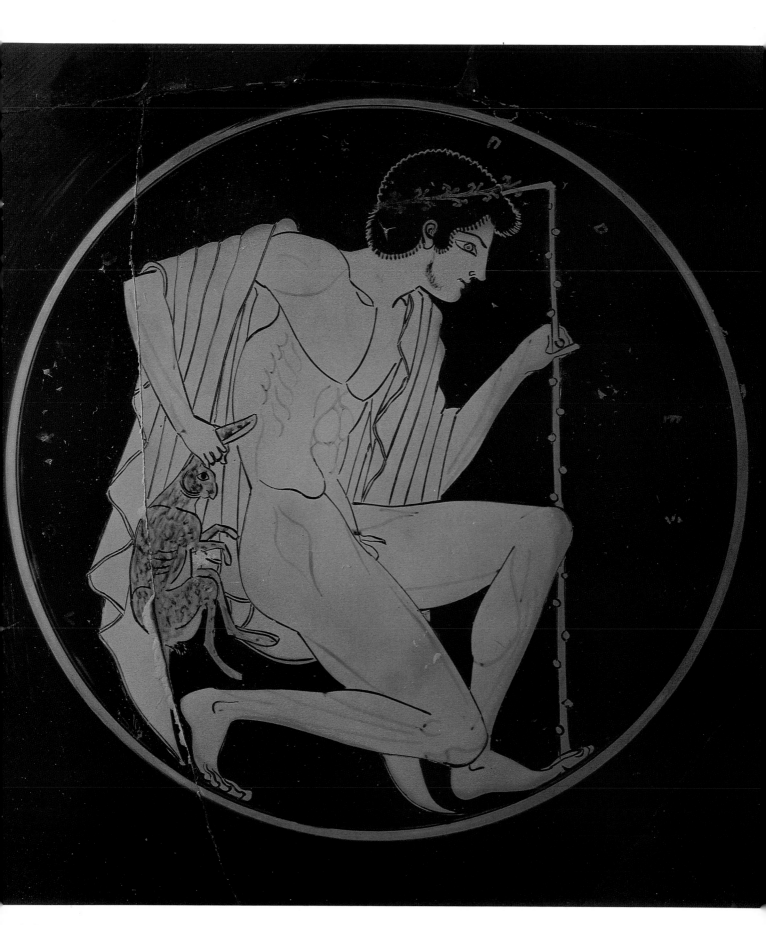

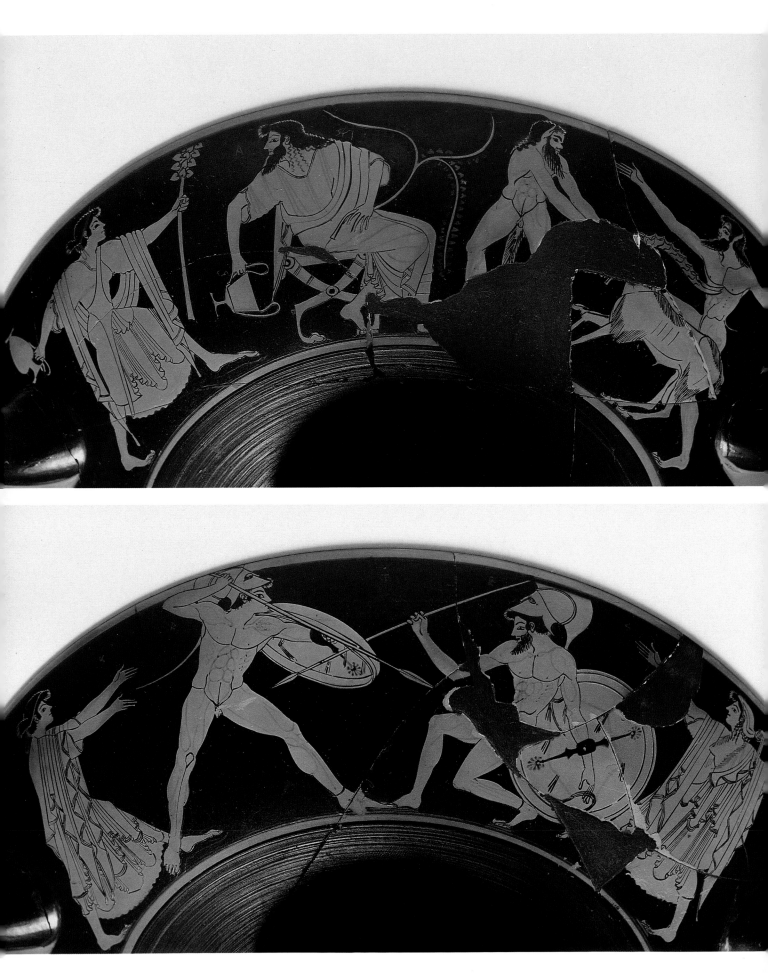

The painter has chosen three disparate subjects that epitomize the main themes of vase painting in this period: everyday life in the interior, heroic and Dionysian scenes on the exterior. He presents, at the same time, the principal manifestations of a young man's life: love, war, and entertainment.

The painter was closely related to the artist of the cup made by the potter Phintias (cat. 50); he was also a contemporary of the famous Berlin Painter and trained in the same workshop. He extolls, with a fully developed awareness of human worth, both beauty and the character of young men as they were shaped in the gymnasia of Athens in accordance with the educational ideals of the time.

Bibliography
Beazley, *ARV*², 213–214, no. 242.
H. A. Thompson, in *Hesperia* 24 (1955): 64–66, figs. 3–4, pl. 30.
M. Robertson, "The Gorgos Cup," *AJA* 62 (1958): 55–66, pls. 6–7, figs. 1–5.
C. M. Cardon, "The Gorgos Cup," *AJA* 83 (1979): 169–173, pls. 22–25.
D. C. Kurtz, "Gorgos' Cup: An Essay in Connoisseurship," *JHS* 103 (1983): 68–86, pls. 3–9, with discussion of the attribution history.

D. T.

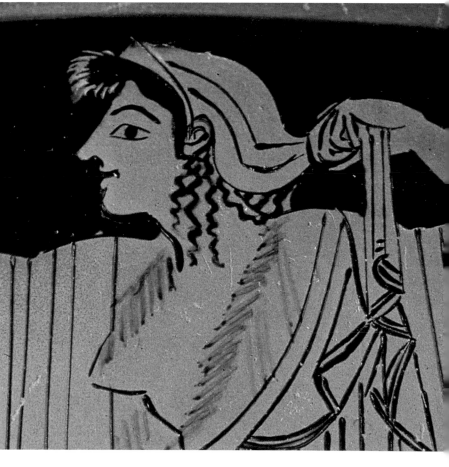

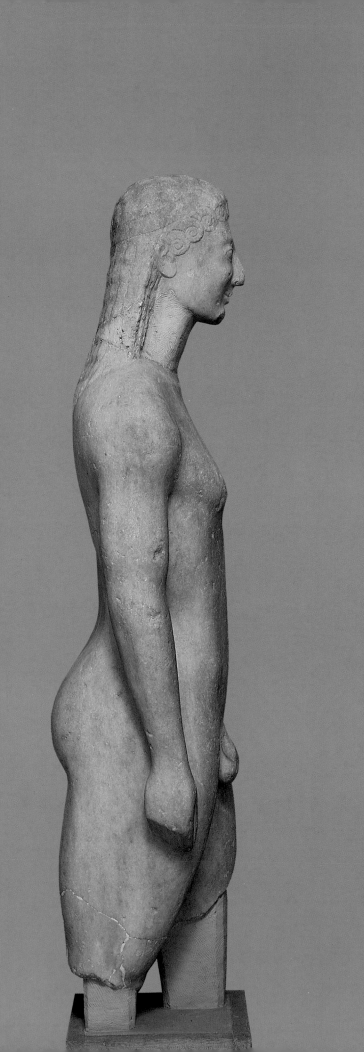

Marble Statue of a Kouros

Found on Thera (opposite the cemetery at
 Cape Exomytis) in 1836
Ionian work of a local workshop, c. 570–
 560 B.C.
Height 124 (48⅞)
Athens, National Archaeological Museum, 8

The discovery of a series of larger than life-size *kouroi* in Thera demonstrated that this volcanic Aegean island was a flourishing center in the sixth century B.C. as well as in the tenth and ninth. Carved in island marble, with soft fluid curves, this figure is deeply influenced by East Greek art. Nothing about it reminds us that it comes from a Dorian colony.

The place where it was found indicates that this *kouros* must have adorned the grave of a young man. Clothed in his disarming nudity, with all the vigor of young manhood, he radiates eternal youth and generative power.

The *kouros* from Thera, preserved only as far as the knees, stands with his left leg forward, like all *kouroi*, and with his hands attached to his thighs. The squared mass of the marble has been carved out in ample curves to denote the different parts of the body, while a few incised grooves indicate anatomical details. A slight divergence of the torso from the frontal plane gives the statue a restrained and understated yet dynamic movement.

The long neck, stretched forward, supports the head, which has the same square structure as the body. The hair, bound with a ribbon whose ends are not shown, hangs down the back in a mass of schematized tresses. Stylized spiral curls over the forehead and the temples frame the face, in which shine the big almond eyes. The emphatic nose, the fleshy smiling lips with the typical little triangles at the corners, and the modeling of the face as a whole give this youth from Thera an individual countenance on which play the freshness and joy of youth.

Bibliography
Richter, *Kouroi*, 69–79, no. 49, figs. 178–183.
 D. T.

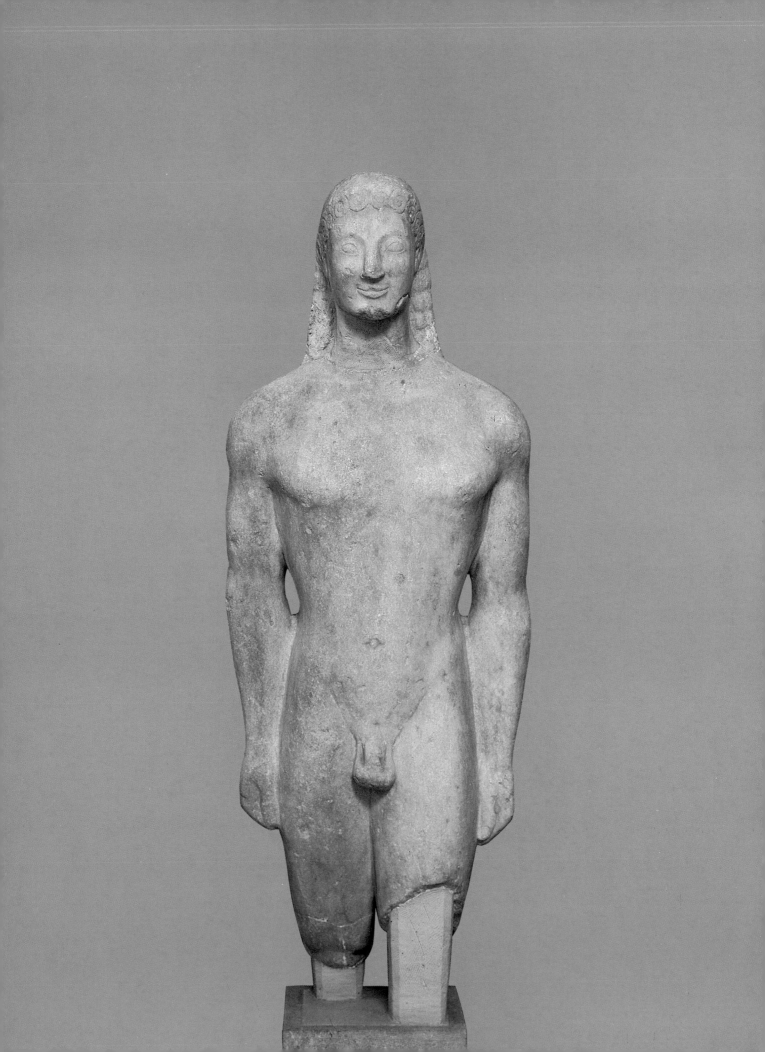

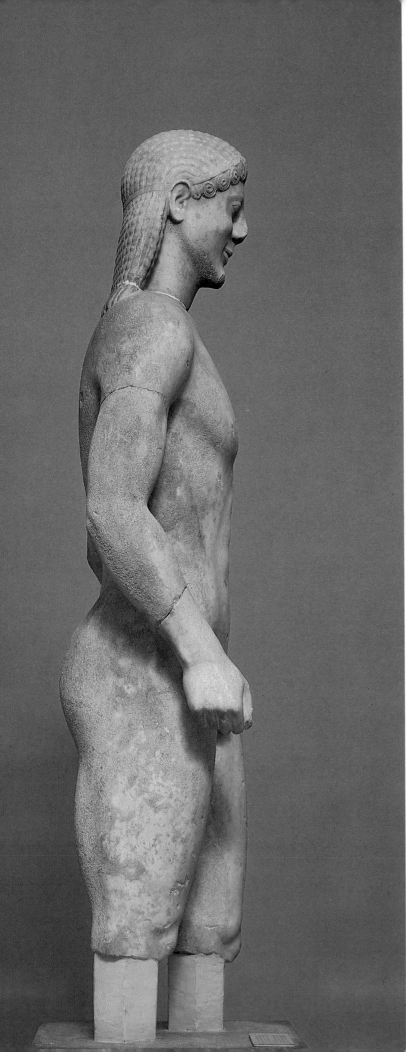

Marble Statue of a Kouros

Found in the sanctuary of Apollo on Mount
 Ptoon, the torso in 1885, the head in
 1903
Boeotian(?) work, c. 530–520 B.C.
Height 160 (63)
Athens, National Archaeological Museum,
 12

This *kouros* was a dedication to Apollo in his
sanctuary by a well-to-do Boeotian or other
Greek in the years when the Peisistratids ruled
in Athens.

Carved in island marble and showing the
influence of island sculpture, it is reminiscent
of the *kouroi* of Attica and Kea, but it has
gentler lines and is less sturdily built than
they. In the approximately forty years that
passed between the *kouros* from Thera (cat.
52) and this one, Greek artists achieved greater
naturalism. The youth from Mount Ptoon,
lighter than the one from Thera, has softly
modeled flesh. The shoulders, the chest, the
thorax, the buttocks, and the muscles are more
plastically rendered.

The weight of the body rests on the right
leg, while the left is now advanced more freely.
The elbows are bent and the hands are brought
forward free of the body, to which they are
attached only by two little struts. The fists
remain closed, however, as in the earlier Ar-
chaic examples.

There is a notable change also in the treat-
ment of the head, which now has truer pro-
portions and is rounded, and the mass of hair,
which has taken on its own plastic form. The
bulk of the hair is bound by a ribbon high on
the head and hangs down behind, resting softly
on the neck and back. The forehead is framed
by a row of twisted curls more plastically ren-
dered than those of the Thera *kouros* (cat. 52),
but less so than those of the bearded head
found on the Acropolis (cat. 65).

The softly modeled face with its regular
and harmoniously placed features has an aura
of sweetness and intelligence. This youth from
the Ptoan sanctuary, fully aware of the vig-
orous beauty of his nude male body and a
delight to the eyes of gods and men, stands
eternal before us, the god Apollo in human
form or the human being in his divine image.

Bibliography
Richter, *Kouroi*, 113, 122–123, no. 145, figs. 425–
429.
J. Ducat, *Les Kouroi du Ptoion* (Paris, 1971), 347–
351, no. 197, pls. 112–114.

D. T.

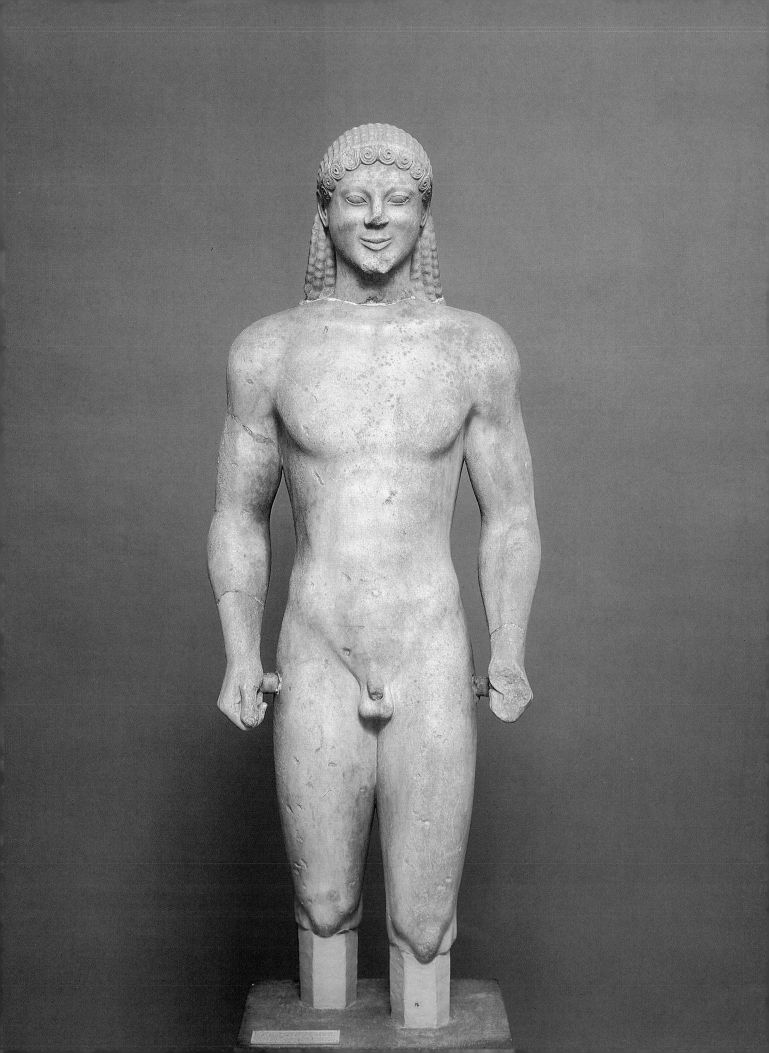

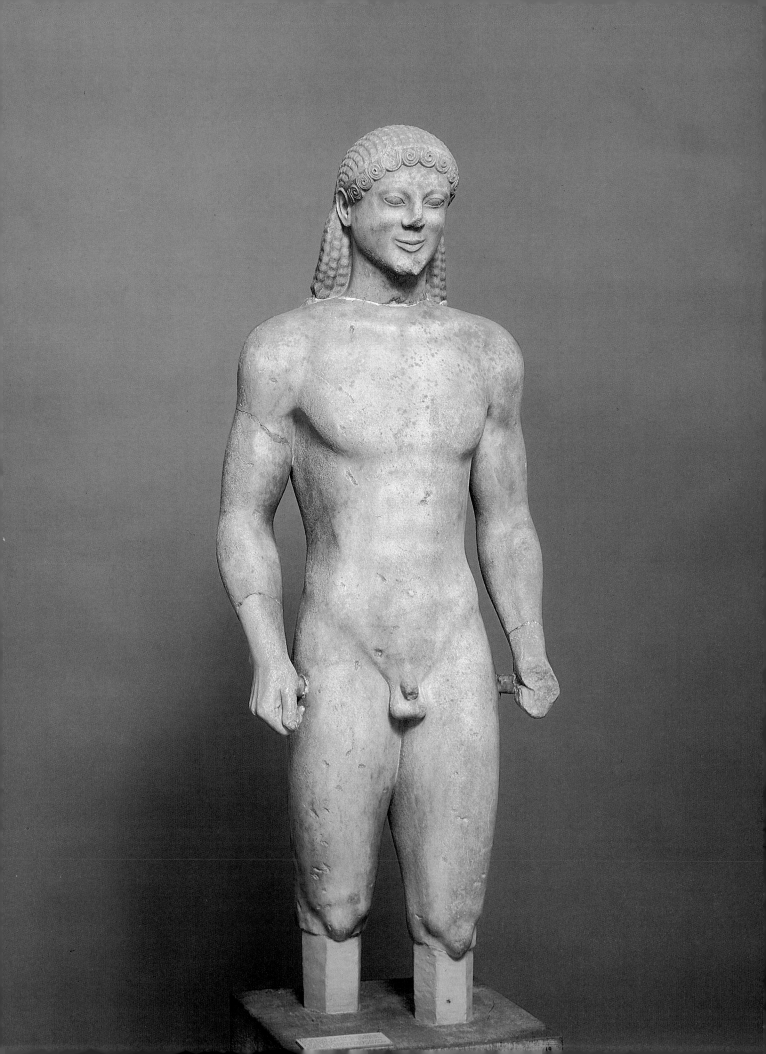

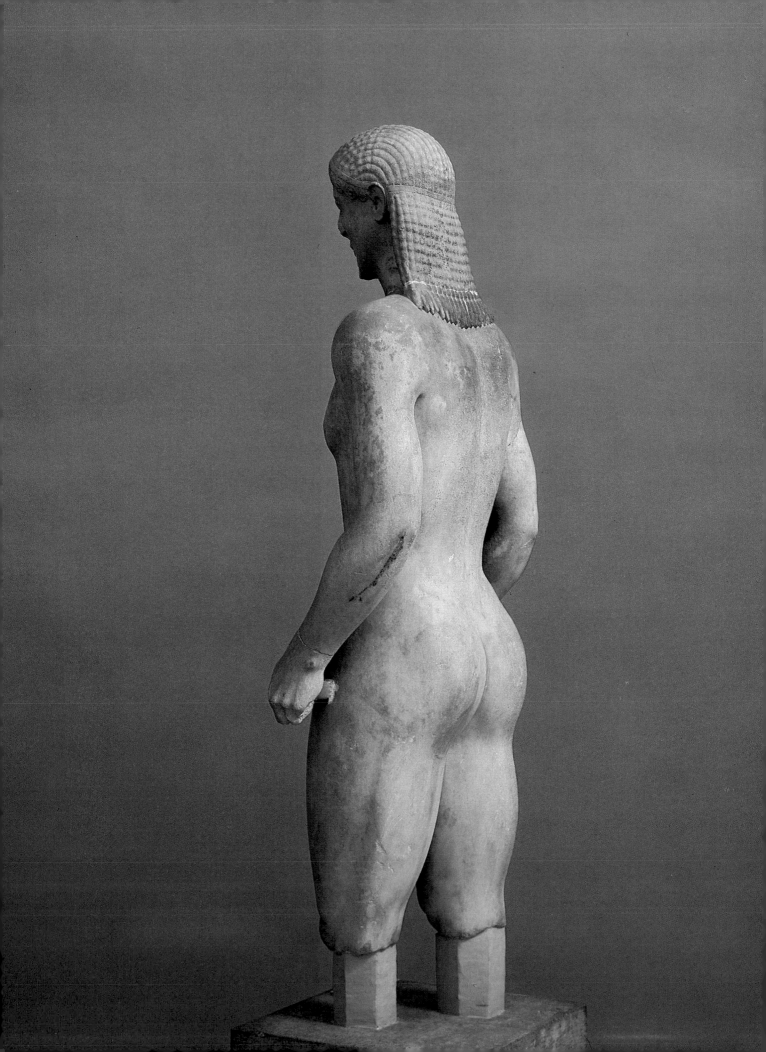

Marble Kouros

From Thracian Raidestos
End of the sixth century B.C.
Height 58 (22¾)
Thessaloniki, Archaeological Museum, 930

In this statue of a young ephebe from Thrace, now headless and with arms and lower legs missing, the warm, soft skin of chest and shoulders harmonizes admirably with the sharp, revealing folds of the mantle that curve across the body and fall down along his left leg.

One of the rare examples of a draped *kouros*, the youth from Raidestos is among the few statues of Archaic date from the northern Aegean area that survive. Both the draped type and the style show Ionian influence.

Bibliography
Makedonika 9 (1969), Chronika 136, no. 36.
I. T.

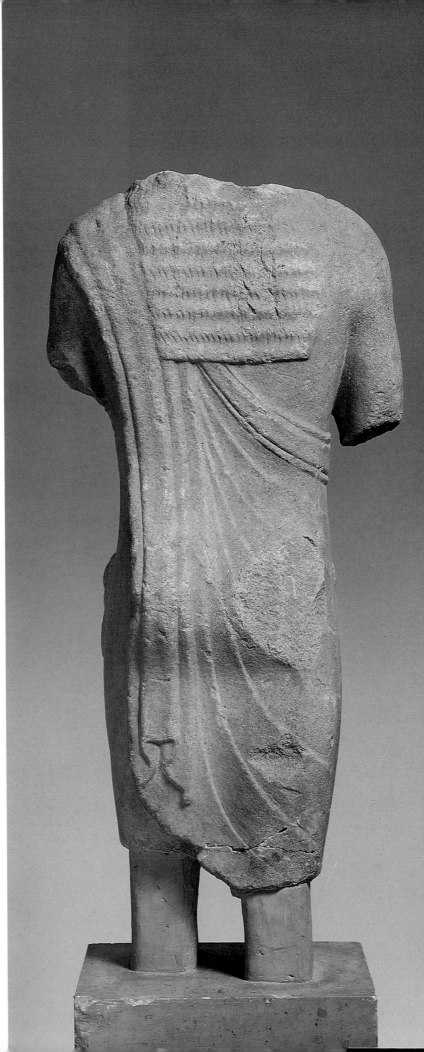

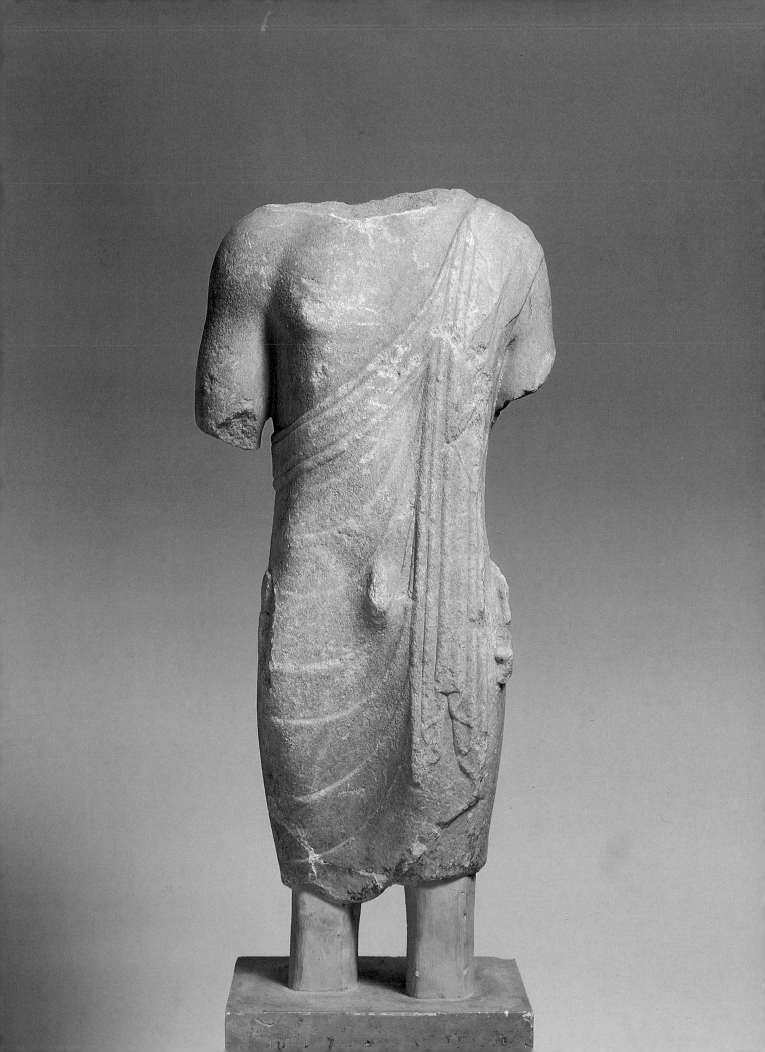

55

Marble Statue of a Kore

Found on the Acropolis west of the
 Erechtheum in 1886
Attic, c. 530 B.C.
Height 95.4 (37½)
Athens, Acropolis Museum, 678

This young girl from the Acropolis of Athens wears either a symmetrically draped himation buttoned on both shoulders or, more probably, a chiton buttoned on both shoulders, with an overfall that produces vertical folds from the breasts down to where they end in an oblique, wavy edge. The convergence of the curving folds in the lower part of the dress indicates that the *kore* is beginning to lift her skirt to the side with her right hand.

On her head she wears a chaplet of large beads. The long wavy tresses that fall over her shoulders in front are carved into separate strands, as are the bands of wavy hair across the forehead. The rest of the hair, on the top of the head and falling down the back, is more simply treated, with angular chisel cuts to suggest crinkly waves.

A full generation before this statue was made, artists had begun experimenting with combining the human body with clothing so as not to detract from the liveliness and charm of the underlying form. The artist has emphasized the head with its luxuriant hair and delicately modeled face, in contrast to the simple dress that has no parallel among Attic *korai*. He has minimized the asymmetries of the standard *kore* pose and the natural volumes of the cloth to show a youthful body with elegant contours and very simple planes.

There is certainly some kinship between this *kore* and the famous Peplos Kore, made perhaps a few years later. Scholars disagree as to whether this figure is an earlier, tentative work by the same master, or the product of a lesser member of his workshop. Some have regarded this workshop as descended from that of the Rampin Master (see cat. 38).

Bibliography
Boardman, *Greek Sculpture*, fig. 118.
H. Schrader, E. Langlotz, W. H. Schuchhardt, *Die archaischen Marmorbildwerke der Akropolis* (Frankfurt am Main, 1939), 53–54, no. 10, pl. 20.
Richter, *Korai*, 71–72, figs. 345–348.

N. K.

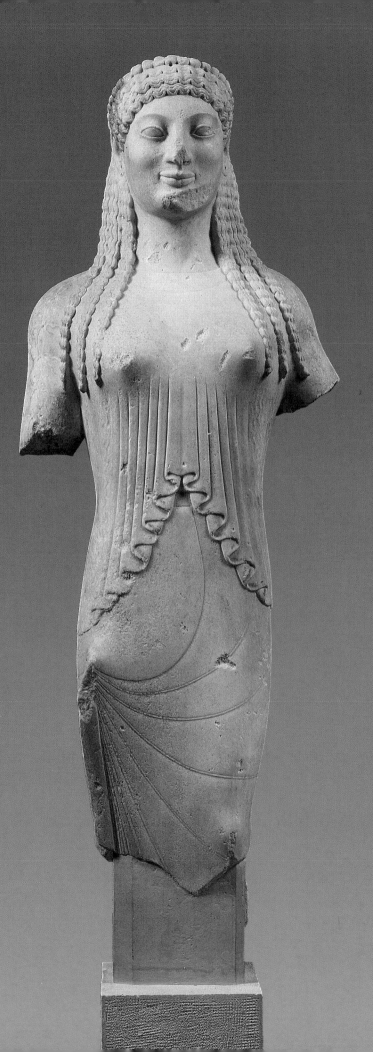

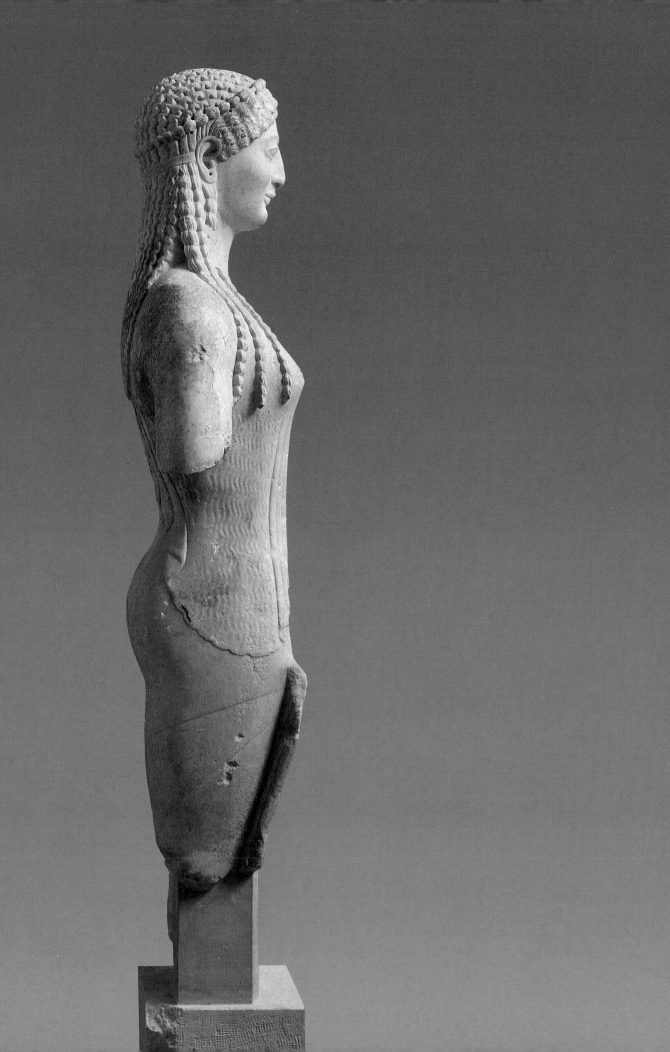

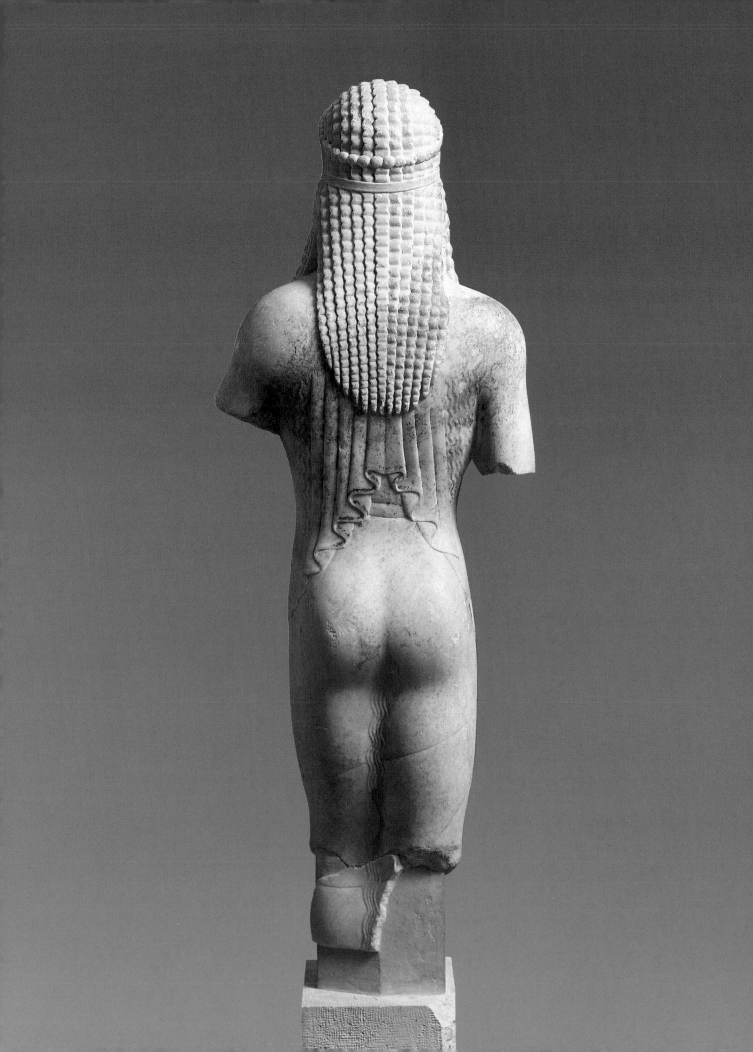

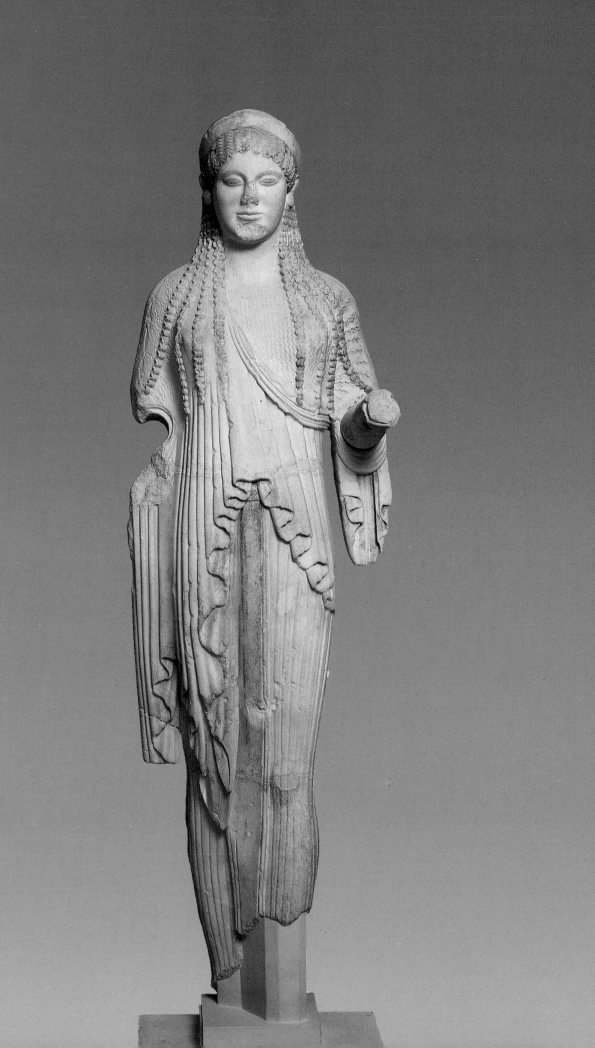

Marble Statue of a Kore

Found on the Acropolis southwest of the
 Parthenon in 1888
Attic, beginning of the fifth century B.C.
Height 122.5 (48¼)
Athens, Acropolis Museum, 685

An adornment for the Sacred Rock, this slen-
der, delicate *kore* is an offering to the goddess
Athena by a pious dedicator. She faces us with
an air of circumspection in her half-closed
eyes and in the restrained smile on her lips.

Carved from marble that resembles Parian,
she was worked in separate pieces, which were
later joined. She advances her left foot slightly
and, unlike most *korai*, does not lift her dress,
but extends both bent arms. Her right fore-
arm is lost; in her missing left hand she held
a bird whose tail alone is preserved above her
wrist.

The *kore* wears a chiton and diagonal man-
tle. The upper part of the chiton has fine wavy
folds and shows remnants of dark green paint.
The wider folds of the lower part run straight
down, revealing the lines of the thighs, knees,
and calves. The mantle falls obliquely from
the right shoulder and slips under the left
breast; its upper edge forms small pleats. The
loose chiton sleeve falls in folds from her left
arm, a foil for the hanging ends of the hima-
tion on the right. The dress still preserves a
painted stripe on the chiton between the legs
and another on the edge of the mantle.

Her hair, which still has bright red paint,
falls down the back in a mass of waving tresses.
The front hair is drawn back over the ears
and falls over the shoulders in four locks on
each side. A diadem painted with a meander
pattern and saltire squares binds the hair,
which frames the face in close horizontal waves.
A wreath may have been fastened in the holes
at the left and right. Disk-shaped earrings
complete the jewelry on her head.

This slim *kore*, with the rich folds of her
clothing, lacks both the intensity of earlier
korai and the deep introspection of her suc-
cessors. It is one of the genuine Attic works
of the end of the Archaic period, but is deeply
influenced by Ionian art.

Bibliography
H. Schrader, E. Langlotz, W.-H. Schuchhardt,
Die archaischen Marmorbildwerke der Akropolis
(Frankfurt am Main, 1939), 97–98, no. 47, pls.
70–71.
Richter, *Korai*, 100, no. 181, figs. 573–577.
Brouskari, *The Acropolis Museum*, 73, fig. 137.

D. T.

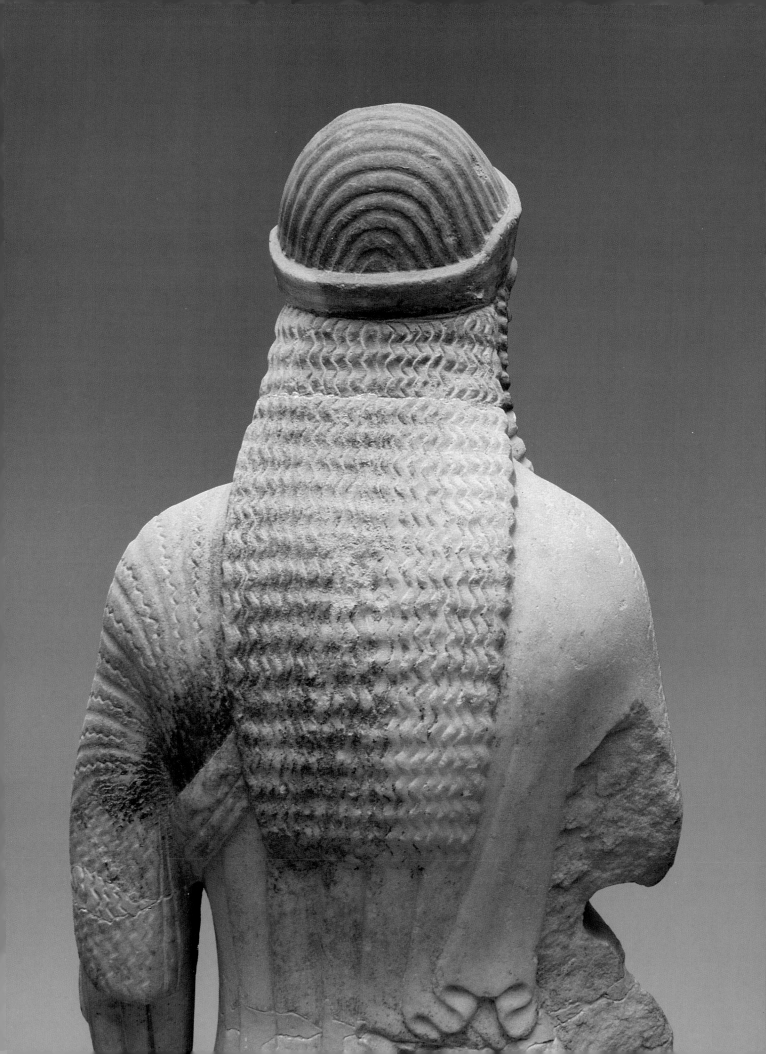

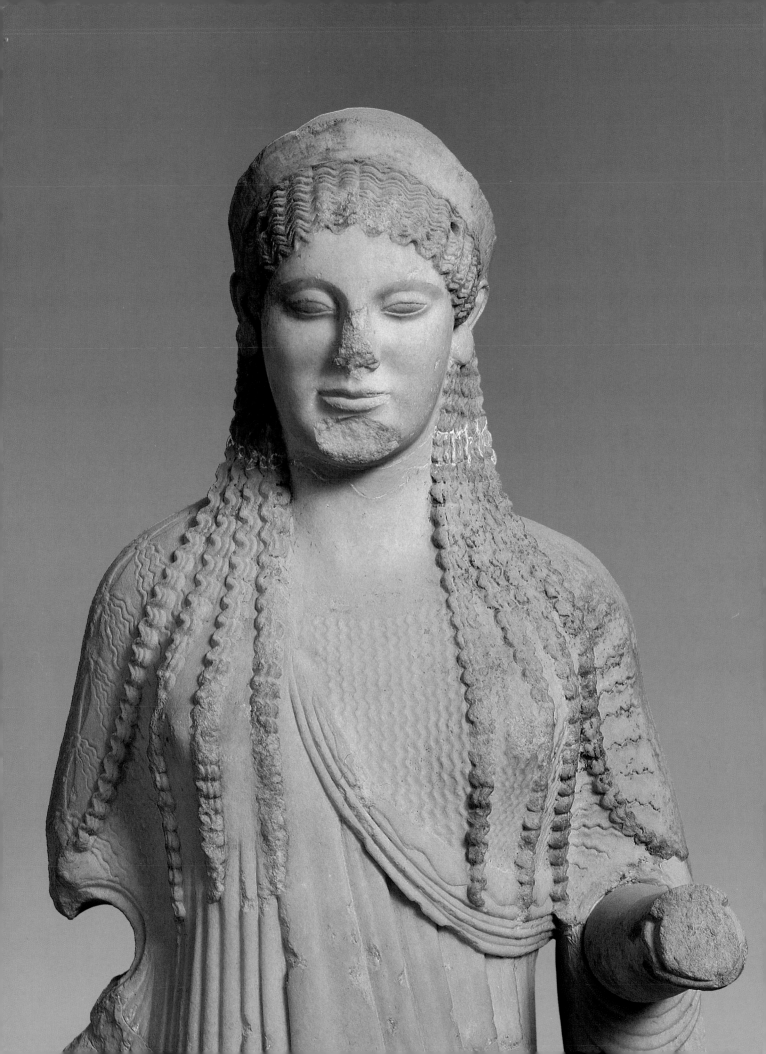

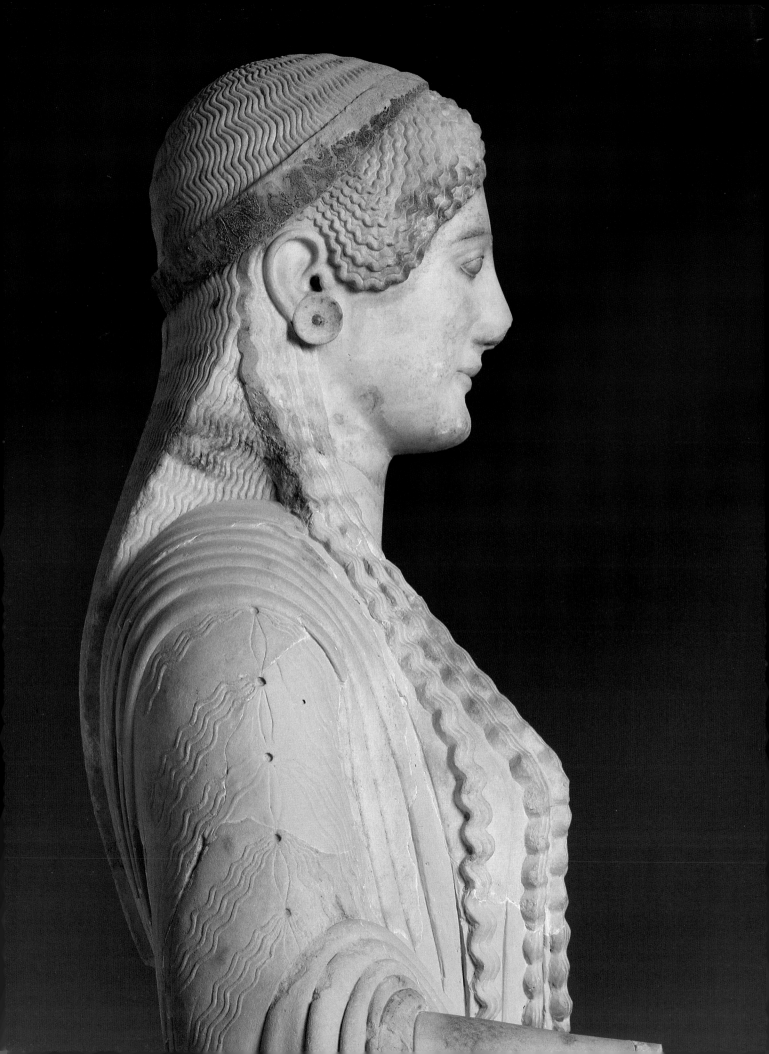

57

Marble Statue of a Kore

Found on the Acropolis east of the
 Parthenon in 1882–1883
Attic, c. 490 B.C.
Height 119 (46⅞)
Athens, Acropolis Museum, 684

Hieratic, formal, and monumental, this *kore* from the Acropolis is exceptionally imposing, even though her face radiates joy and sweetness. This statue, made of white island marble, was dedicated to Pallas Athena, as were the other *korai* of the Acropolis.

The *kore* places her left foot forward. Her left arm and the right hand are missing. Her right hand was stretched forward holding an offering, now also missing, while with her left hand she lifted her long linen chiton, over which is still visible a short diagonal mantle and an *epiblema* (shawl or veil). The mantle falls in rich folds from her right shoulder to below her left breast. Its folded upper edge forms a series of short pleats. The *epiblema* is draped loosely across the upper back below the hair and falls free in heavy folds over both shoulders; one of its ends is looped around the right elbow. A diadem painted with white flowers on a dark green background, a necklace, a bracelet on her right wrist and disk-shaped earrings with painted rosettes com-

plete the *kore*'s formal appearance. Another row of metal buttons was applied to the sleeve of the right arm.

Her thick wavy hair falls freely down her back, while in front it separates over each shoulder into three narrow locks that rest softly on the breast and descend almost to the waist. In front, above the forehead, it is arranged in horizontal wavy tresses, which form two loops at the sides.

The full face radiates a festive formality. Large almond-shaped eyes with painted eyebrows dominate it, and the corners of the lips are drawn imperceptibly back and upward, giving a serene sweetness to its expression.

Harmonious combinations of colors, only a few traces of which remain, enlivened this statue. Made at the beginning of the fifth century B.C., it heralds, in its rectangular, almost monumental construction, the coming Severe Style.

Bibliography
H. Schrader, E. Langlotz, W.-H. Schuchhardt, *Die archaischen Marmorbildwerke der Akropolis* (Frankfurt am Main, 1939), 104–106, no. 55, pls. 78–81.
Richter, *Korai*, 101, figs. 578–582.
Brouskari, *The Acropolis Museum*, 68–69, figs. 125–126.

D. T.

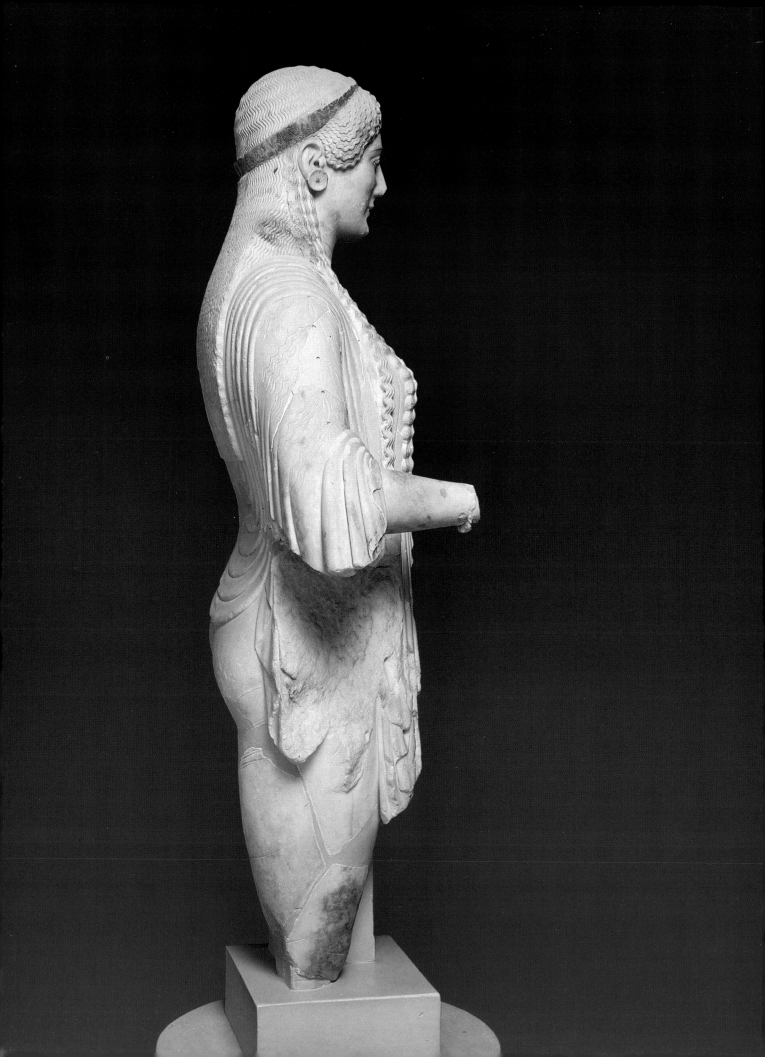

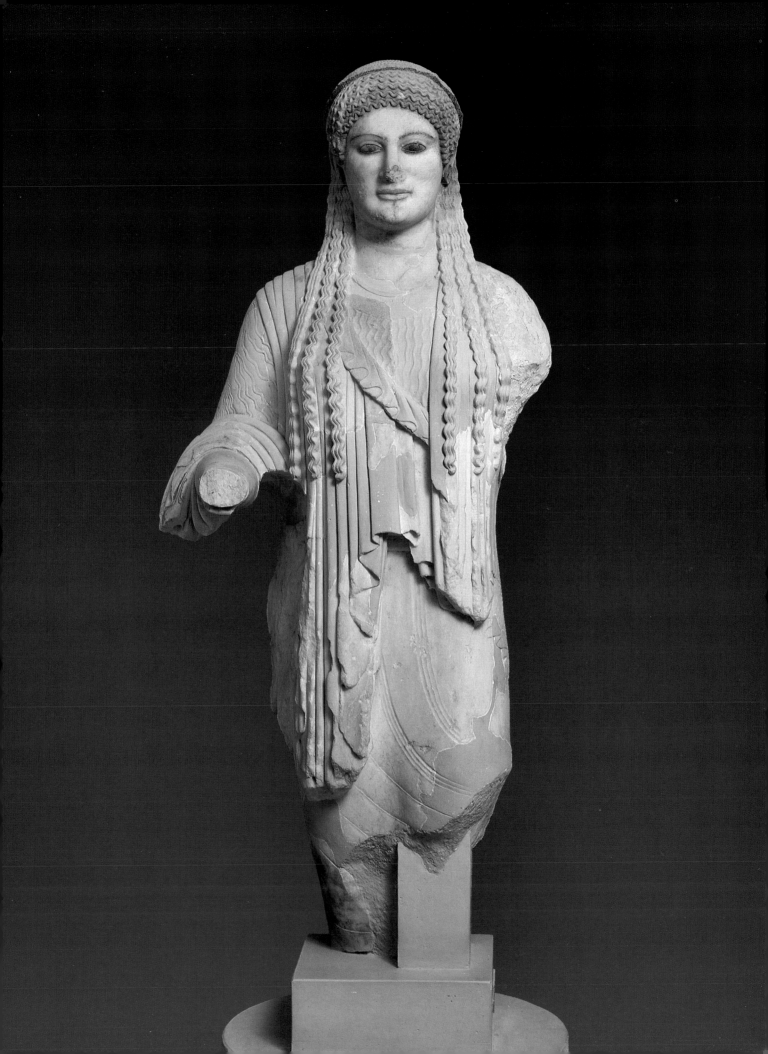

Marble Head of a Kore

Found on the Acropolis
Around 510 B.C.
Height 14.2 (5½)
Athens, Acropolis Museum, 643

This small head from a full statue of a *kore* is regarded as one of the masterpieces of ripe Archaic art. The subject's humanity is depicted in marble with all its liveliness, sensitivity, and independent existence.

Nobility and tenderness pervade the facial features of this little *kore*: the almond-shaped eyes with the fleshy lids, slightly lowered, and the soft lips with their expressive smile, subtly transforming the rounded surfaces of the cheeks and the flesh around the nostrils.

The hair of the *kore* is arranged around the forehead and on the sides with wavy strands looped back over the ears (compare the better preserved coiffure of cat. 57). The roughly worked upper part of the head suggests that it has been repaired. The diadem has holes for metal ornaments.

With this work Archaic art approaches its end, and opens roads for new types of expression at the end of the sixth century B.C.

Bibliography
H. Payne, *Archaic Marble Sculpture from the Acropolis* (London, [1936]), 37–38, pl. 70, no. 1, pl. 71.
Richter, *Korai*, 82, figs. 417–419.
Brouskari, *The Acropolis Museum*, 66–67, fig. 122, with bibliography.
Boardman, *Greek Sculpture*, fig. 154.

N. K.

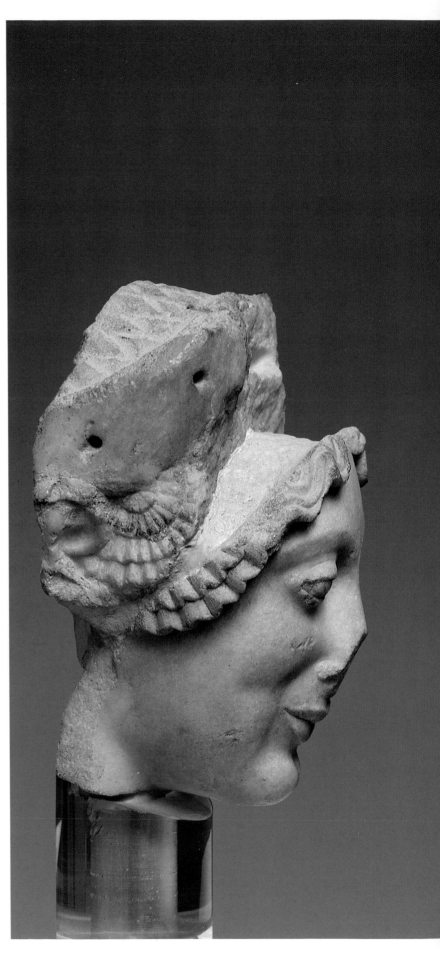

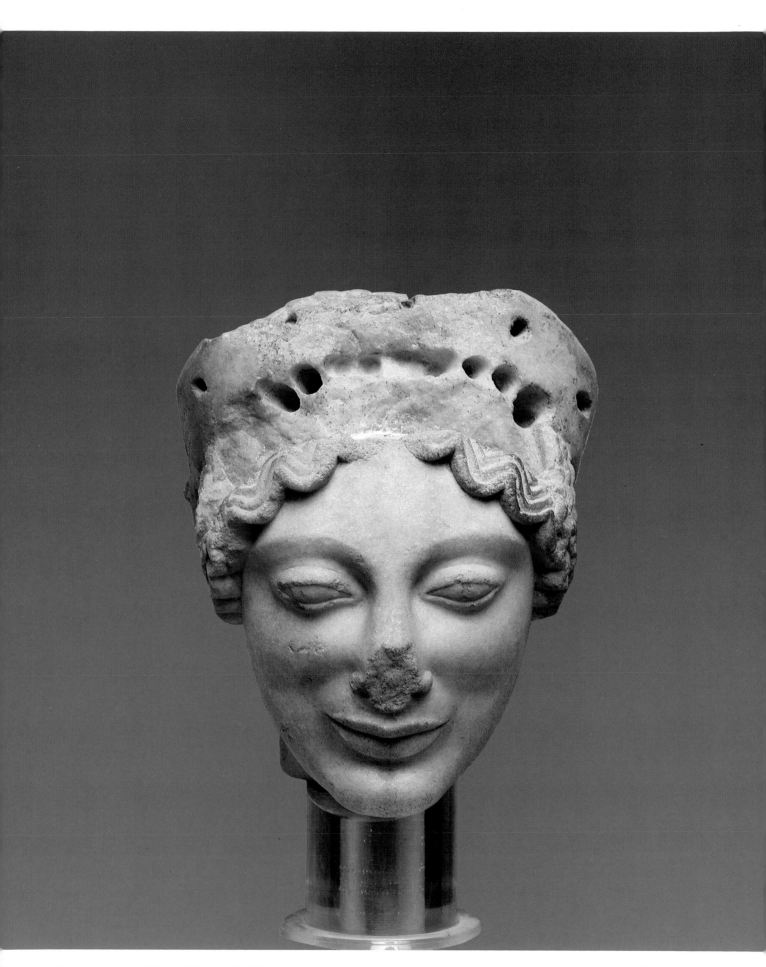

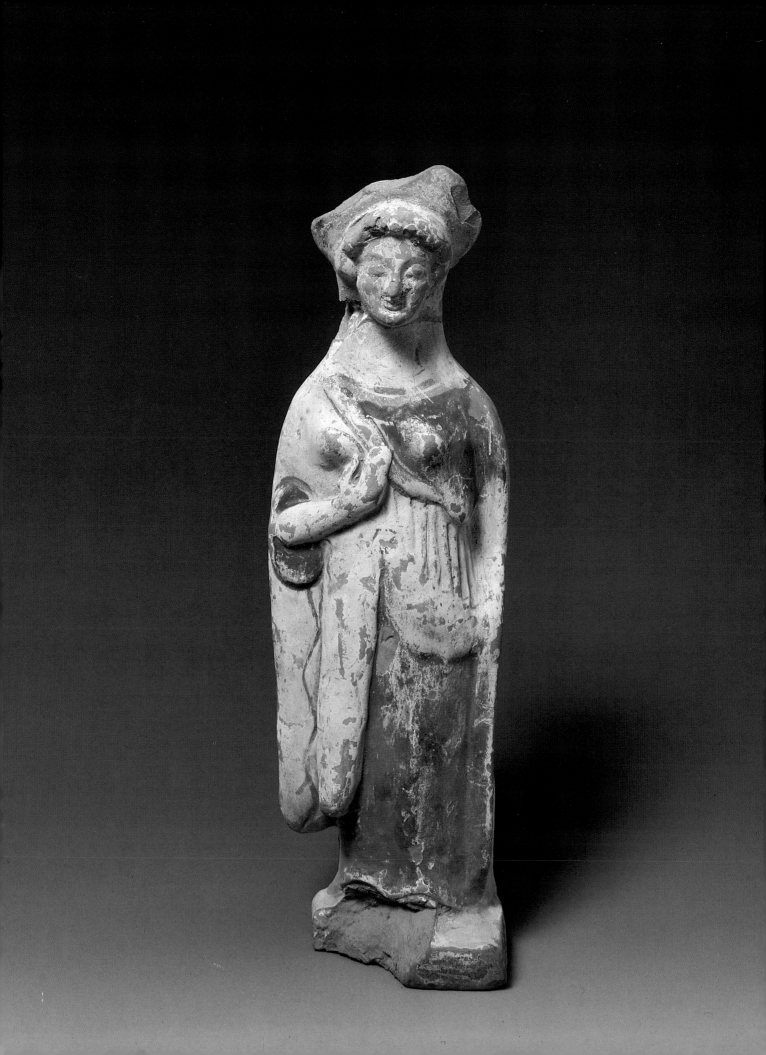

59

Clay Figurine

Found on the Acropolis
Attic, end of the sixth century B.C.
Height 31.1 (12¼)
Athens, Acropolis Museum, 10484

Beside the expensive dedications of the wealthy citizens to Athena, there was no lack of dedications of poorer people. These were pure and pleasing offerings to the protectress of the city of Athens, even though they could not vie in size and magnificence with the great marble statues. Numerous small clay figurines, dedicated to Athena and representing standing or seated females, were found in the excavations of the Acropolis. This little figure is an example of that type of offering.

The female figure is shown frontally and almost motionless, with the left leg slightly advanced. For all its small size, the work shows an impressive rendering of details both in modeling and in paint. The woman, who probably stands for the female dedicant, is wearing a long red chiton and a richly folded white mantle with black border, fastened on the right shoulder and passing under the left arm. Below the diadem that proudly crowns the head, the hair is arranged in two rows of spiral curls over the forehead. A veil, token of modesty and sobriety, is worn over the diadem and falls to the shoulders. The position of the right hand, holding a fruit or flower before the breast, is typical of all the figurines of this group.

The unpretentious material and small size of the work do not detract from the expressiveness and sculptural quality, the delicate charm and the artistic sensitivity of which are heightened by the use of the colors.

Athens held an important place among the other Greek cities in the production of such figurines in the late Archaic period.

Bibliography
S. Casson (and D. Brooke), *Catalogue of the Acropolis Museum* 2 (Cambridge, 1921): 350, no. 4.
R. Nicholls, "Two groups of archaic Attic terracottas," in *The Eye of Greece*, edited by D. Kurtz and B. Sparkes (Cambridge, 1982), 89–122, especially 93–94.

N. K.

60

Red-Figure Alabastron

Found in Athens in 1891
Attic workshop, attributed to the painter
 Paseas, c. 520 B.C.
Height 17 (6⅝)
Athens, National Archaeological Museum,
 1740

The painter Paseas was a master of the early red-figure style. With clear, expressive drawing and thin relief lines, he painted two female figures enclosed in panels bordered by bands of net pattern. On one side, a woman with a long dress and an embroidered mantle, in a restrained, quiet pose, holds flowers in her slender fingers. On the other side, a dancer, also in a long dress, animated by an inner vigor, dances to the sound of her *crotala* (castanets).

The hair of both women is gathered into a knot (*korymbos*) and tied low on their heads with narrow ribbons. Very fine small curls frame the expressive faces, which have large almond-shaped eyes shown in a frontal view. Earrings complete their fashionable, well-groomed appearance.

With these two charming, graceful figures, the artist demonstrates his ability to adjust the drawing to the shape of the vase.

Bibliography
S. Karouzou, "Scènes de Palestre," *BCH* 86 (1962): 431–432, fig. 2.
Beazley, *ARV*², 163, no. 13.
CVA Athens, pls. 1, 1–2 and 6–8.

R. P.

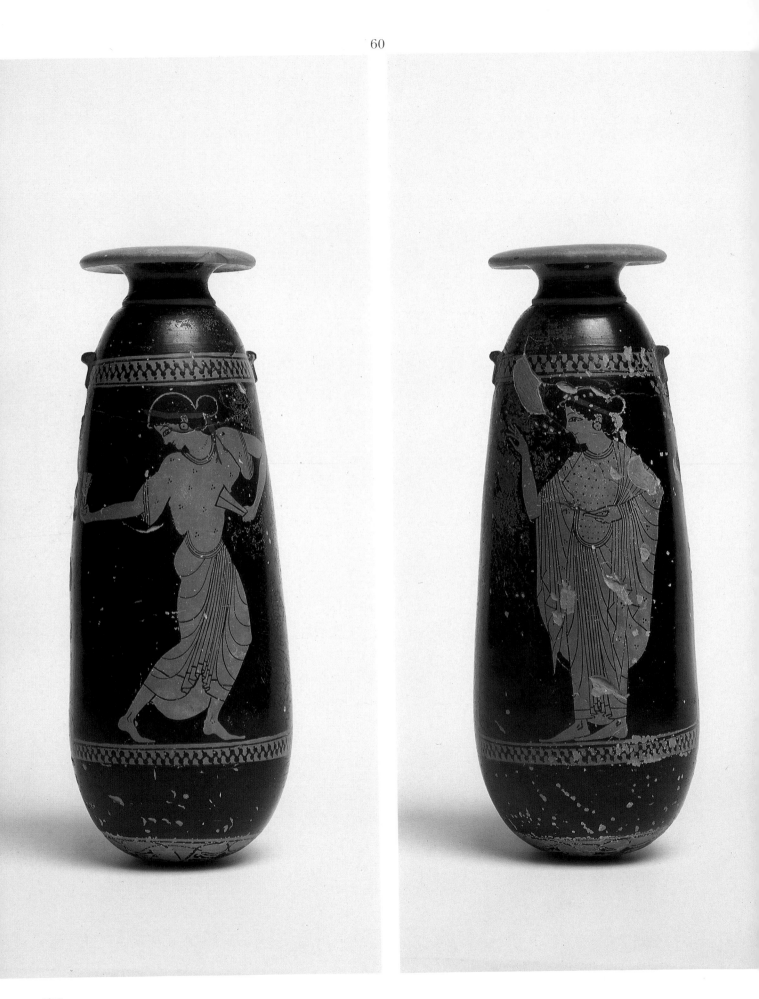

Clay Relief Plaque
Found on the Acropolis
End of the sixth to beginning of the fifth
 century B.C.
21.8 x 15.7 (8¾ x 6⅛)
Athens, Acropolis Museum, 13055

This plaque, found on the Acropolis, was evidently a dedication to the goddess Athena.
It belongs to a class of decorative or "applied"
arts produced in quantity for household, votive, or other purposes that conform to styles
established by major works of art. Plaques of
similar size, shape, and style have been found
in great numbers on the Athenian Acropolis,
and at the sanctuary of Artemis at Brauron
and in smaller numbers elsewhere in Attica.
The majority but by no means all of those
from the Athenian Acropolis represent Athena
herself in her different aspects: Promachos,
the goddess of war, Polias, the goddess of the
city of Athens, or Ergane, the goddess of domestic tasks.

The female figure in this relief sits on the
edge of a couch swinging her legs, the toes
of her right foot touching the footstool. She
wears a long, sleeved Ionic chiton, marked all
over by fine, wavy folds. On her head she
wears a kerchief (*sakkos*), leaving only a little
hair visible on the forehead and the temples.
Originally the plaque was completely whitewashed; other colors were probably added to
indicate details.

Although the figure's hands are missing,
similar representations show that she was
spinning, holding a distaff in her left hand
and the thread, from which the spindle hangs,
in the right. Before the wider range of these
reliefs became known, scholarly opinion used
to interpret this figure as Athena Ergane
(goddess of work), the most peaceful of her
aspects, although the obvious attributes of
Athena are completely missing, for example
her helmet and her aegis. Regardless of the
identification, the plaque features a typical
scene of one of the most common occupations
in the everyday life of women in ancient
Greece.

The holes in the upper corners and below
show that the plaque was hung up and displayed.

Bibliography
C. A. Hutton, "Votive Reliefs in the Acropolis
Museum," *JHS* 17 (1897): 306–312.
S. Casson (and D. Brooke), *Catalogue of the Acropolis Museum* 2 (Cambridge, 1921): 420–421.
H. A. Thompson, in *Hesperia* 17 (1948): 180.
S. Stucchi in *RM* 63 (1956): 122–128, pl. 58, 1.
Brouskari, *The Acropolis Museum*, 41, fig. 65.
LIMC 2 (1984): 962, no. 43, pl. 708. N. K.

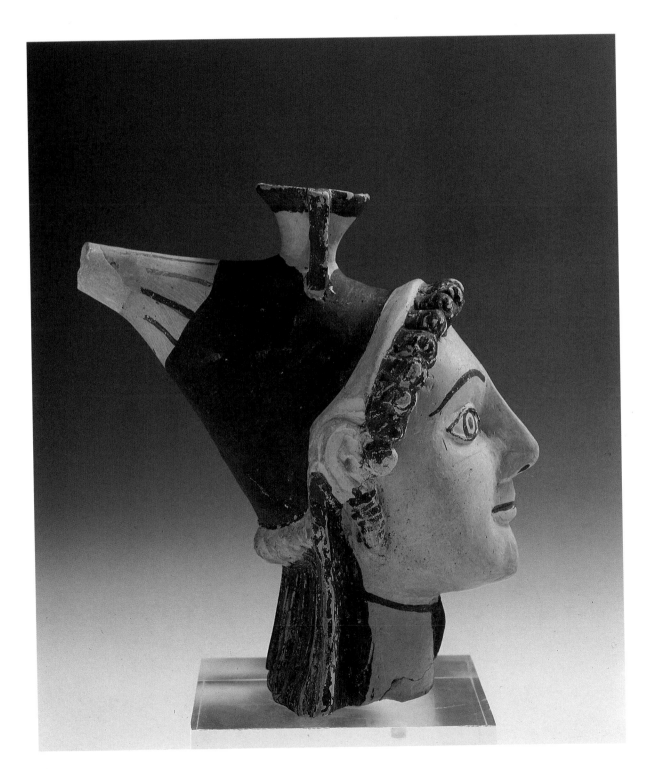

172

62

Clay Plastic Vase in the Shape of a Female Head

Found in Tanagra, Boeotia
Boeotian, c. 490–480 B.C.
Height 13 (5⅛)
Athens, National Archaeological Museum,
 4073

Boeotia, neighbor to major artistic centers and not having developed an important tradition of her own, began from early times to imitate others in many forms of artistic expression. By this date the main new fashion in plastic vases was that of the Attic head-vases. An Attic head-aryballos is copied here, although the effect at the back is quite different.

 This plastic vase is a provincial work, hand finished but full of freshness and charm. It shows the artist's attempt to impress the viewer by rendering every ounce of female coquetry. The woman's face, intensely expressive with its large, wide-open, almond-shaped eyes, long curved eyebrows, and pursed lips, is surrounded by thick hair protruding from below the high conical cap, forming small spiral curls across the forehead and falling behind the ears and low on the shoulders at the back. Long earrings and a necklace with a large conical bead complete the figure's well-groomed appearance. On the top of the head is formed the mouth of the vase with two handles, at the peak of the cap, its spout. Red paint was used for the rendering of details on the mouth of the vase, the cap, earrings, lips, necklace, and inner corners of the eyes. Brown was used on the hair, eyebrows, eyes, and earrings.

Bibliography
S. Karousou, "Documents du Musée National d'Athènes," *BCH* 61 (1937): 361–362, fig. 8, pls. 27:1, 27:3.

R. P.

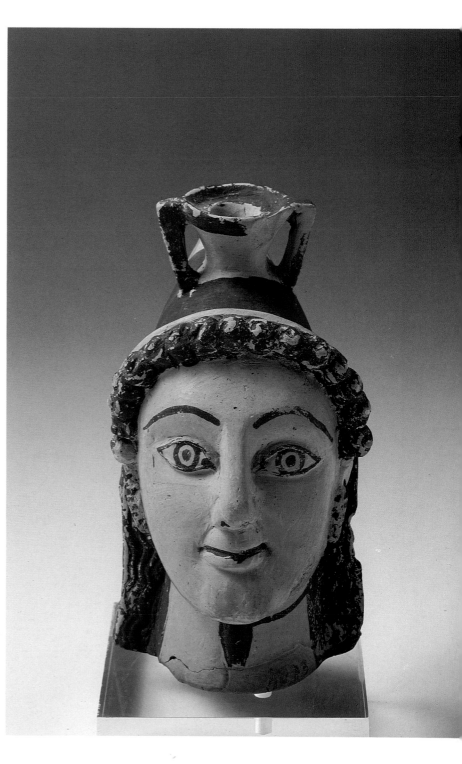

63

Square Marble Relief Base for a Statue

Found south of the Piraeus Gate in the city
 wall of Athens in 1922
Attic, under island influence, end of the
 sixth century B.C.
27 x 72 x 79 (10⅝ x 28¼ x 31⅛)
Athens, National Archaeological Museum,
 3477

The Greek historian Thucydides tells us (1.90,
3) that after the defeat by Xerxes, the Athe-
nians returned to their destroyed city and has-
tily rebuilt the walls using materials taken from
public and private buildings (478 B.C.). The
truth of this account was once more dem-
onstrated when this base, another one with
reliefs, and a third plain one were found built
into the wall constructed by the Athenian
commander Themistocles.

Carved in Pentelic marble, the base must
have been the capping block of a pedestal on
which rested a seated statue, to judge from
the cuttings in its upper and lower surfaces.
All three bases and their statues could have
belonged to the burial plot of a single family.
Inscribed on the third, undecorated base is
the name of the sculptor Endios, who could
have been the designer of the whole monu-
ment and the sculptor of the statues. The two
relief bases were probably made by members
of his workshop.

The base shown here is worked on three
sides in flat, restrained, rather unemphatic
carving. The figures stand out against a back-
ground that has been chiseled away, leaving
a projecting frame that serves at the corners
to separate the three subjects.

The relief on the front is of an ancient ball
court, where six youths are playing a game,
something like our modern hockey, with a
ball and curved sticks, a unique representa-
tion in Greek art. The two center figures are
facing off, while the other four, two on either
side, appear to be awaiting their turns, as we
can see from their poses, particularly that of
the youth on the right who is leaning against
the frame as if it were a wall. The artist has
sought to define depth of space by overlap-
ping the figures. He shows heads, torsos, and
legs straight or in profile, but never in a three-
quarter view.

A different subject appears on the two sides:
the departure of a chariot, a theme well known
in Ionic art. On each side is depicted a four-
horse chariot, with its charioteer and an armed
warrior who rides beside him. Two armed
warriors, a youth and a bearded man, follow
on foot. It is noteworthy that the two groups
are represented as if they were one, seen from
two vantage points: in the relief on the left
are the interiors of the warriors' shields, while
in that on the right are the exteriors.

The artist has enlivened his work with color,
traces of which survive on the rims of the
shields carried by the soldiers on the right
side. Some details, now difficult to make out,
were rendered with light engraving and color:
the reins, the whip, and the spears of the foot
soldiers on the right side and the spear of the
warrior on the left.

Bibliography
A. Philadelpheus, "Bases archaïques trouvées
dans le mur de Thémistocle à Athènes," *BCH*
46 (1922): 17–26, pls. 4–6.
B. S. Ridgway, *The Archaic Style in Greek Sculpture*
(Princeton, 1977), 135, 146, 295, 301.
L. H. Jeffery, "The Inscribed Gravestones of
Archaic Attica," *BSA* 57 (1962): 127–128, no. 2.
H. A. Harris, *Sport in Greece and Rome* (London,
1972), 101–102, pl. 47.

D. T.

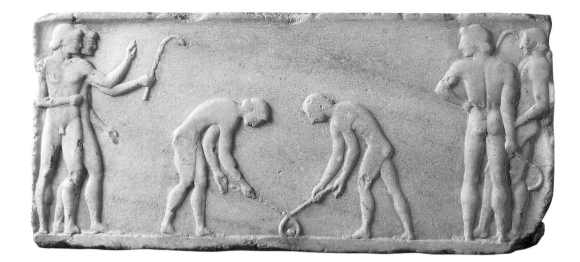

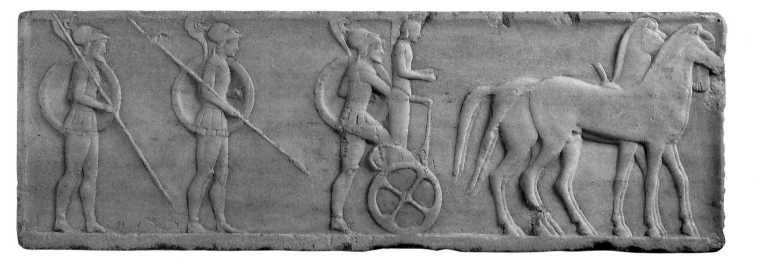

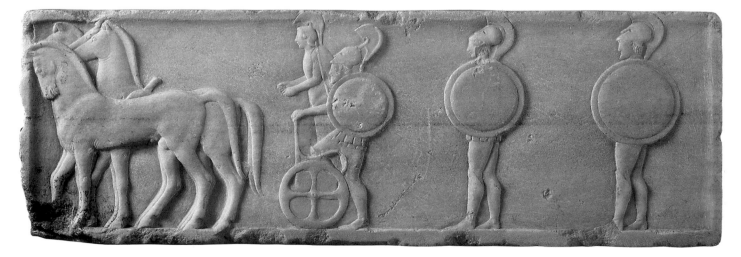

64

Marble Relief Plaque from a Funerary Monument

Found in Athens near the Theseion
End of the sixth century B.C.
Height 101 (39¾)
Athens, National Archaeological Museum, 1959

The love of Greek artists for and their progress in working marble was not restricted to freestanding statuary. The surface of every type of monument that was available for such decoration provides proof of artistic creativity.

This marble plaque of trapezoidal shape and topped by a volute crown must have adorned the end of a funerary monument. The positioning of the figure on the slab is truly admirable.

The representation is highly unusual; opinions are divided as to whether it depicts a *hoplitodromos* (armed runner) or a warrior dancing the "Pyrrhic" war dance. The naked youth wears only a helmet and does not carry a shield. The pose as a whole, with head turned back, torso frontal, and legs in profile with knees bent, is unparalleled. Earlier depictions

of running and flying figures sometimes render the legs this way. But the runner in a race always looks forward in his eagerness, and the pose of these arms and hands recalls pictures of Spartan dancers. So, we might think that the sharp turn and deep knee-bend are part of the young man's dance.

The eyes were open: the irises and the edges of the eyelids would have been indicated in paint (compare cats. 57 and 65). As always on Archaic gravestones, the dead youth is shown in the full vigor of life.

The perfectly formed body, the vigorous physique, and the lively rendering of the youth's limbs, combined with the movement, give us a unique depiction of a human figure in which the artist managed to capture a specific moment in time and to immortalize it on the surface of marble.

Bibliography
M. Andronikos, "Peri tis Stilis tou Oplito-dromou," *ArchEph* (1953–1954, part 2 [1958]):317–326.
M. Robertson, *A History of Greek Art* (Cambridge, England, 1975), 111–112, 135, pl. 31b.
Boardman, *Greek Sculpture*, fig. 239.

N. K.

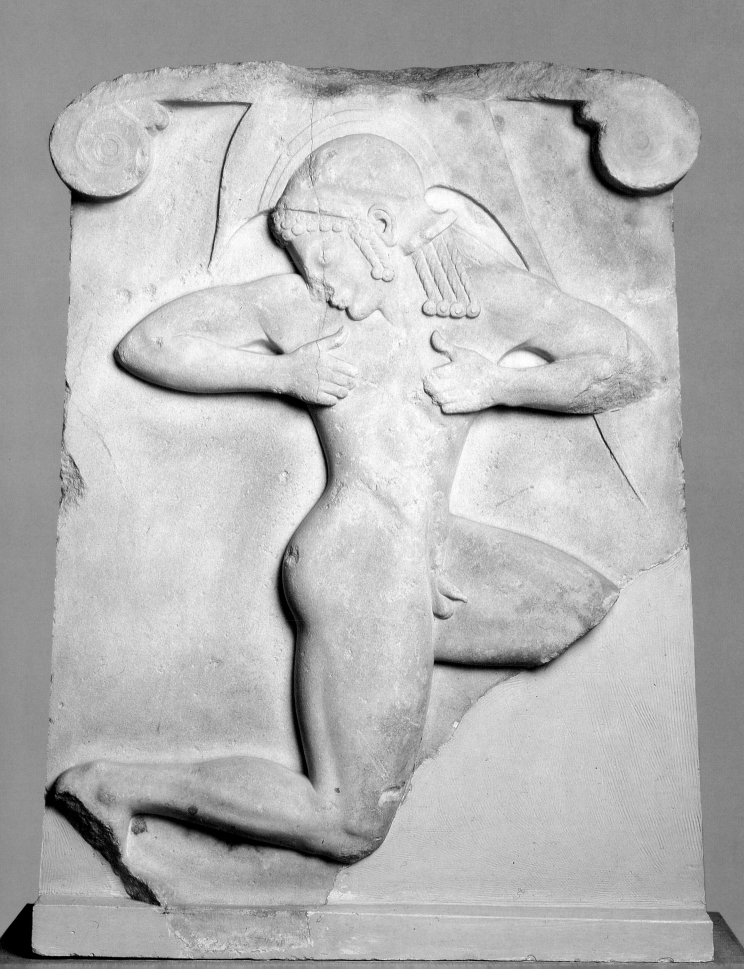

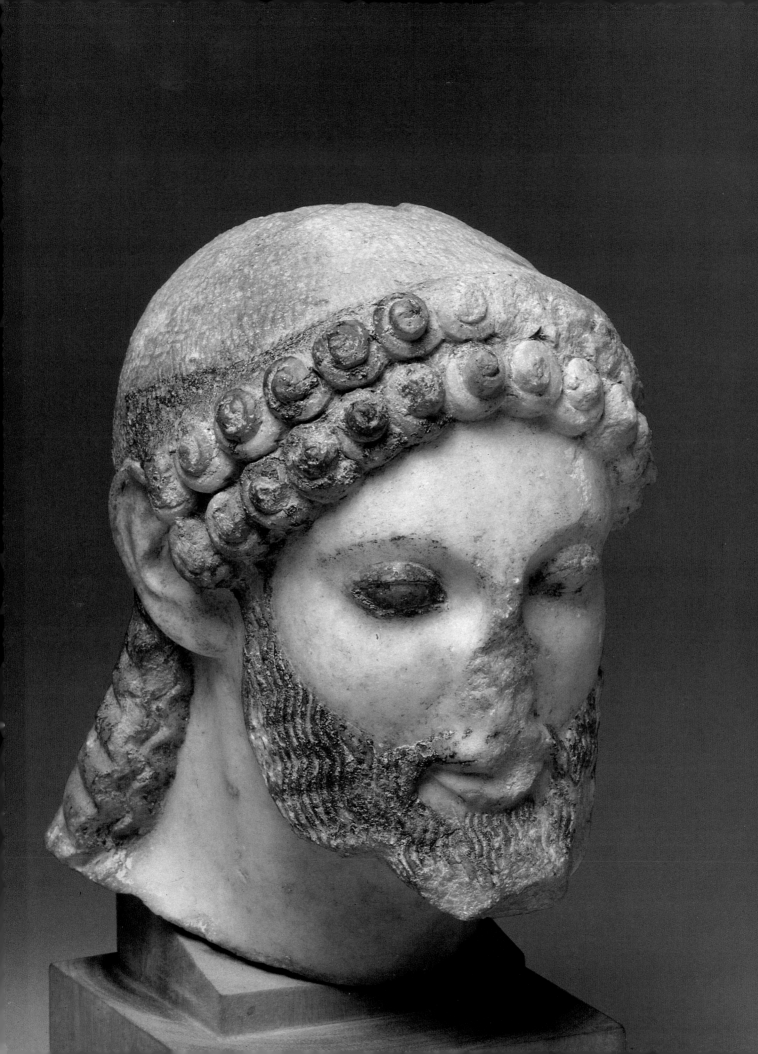

65

Marble Head of a Bearded Man

Found on the Acropolis
Around 500 B.C.
Height 17.9 (7)
Athens, Acropolis Museum, 621

This male head, probably a portrait of an Athenian citizen from the period of great political reforms, comes from a less than life-size statue, perhaps a rider. The upper part of the head is roughly worked and has a hole in the top for attachment of another piece, probably a metal helmet.

The paint, which is relatively well preserved, gives important evidence for the hair and details of the face, such as the eyes, eyelids, and eyebrows. The hair covers the nape of the neck, arranged over the forehead in two especially carefully worked series of "snail-shell" curls. Both the hair and the well-tended beard now appear black, but were once blue. This head, one of the latest examples of Archaic art, closes the chapter on the Archaic period and lays the groundwork for the opening of the early phase of Classical art, the Severe Style.

Bibliography
H. Schrader, E. Langlotz, W.-H. Schuchhardt, *Die archaischen Marmorbildwerke der Akropolis* (Frankfurt am Main, 1939), 231, no. 315, pl. 142.
Brouskari, *The Acropolis Museum*, 96, figs. 180–181, with bibliography.

N. K.

66

Marble Group of Theseus and Antiope

Found in Eretria (excavations of the Temple of Apollo Daphnephoros) in 1900
Attic workshop(?), 500–490 B.C.
Height 112 (44⅛)
Chalcis, Archaeological Museum, 4

The Amazonomachy (battle of Greeks and Amazons) was a much-loved subject in ancient art, popular with vase painters as well as with sculptors of all periods. One of the most successful treatments, in the depiction of the myth and in the execution of the figures, is that which was made, perhaps by the great Athenian sculptor Antenor, to adorn the West Pediment of the Temple of Apollo Daphnephoros in Eretria.

The fragment from this pediment shown here represents the hero Theseus carrying off Antiope, the queen of the Amazons, whom he is abducting against her will. In the center stood the hero's divine helper Athena and to our right the chariot of Theseus, now lost except for some fragments of the horses. Theseus has set his raised right foot on the chariot and is lifting Antiope up to set her in it. Only the upper part of the figure of Theseus, wearing a short cloak over his shoulders, is preserved, together with the head and body of Antiope, whom he holds pressed against him, facing in the opposite direction. She is dressed in what appears to be a leather cuirass, which was originally painted, and under it a short tunic. The other figures from the pediment, also fragmentary, are either Amazons or warriors.

Bibliography
M. Robertson, *A History of Greek Art* (Cambridge, England, 1975), 163–164, pl. 50b.
E. Touloupa, *Ta enaetia glypta tou naou tou Apollonos Daphnephorou stin Eretria* (Diss. Ioannina, 1983), 29–33, with bibliography.
Boardman, *Greek Sculpture*, 156, pl. 205.2.

I. T.

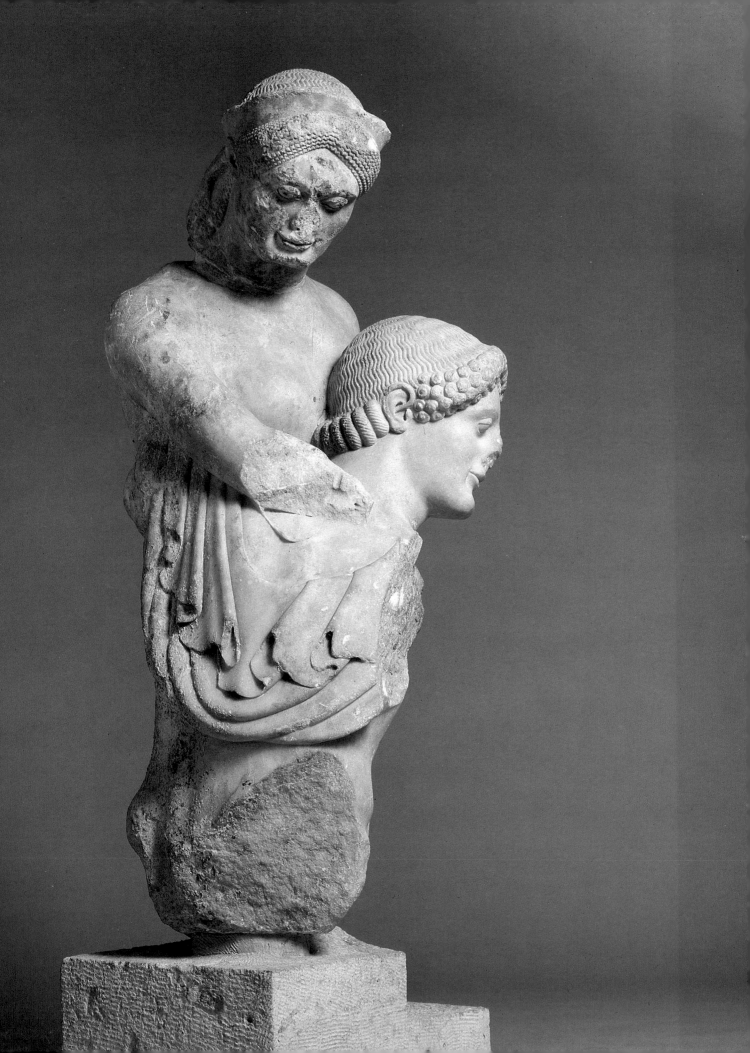

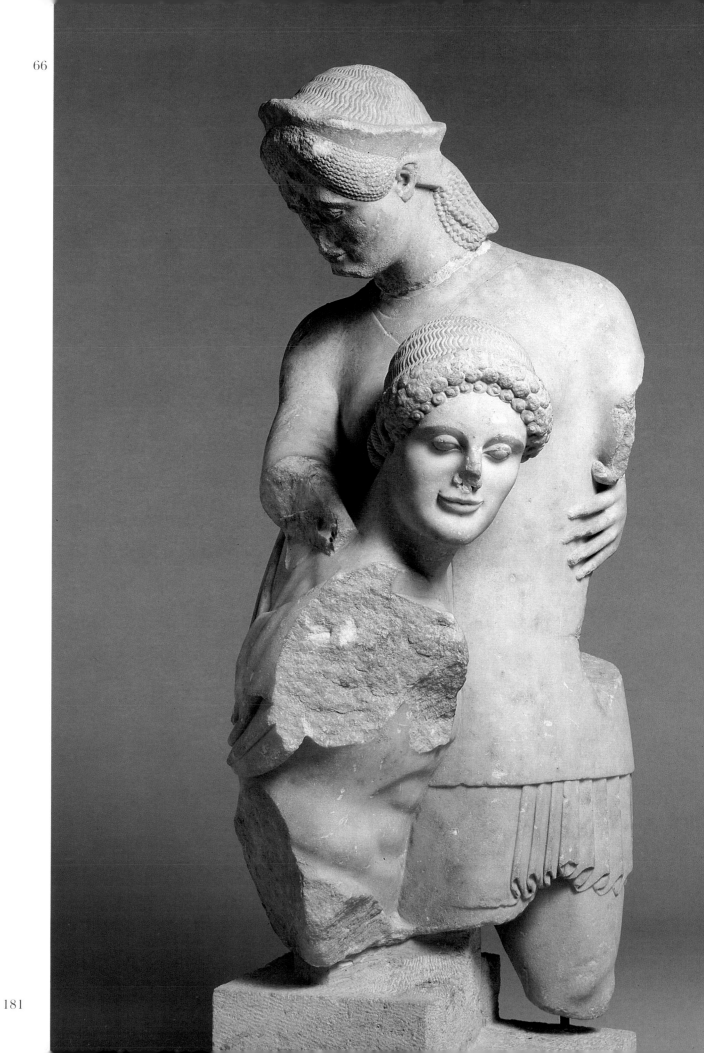

67

Marble Relief of a Victorious Boy Athlete

Found in the sanctuary of Athena at
 Sounion in 1915
Attic, c. 470–460 B.C.
48 x 49.5 (18⅞ x 19½)
Athens, National Archaeological Museum,
 3344

This fragmentary relief is one of the few that survives from the period following the Persian Wars (480–450 B.C.) when the Archaic developed into the High Classical style. It was found buried in the sanctuary of Athena at Sounion and was probably, although not certainly, a votive offering. It is characterized by simplicity and sober gravity (the so-called Severe Style), the creation of Greeks who have won self-confidence and ethnic pride by their victories over the Persians, yet are profoundly conscious of the responsibilities of freedom and human weakness in the face of divine power.

Representative of this period, this exceptional relief represents a young athlete, still a boy, as he places a wreath of victory on his head (*autostephanoumenos*, "self-crowning"). The relief is modeled simply, the anatomy of the torso rendered in a restrained manner. The nude boy, with his body turned in three-quarter view, bows his head slightly as he gracefully sets the wreath of victory upon it. In his short hair, which is bound with a ribbon, are holes by which the now-lost metal wreath was fastened. The gentle features of his face and the whole attitude of his body express the deep, modest, and thoughtful satisfaction that he feels in recognizing not only human value, but also divine power.

The spiritual and dematerialized atmosphere of the work must have once been enhanced by the blue background color, traces of which are still preserved on the left side of the relief.

Bibliography
R. Lullies and M. Hirmer, *Greek Sculpture*, rev. and enlarged edition (New York, 1960), 70–71, pl. 96.
B. S. Ridgway, *The Severe Style in Greek Sculpture* (Princeton, 1970), 49–50, fig. 70.
H. Abramson, "A Hero Shrine for Phrontis at Sounion?" *California Studies in Classical Antiquity* 12 (1979): 4–5, pl. 1, fig. 2.
G. Neumann, *Probleme des griechischen Weihreliefs* (Tübingen, 1979), 38, fig. 20B.

D. T.

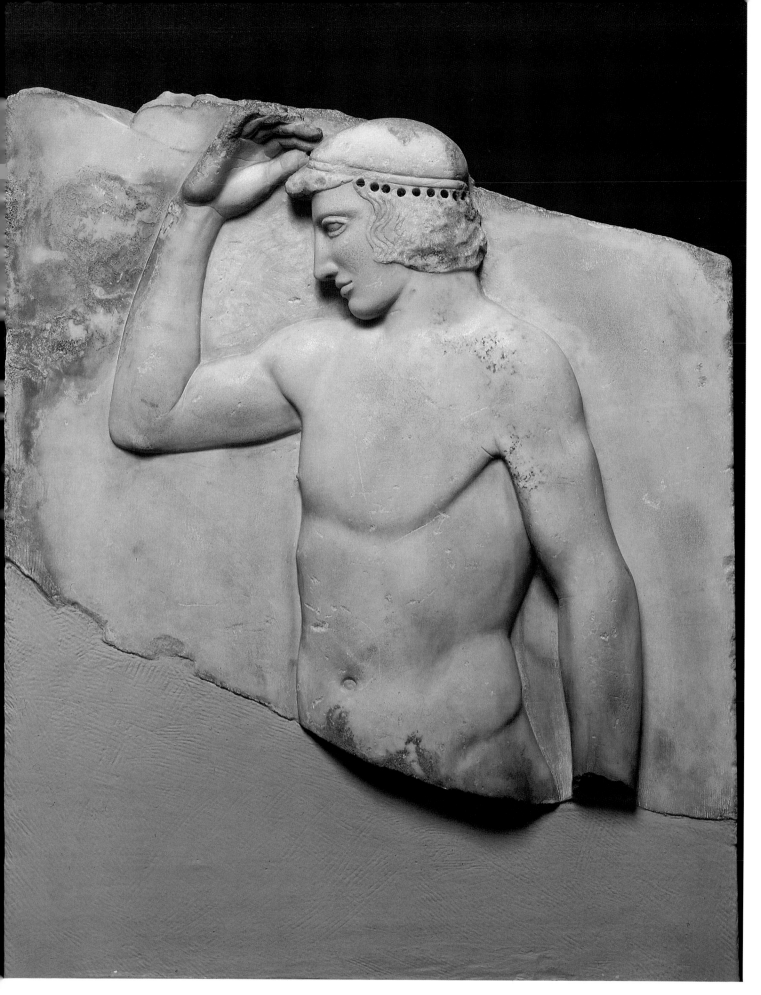

The trustees of the National Gallery of Art are further indebted to Olympic Airways for the generous and careful transportation they have provided for the objects to and from Greece as well as for many people involved in this exhibition.

J. Carter Brown

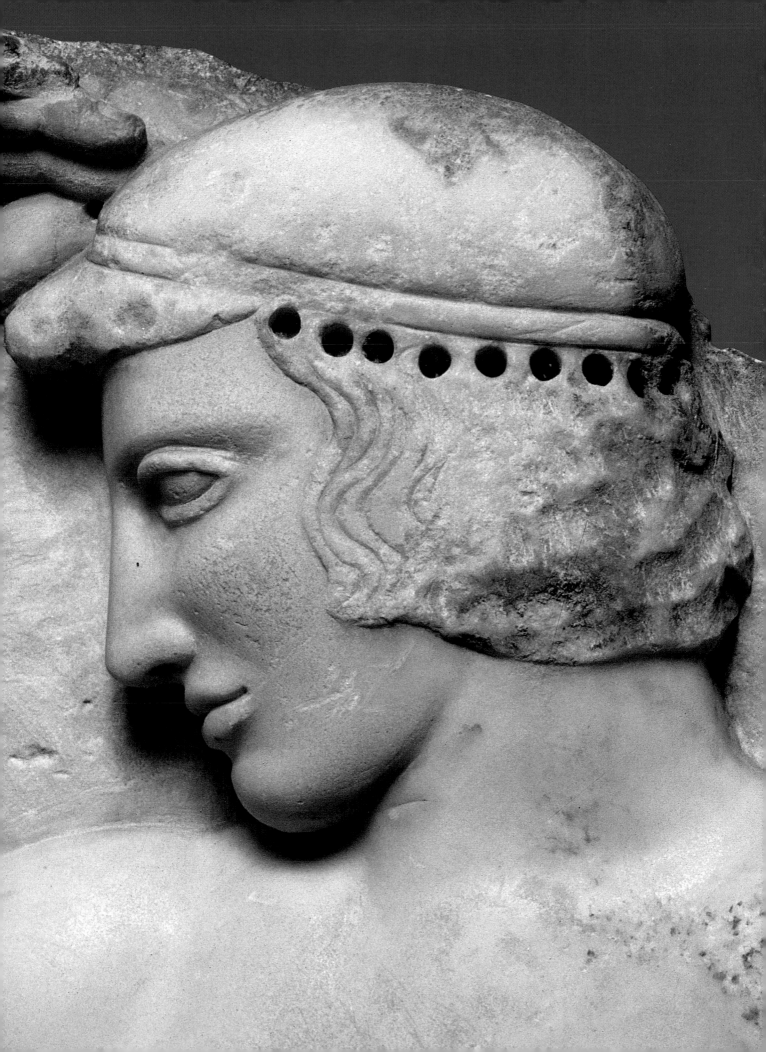